Graphis Photo Annual 2001

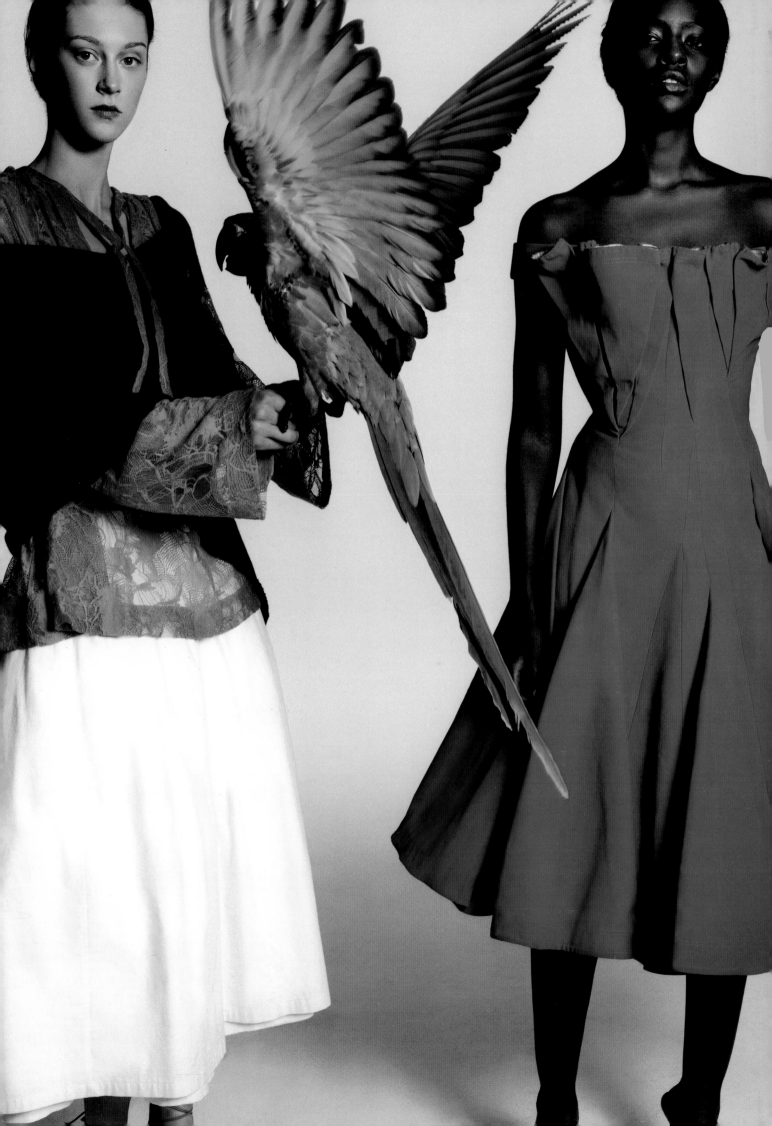

Graphis Photo Annual 2001

An International Annual of Photography

Das internationale Jahrbuch der Photographie

Le répertoire internationale de la photographie

Publisher and Creative Director: B. Martin Pedersen

Editors: Vance Lin, Heinke Jenssen
Art Director: Lauren Slutsky

Assistant Editor: Michael Porciello
Design & Production Assistant: Joseph Liotta

Published by Graphis Inc.

Dedicated to:
Im Gedenken an:
Ce livre est dédié à:
Dr. Karl Steinorth, 1931-2000
Ferenc Berko, 1916-2000

(opposite) Michael Thompson

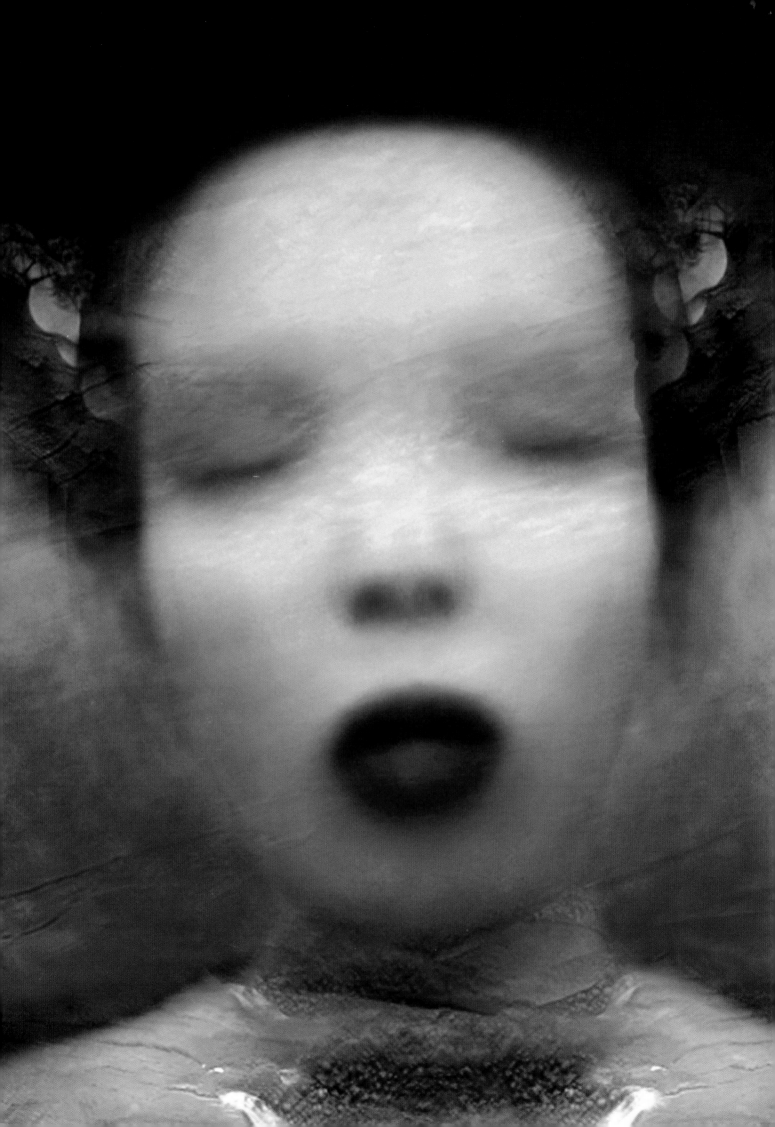

Contents Inhalt Sommaire

Remarks: We extend our heartfelt thanks to contributors throughout the world who have made it possible to publish a wide and international spectrum of the best work in this field. Entry instructions for all Graphis Books may be requested from: **Graphis Inc.**, 307 Fifth Avenue, Tenth Floor, New York, NY 10016 or visit our Web site, www.graphis.com

Anmerkungen: Unser Dank gilt den Einsendern aus aller Welt, die es uns durch ihre Beiträge ermöglicht haben, ein breites, internationales Specktrum der besten Arbeiten zu veröffentlichen. Teilnahmebedingungen für die Graphis-Bücher sind erhältlich bei: **Graphis Inc.**, 307 Fifth Avenue, Tenth Floor, New York, NY 10016. Besuchen Sie uns im World Wide Web, www.graphis.com

Remerciements: Toute notre reconnaissance va aux designers du monde entier dont les envois nous ont permis de constituer un vaste panorama international des meilleures création. Les modalités d'inscription peuvent être obtenues auprès de: **Graphis Inc.**, 307 Fifth Avenue, Tenth Floor, New York, NY 10016. Rendez-nous visite sur notre site web: www.graphis.com

(oppposite) Roxann Arwen Mills

ICP: The International Center of Photography

New York's International Center of Photography (ICP) is a museum, an exhibition center and a school offering instruction in photography at every level. It was founded in 1974 by photojournalist Cornell Capa as an outgrowth of the International Fund for Concerned Photography (IFCP), to preserve the memory of four photojournalists who died in the pursuit of their work: Robert Capa (Cornell's brother), Werner Bischof, David Seymour ("Chim") and Dan Weiner. A nonprofit group dedicated to the idea of socially engaged photographic reporting, the IFCP organized exhibitions in the U.S. and abroad. Its success enabled the newly established ICP to secure a permanent location on 1130 Fifth Avenue. In the coming years, ICP will move to expanded facilities at 1133 Avenue of the Americas, in midtown Manhattan.

The ICP collection began with 2,500 photographs inherited from the IFCP. Today it has grown to include nearly 50,000 original prints by more than 1,000 photographers from around the world. The collection's greatest concentration lies in the area of documentary photography and photojournalism, notably in extensive holdings of works by Robert Capa, Weegee, Roman Vishniac and Lisette Model, as well as works by Magnum photographers such as Henri Cartier-Bresson, Bruce Davidson and Inge Morath. It also includes fashion photographs by Horst, Louise Dahl-Wolfe, Guy Bourdin and Helmut Newton, and fine-art photography by Barbara Morgan, Harry Callahan, Adrian Piper, Andres Serrano and Thomas Struth, among many others. Vernacular photography is strongly represented in the Daniel Cowin Collection of images of African-American life from the 1860s to the 1940s. Recent additions include an archive of political graphics from the 1980s and '90s created by the activist group ACT UP to spark awareness of the AIDS epidemic.

ICP's collection and its exhibition program mirror the astonishing diversity of this ever-changing medium. As photography moves into the digital era, ICP will seek to provide through its Web site (www.icp.org) a public forum for the exchange of ideas about photographic images and their many cultural uses.

Christopher Phillips is Curator at the International Center of Photography. His books include Steichen at War (Abrams, 1981) and Photography in the Modern Era (Metropolitan Museum of Art/Aperture, 1989). He is currently preparing an exhibition that will explore the picture weeklies of the 1920s and '30s. (Opposite) Fashion photograph for Vogue (1933), Gelatin silver print, Photo by Edward Steichen, Courtesy of Condé Nast Publications.

Photojournalism: Beyond Crisis by Christopher Phillips

In recent years the warning has been repeatedly sounded by photographers and picture editors that photojournalism has entered a state of crisis, one that threatens its very existence. Of course, photojournalism has passed through many such moments since its flowering in the 1920s and '30s with the rise of big weekly picture magazines like *Life* in the U.S. and *Vu* in France. But from the late 1950s until the early '70s, the advent of broadcast TV and the decline of the picture magazines forced photojournalists to seek out new venues and audiences. Today, at a time when global, real-time TV news and Internet-based news

plore subjects in depth. Today's cost-conscious picture editors are more likely to turn to syndicated news images from global on-line suppliers than to dispatch their own photographers to cover a distant story. Even at a prestigious assignment agency such as Magnum Photos, the situation is essentially no different: on any given day, its photographers are more likely to be shooting for advertising or corporate clients than carrying out the ambitious, hard-hitting photo essays for which Magnum was once known for and celebrated.

In addition to these economic pressures, other factors are

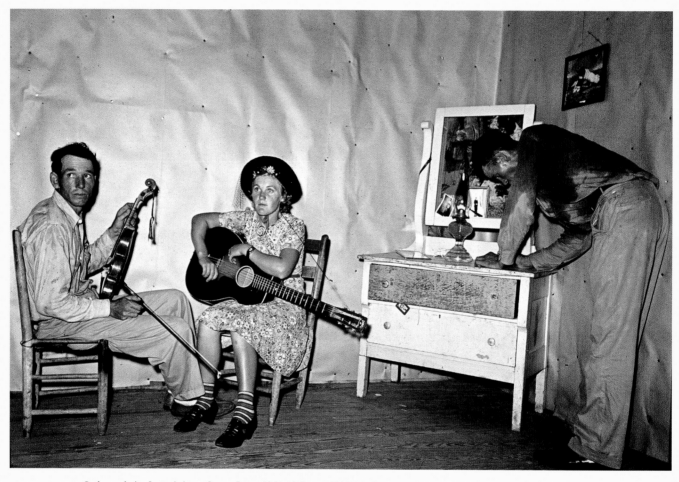

Orchestra during Intermission at Square Dance, McIntosh County, Oklahoma (late 1930s), Modern chromogenic print, Photo by Russell Lee

agencies are reshaping the worldwide information economy, photojournalism is again hard pressed to adapt to this challenging new situation.

Despite the incessant desire of print publications for what Michele Stephenson, *Time*'s director of photography, calls "compelling images that tell stories in interesting ways," today's photojournalists have had to surmount unprecedented obstacles in supplying those images. One such obstacle is the reality of continuing budget cuts at economically hard-pressed general-interest magazines, which results in a dwindling number of photographic staff positions and the virtual disappearance of the extended assignments that once allowed photojournalists to ex-

contributing to what the *Columbia Journalism Review* recently called photojournalism's "vanishing vision." Fred Ritchin, a former picture editor at the *New York Times Sunday Magazine* who now teaches at New York University, criticizes the willingness of both print and broadcast media to devote substantial coverage to staged events used by politicians and corporate leaders to disseminate their prepackaged messages. As a consequence, there has been a dangerous blurring of the line that once separated objective documentary and staged photographs. One predictable result has been a heightened skepticism among readers about the veracity of visual reports, fed by occasional reports of digital manipulation in news imagery. To make matters worse,

the once supple visual language of photojournalism has itself grown sclerotic in a media environment that finds scant use for subtlety. In the battle for audiences, the chief lures used to attract the public's attention have become celebrity profiles and sensational images, focusing on our endless fascination with sex and violence. Ritchin estimates that the kinds of pictures likely to be reproduced in the press have diminished to a handful of generic subjects, which include the powerful executive, grieving widow, the sexy starlet, the down-and-out minority member, the victim of violence, the starving kid and the successful athlete.

What are the paths that can lead photojournalism out of its current predicament? There have been many calls from photographers and picture editors alike, for the support of experiments aimed at finding fresh ways of telling engaging stories with words and images. For the most part, their requests have gone unheeded. Yet photojournalists have perhaps not moved quickly enough to exploit the potential of personal Web sites as a vehicle for bringing their work to the public. Most photographers who have turned to the Web, as Ritchin points out, have presented their images in a single-picture gallery format, or have tried halfheartedly to emulate the layout of the traditional photo essay. He believes that by adding new layers of contextual information and admitting divergent points of view, Web-based photojournalism can empower the reader in ways never before possible. Ritchin predicts that "when we stop thinking of photographers as mechanical scribes 'capturing' events with their cameras while supporting the points of editors and writers, but instead as interpreters attempting to engage both readers and the world in a dialogue, photography will be an appropriate medium for the Web." In order to take advantage of these new modes of presentation, however, photojournalists must become more than specialized producers of their images. They must also begin to verse themselves in such questions as site design, image sequencing, text, sound and so on.

Magnum photojournalist Gilles Peress, for example, collaborated with Ritchin several years ago to fashion a Web site called "Bosnia: Uncertain Paths to Peace" (www.nytimes.com/bosnia). The site enabled readers to follow Peress on his rounds in Sarajevo and to follow the stories that they found most interesting by jumping between photographs, texts, maps, archived articles and the photographer's own spoken reflections on his experiences. A similar example of the expanded possibilities of Web-based photojournalism is the site produced by notable Magnum photographer Susan Meiselas and her colleagues called, "aka Kurdistan" (www.akakurdistan.com). The site grew out of Meiselas's recent book *Kurdistan: In the Shadow of History* (Random House), which explores the predicament of the Kurds, a Middle Eastern people whose persistent efforts to form their own state have met with bloody repression in Turkey and Iraq.

Like the book, Meiselas's site is fashioned from multiple, interwoven stories and images. It features, for example, an elaborate pictorial timeline that tells the history of the Kurds from the 18th century to the present, often using the words of travelers who passed through the former Kurdistan. Perhaps the most innovative part of the site is its "unknown picture archive," where anyone can post a picture related to Kurdish life and invite others to help to identify the people, places or events that are depicted. The resulting potpourri of speculation, interpretation and detailed information from participants around the world opens a fascinating window onto the Kurdish past and present. At the same time, by acknowledging multiple voices and viewpoints, the "unknown picture archive" demonstrates the elusiveness of any single, objective truth.

Another instance of the Internet being used as an innovative vehicle for expanded photojournalistic presentations is the Web site (www.f8.org) from the San Francisco-based group Focal Point f8. Among the stories that can be found there is "The Devil's Cauldron," by award-winning Brazilian photographer André Cyprianos. In an enthralling combination of photographs and first-person narrative, Cyprianos recounts his efforts to gain admittance to a notorious prison island off the coast of Brazil. He leads us through his complex negotiations with the criminal gang which wielded real power within the prison, and then introduces us to the prisoners and guards whose astonishing personal stories unfold in a spectacular selection of words and images. The site is organized so that the black-and-white photographs can be seen sequentially on their own, with short captions, or as components of the full written account.

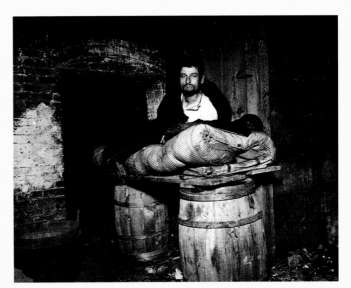

(Above) Peddler's basement quarters on New York's Lower East Side (1892), Gelatin silver print, Photo by Jacob Riis

As with the earlier moments of dramatic reorientation in photojournalism's career, the present crisis may bring photographers and picture editors to a new appreciation of the unique qualities inherent in the still image. The visual stability and the extraordinary informational density of the photograph could well acquire new cachet value in a Web environment that has been overrun by a dizzying mix of graphics, moving images and sounds. Photography experienced just such a rebirth during the 1920s, when it was suddenly seen as an interesting alternative to the rapidfire flux of cinema. In the years ahead, photographic images may well come to play a vital role in Internet journalism, offering readers both an occasion for contemplative immersion in the details of an image and a point for linking to a wide array of informational sources. A revived photojournalism, rooted in the rich new possibilities for visual storytelling opened up by the Web, could prove one of the most interesting surprises in the coming decade.

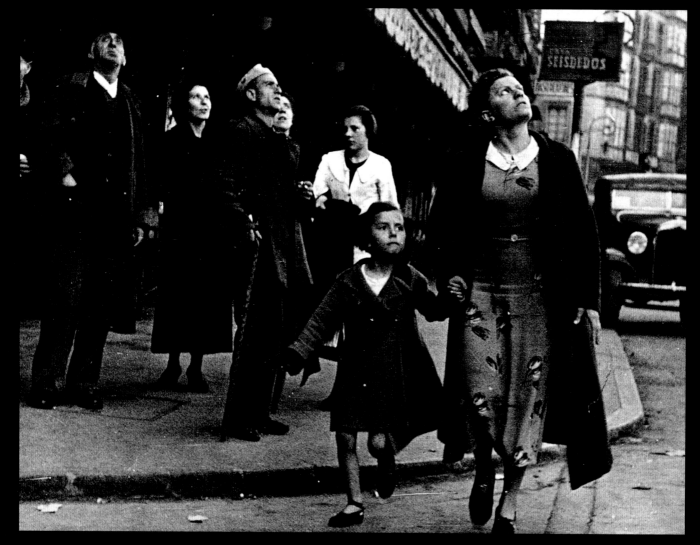

Air Raid Alarm, Bilbao, Spain (1937), Gelatin silver print, Photo by Robert Capa, Courtesy of ICP

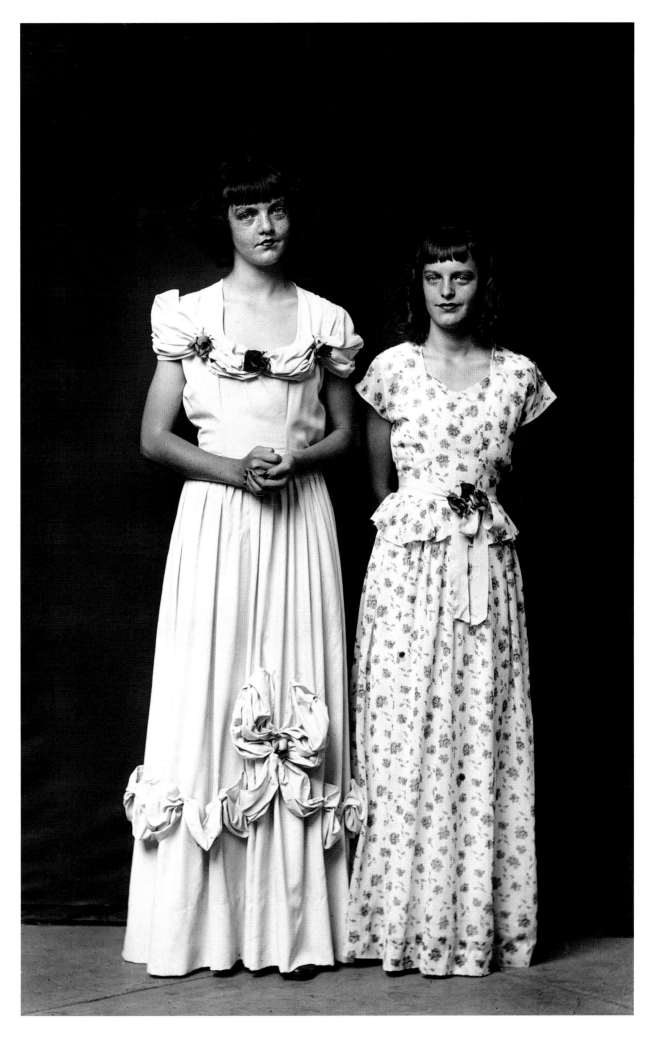

Picola and Ida Harper, Sisters, Heber Springs, Arkansas (ca. 1939-46), Gelatin silver print, Photo by Mike Disfarmer, Gift of Peter Miller and THE GROUP, INC.

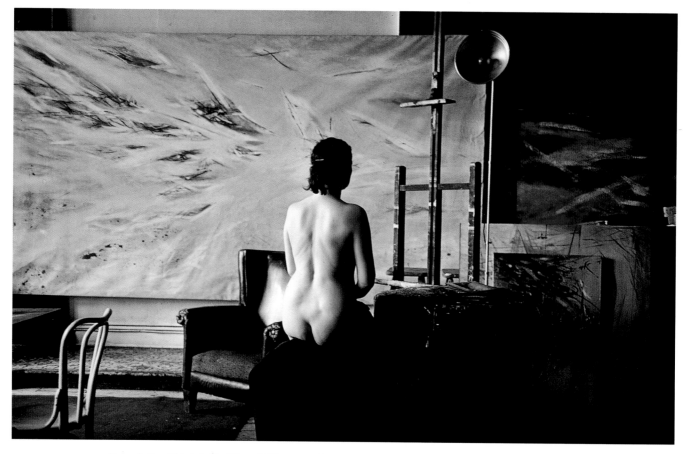

Eleanor in Hugo Weber's Studio, Chicago (1950) Dye-transfer print, Photo by Harry Callahan, Courtesy of Pace Wildenstein McGill

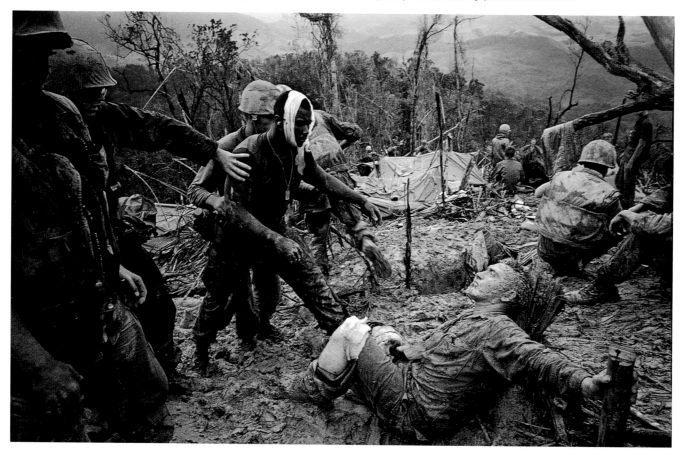

At a First-Aid Center during Operation Prairie (1966), Chromogenic print, Photo by Larry Burrows, Courtesy of The Burrows Foundation

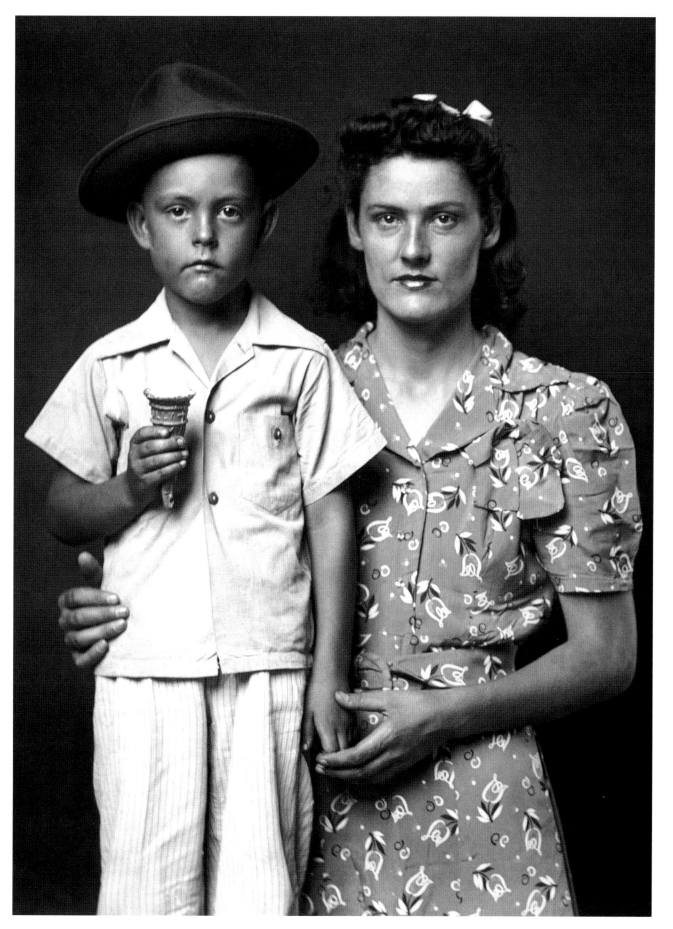

Woman and child holding ice-cream cone (ca. 1939-1946), Gelatin silver print, Photo by Michael Disfarmer, Courtesy of ICP

Architecture

Andrea Wells

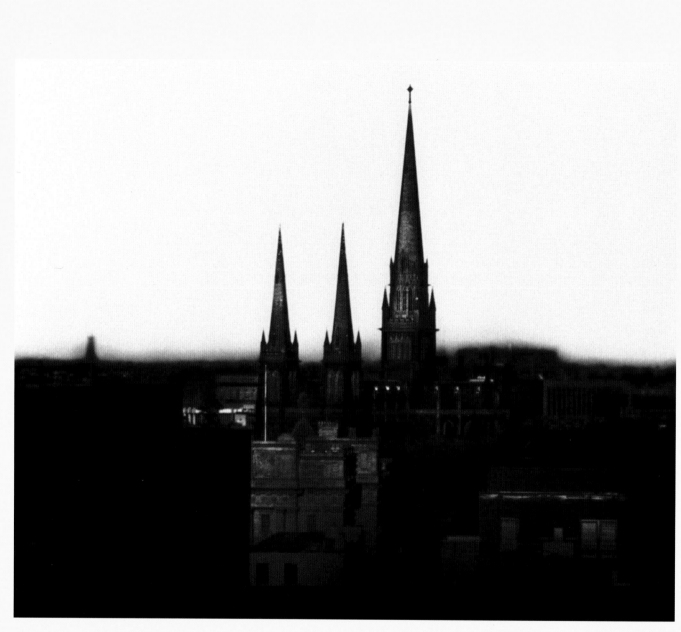

Melvin Lee

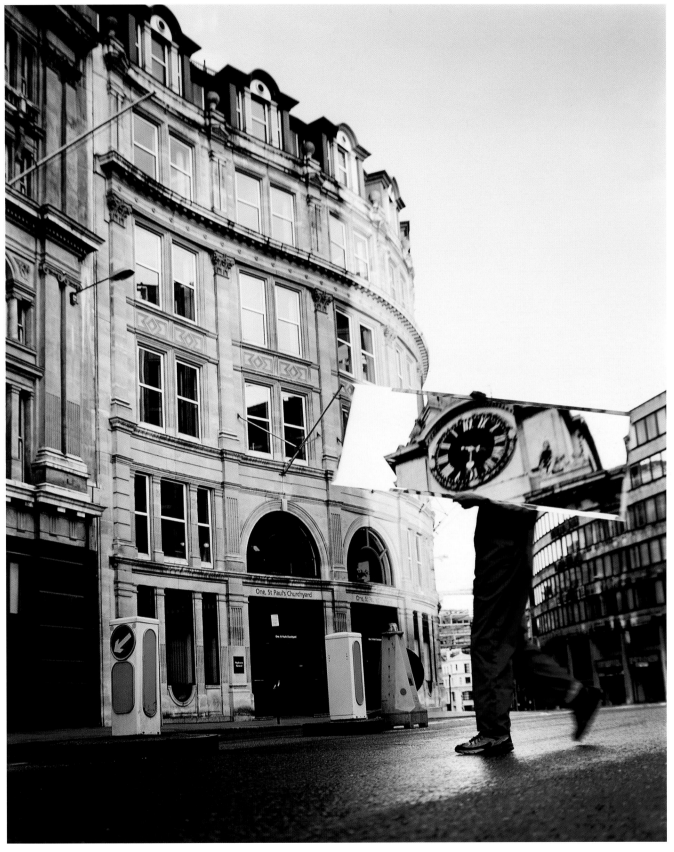

Craig Cutler

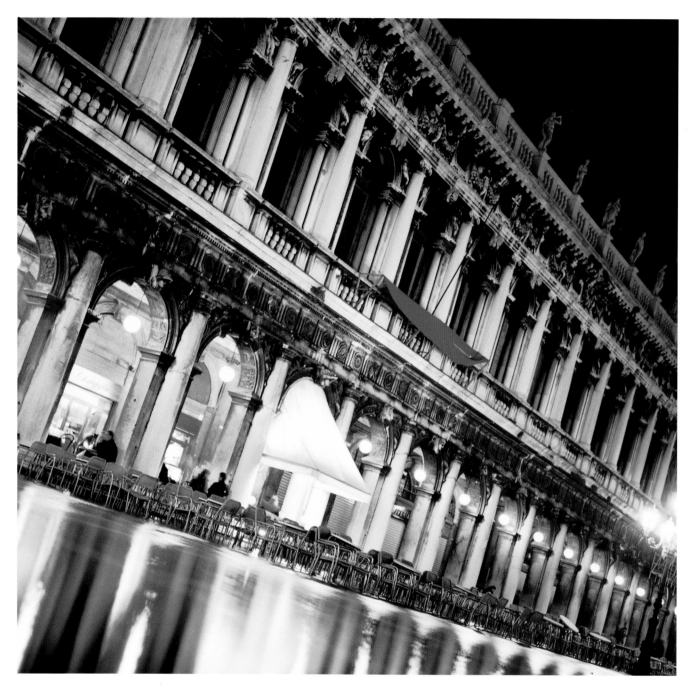

Craig Cutler

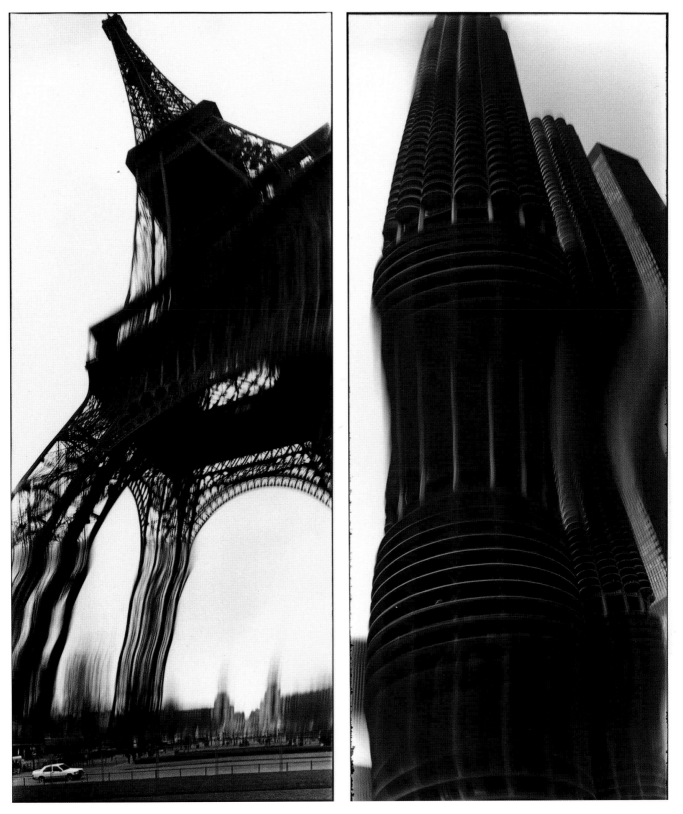

Eugene Zakusilo

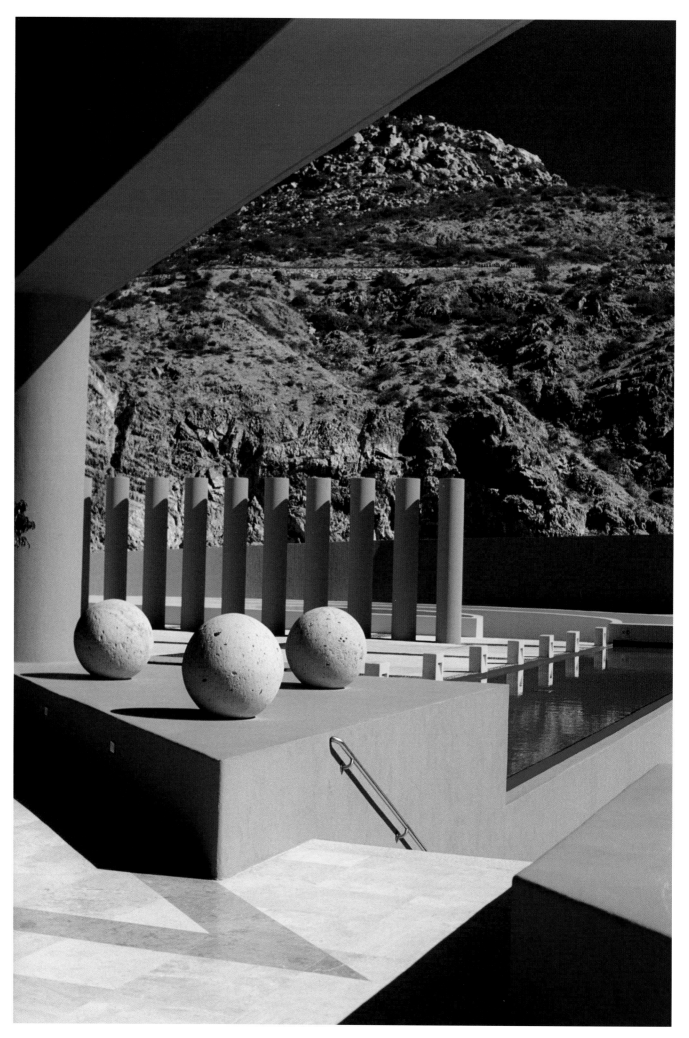

(This Spread) Mike Seidl

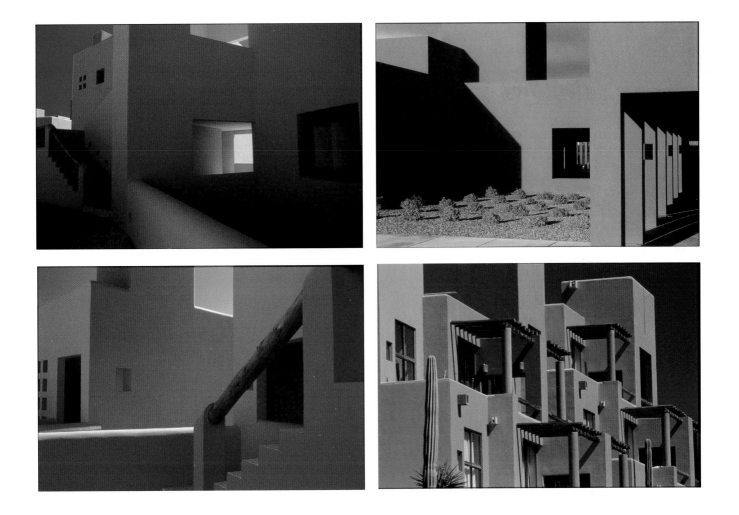

Jon Shireman

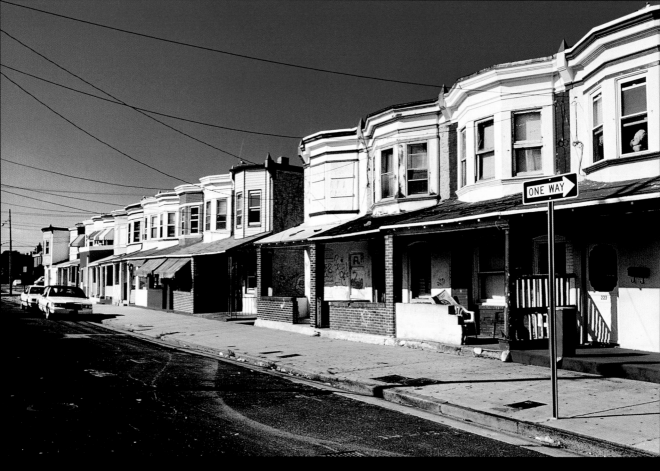

ONE WAY

223

(This Spread) Craig Cutler

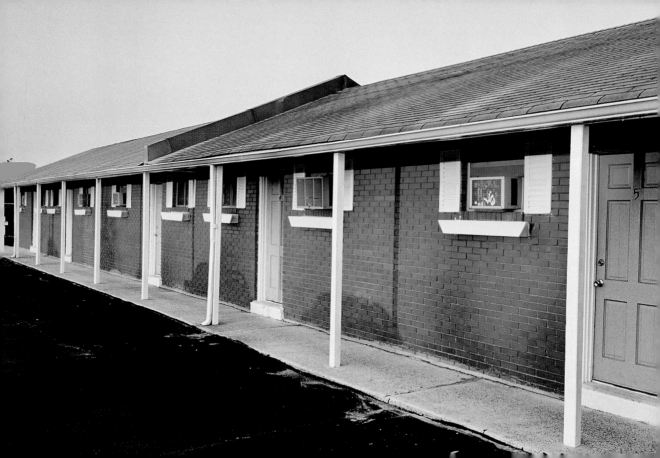

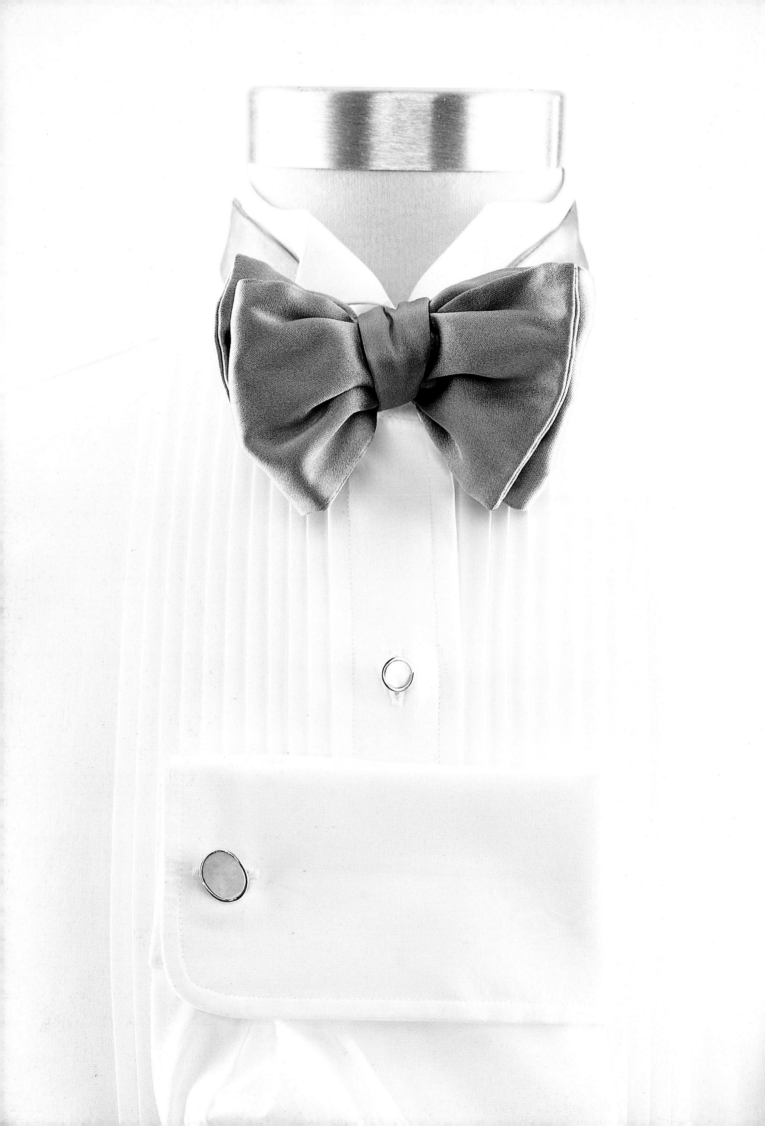

Fashion

James Worrell

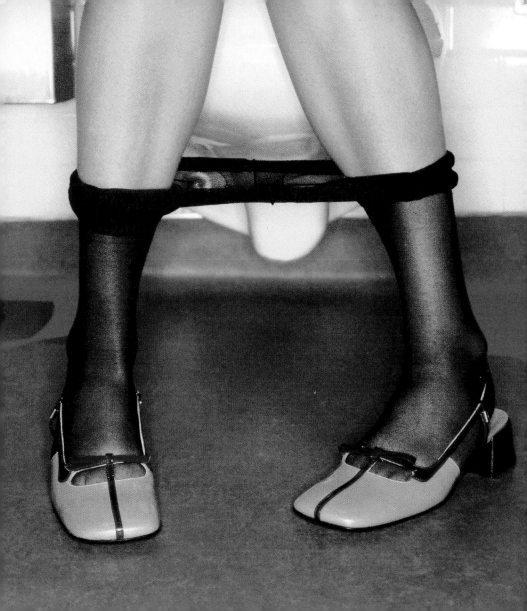

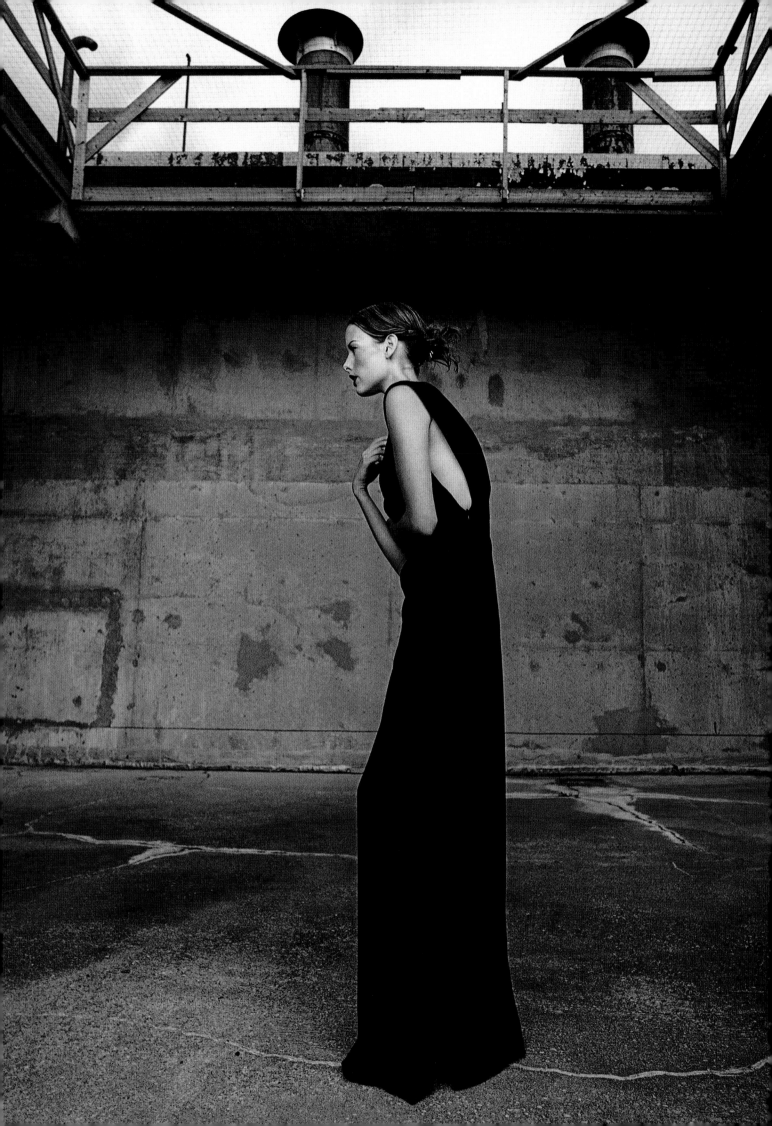

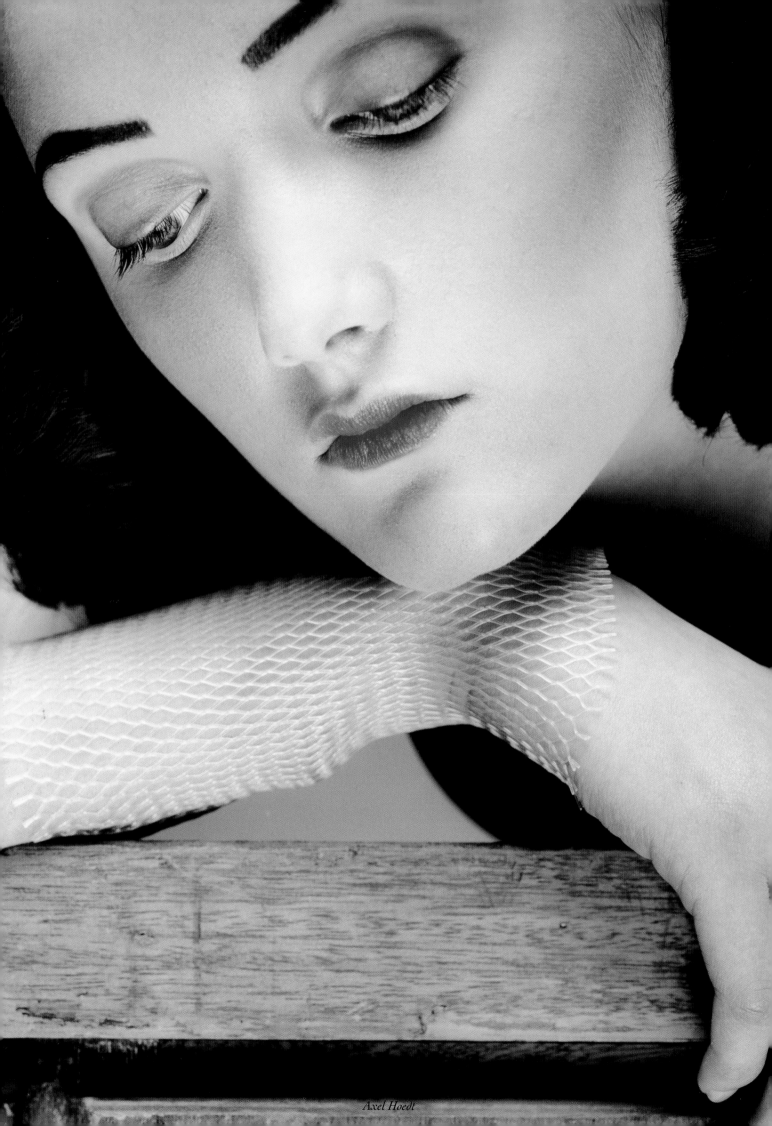

Axel Hoedt

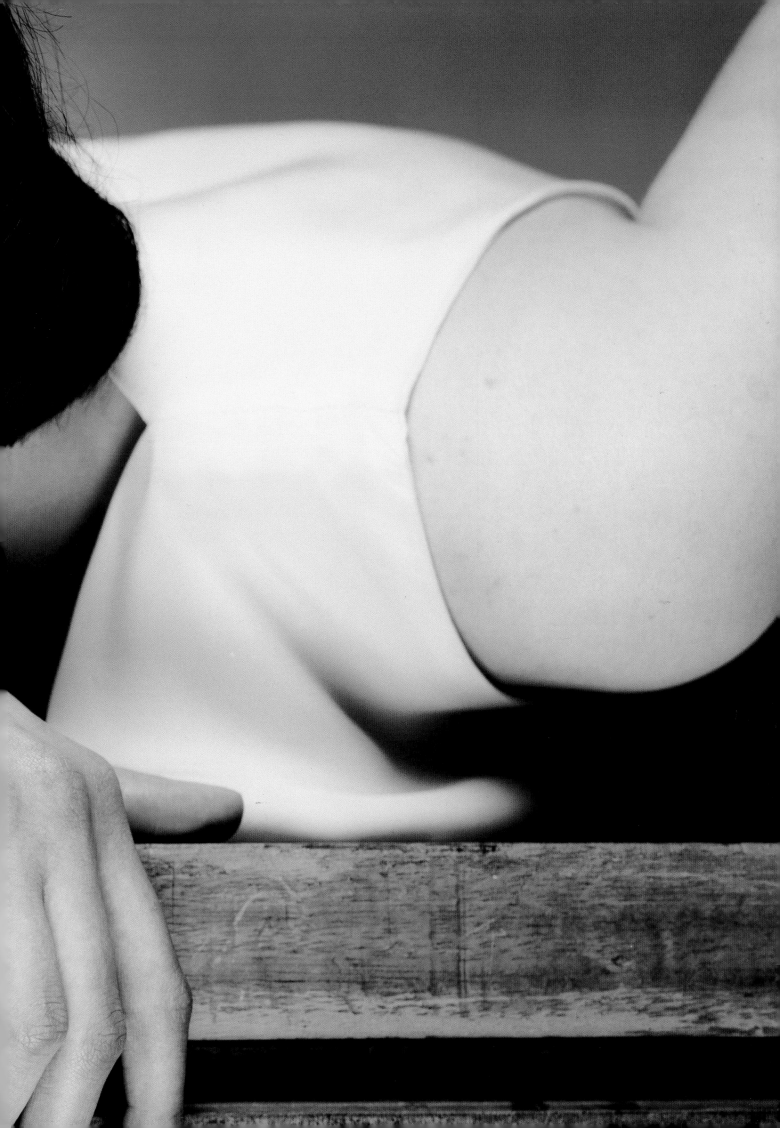

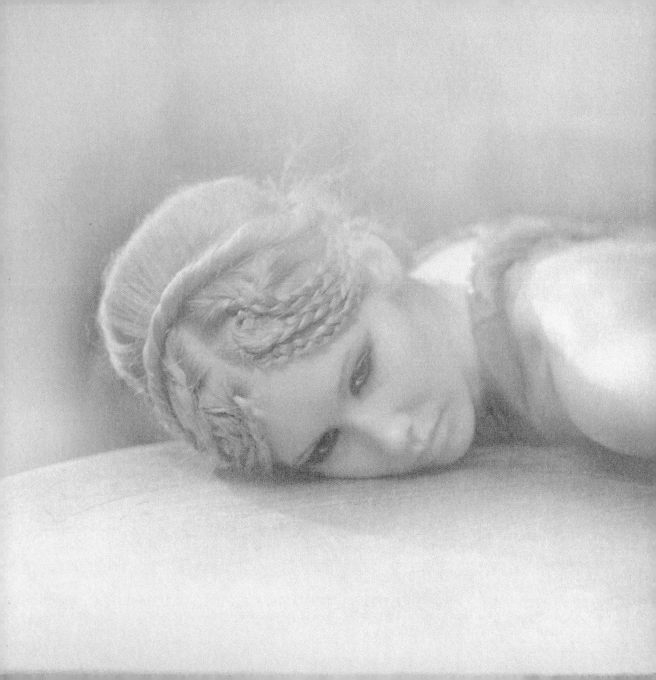

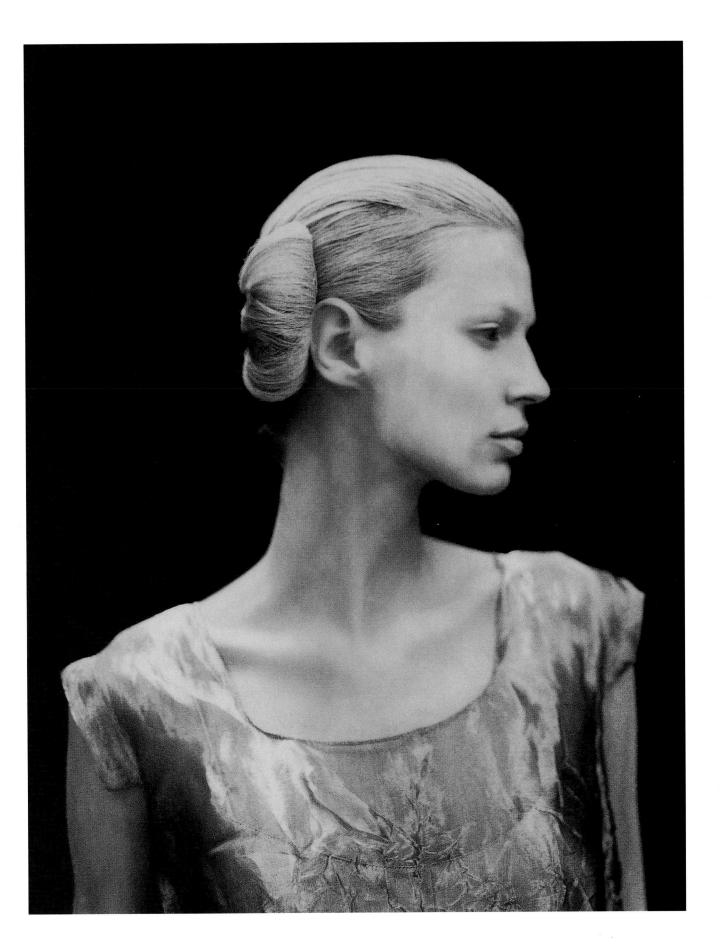

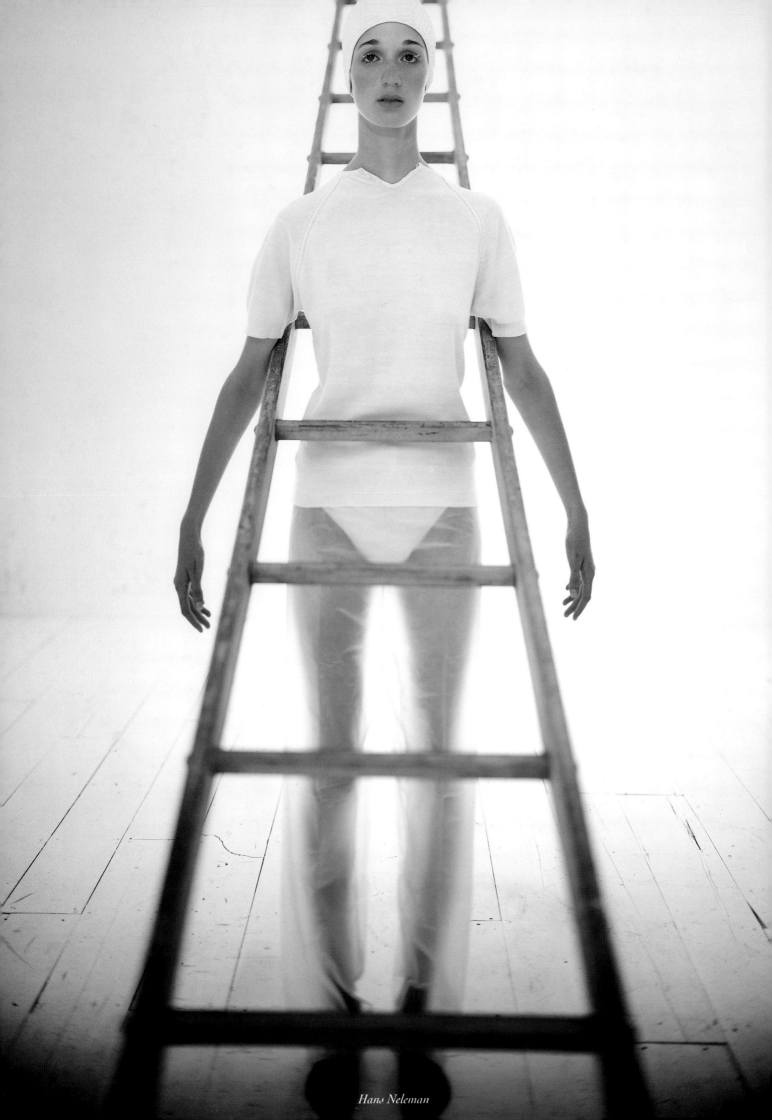

Hans Neleman

Laetitia Negre

Hans Neleman

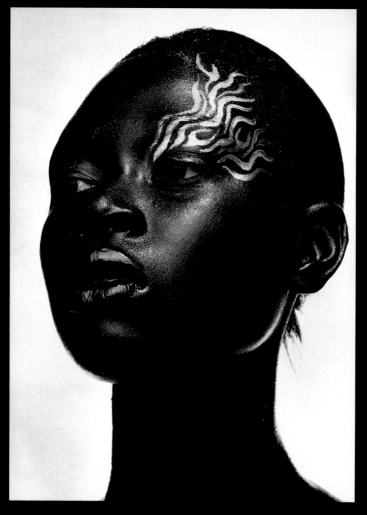

(This spread) Timothy W. Hogan

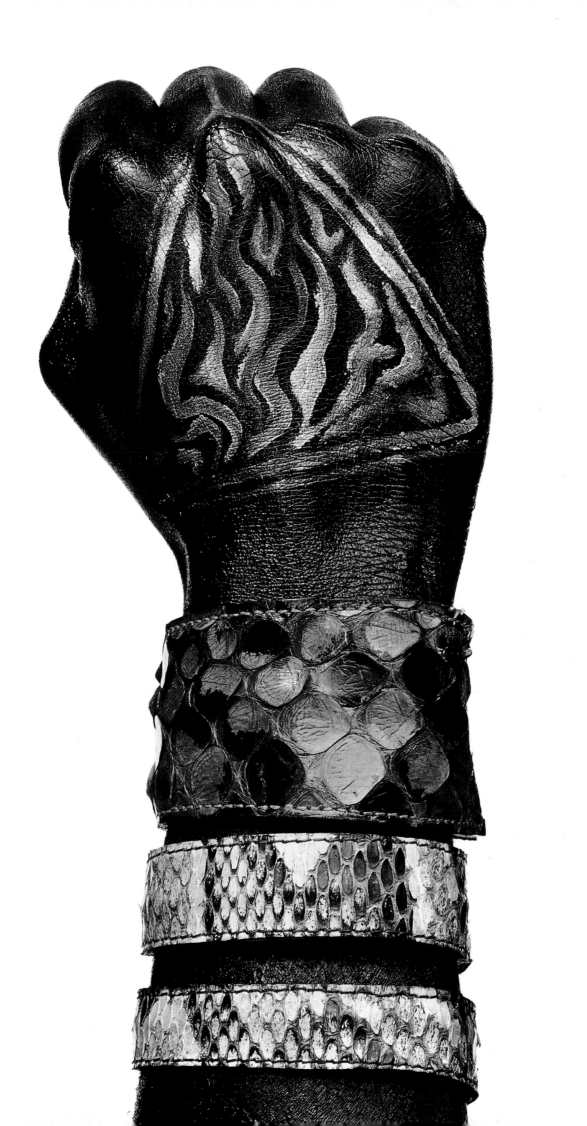

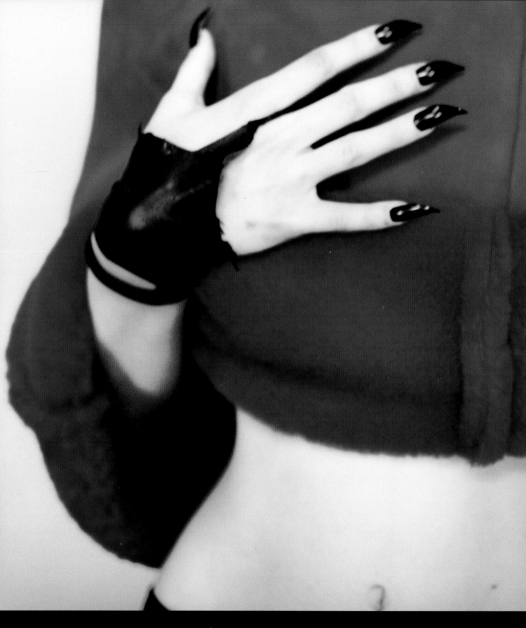

(This spread) Mario De Lopez

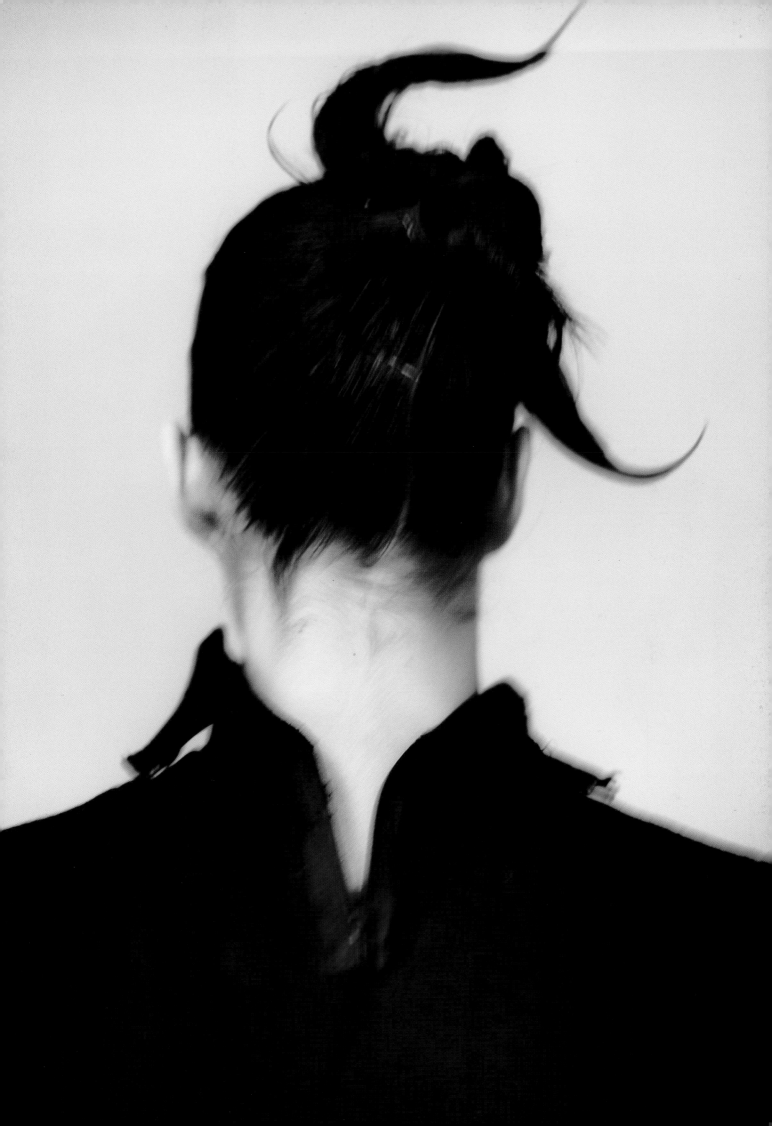

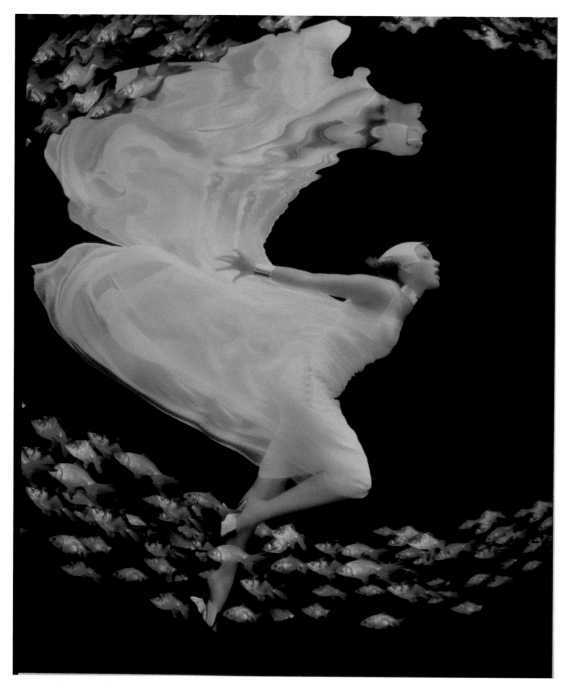

(This spread) Howard Schatz

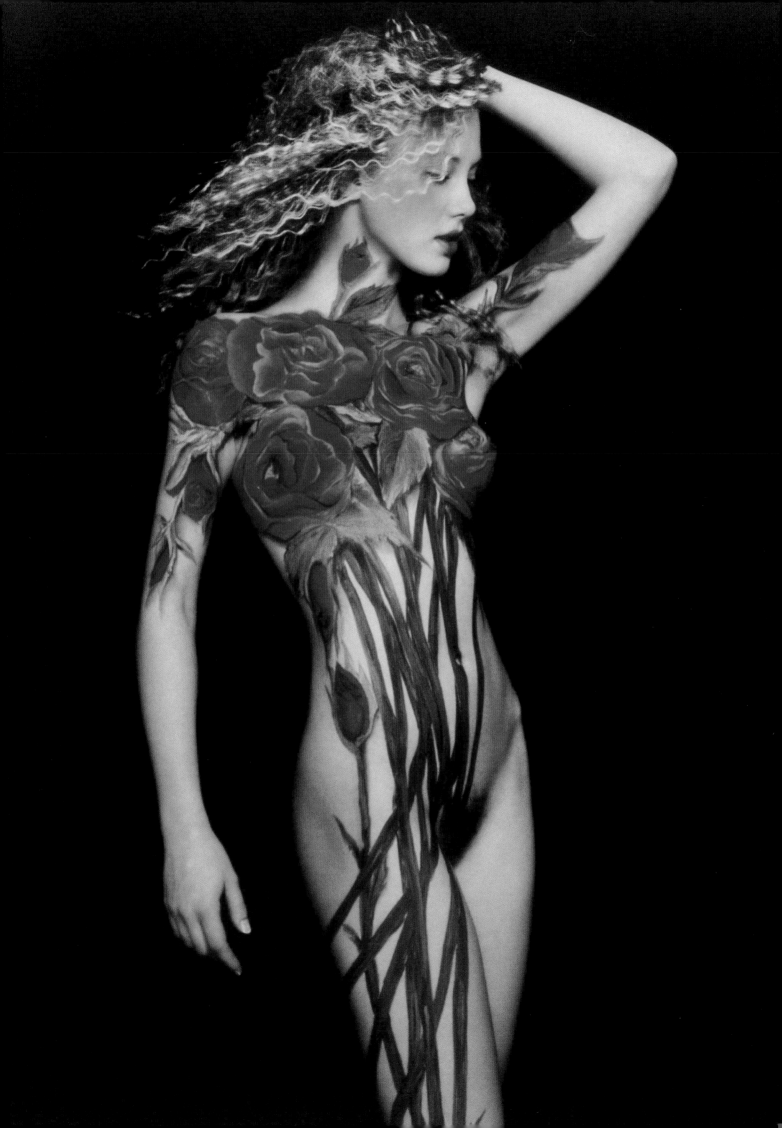

(This spread) Parish Kohanim

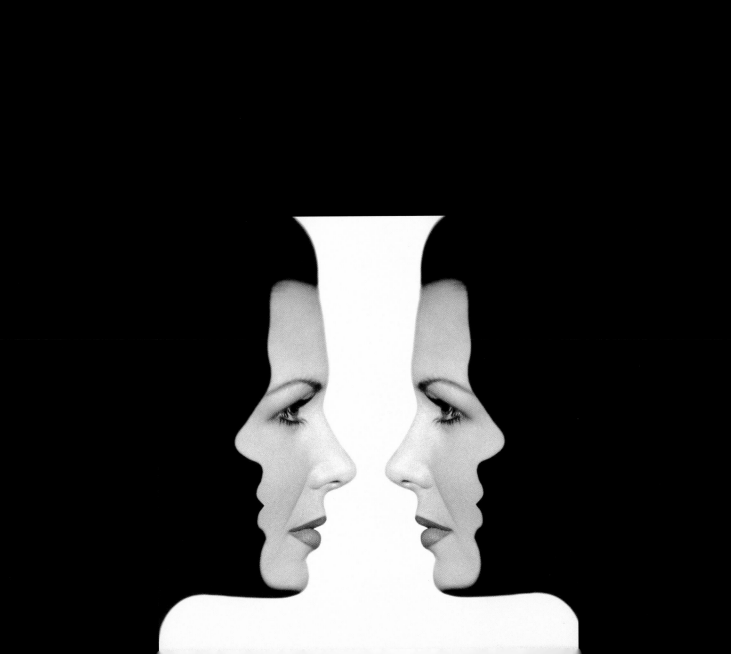

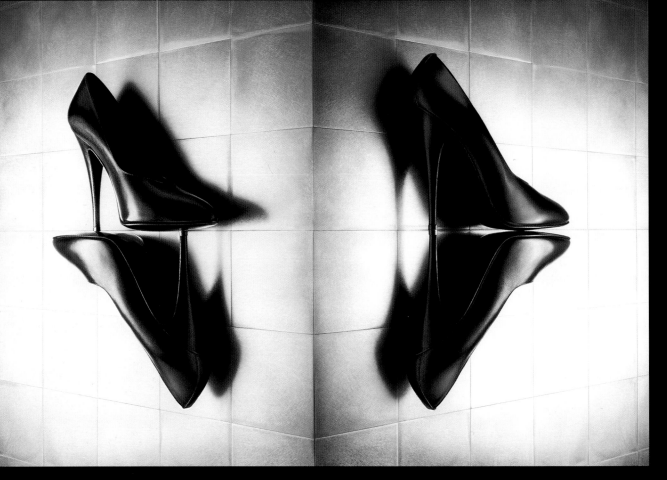

Staudinger Franke

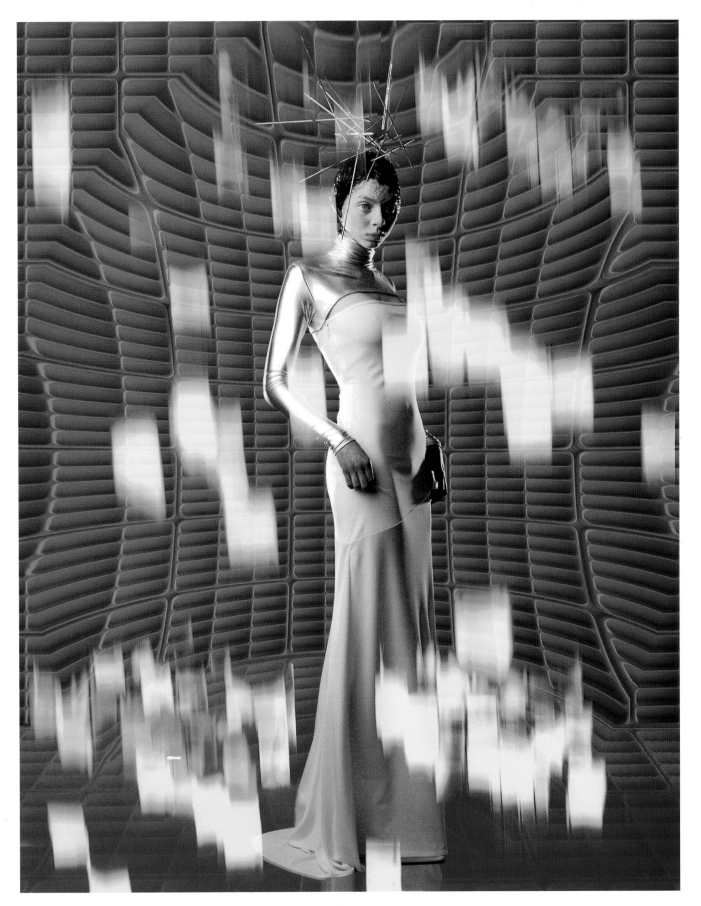

John Eder

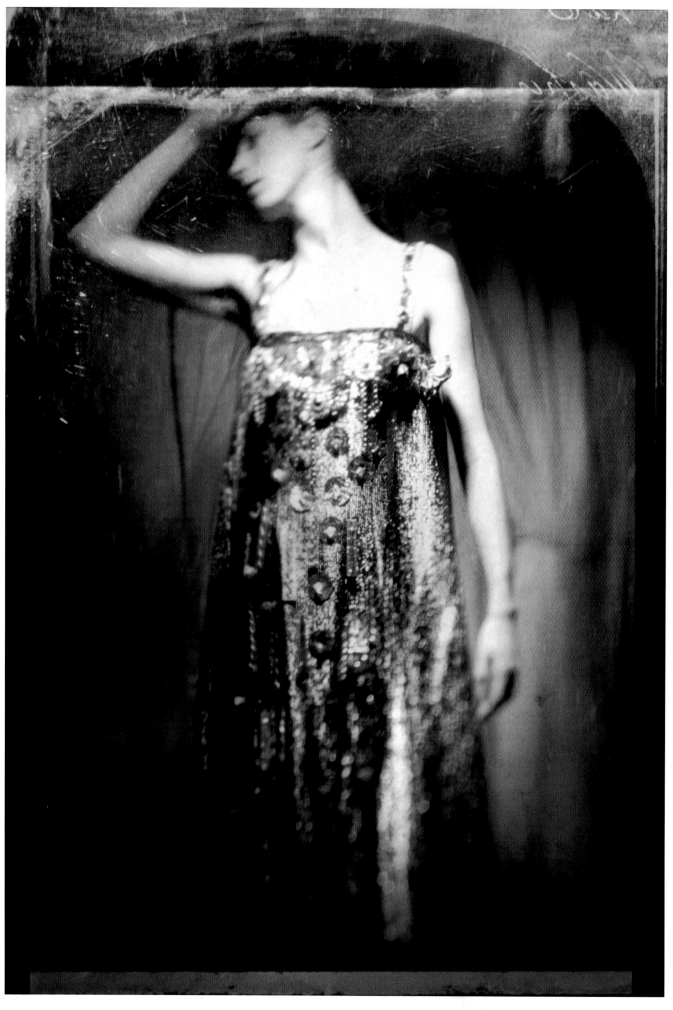

Dominique Thibodeau

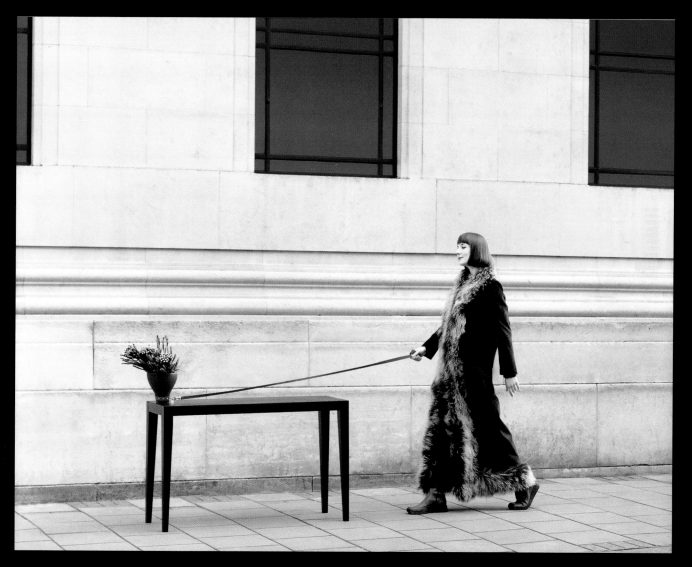

David Stewart

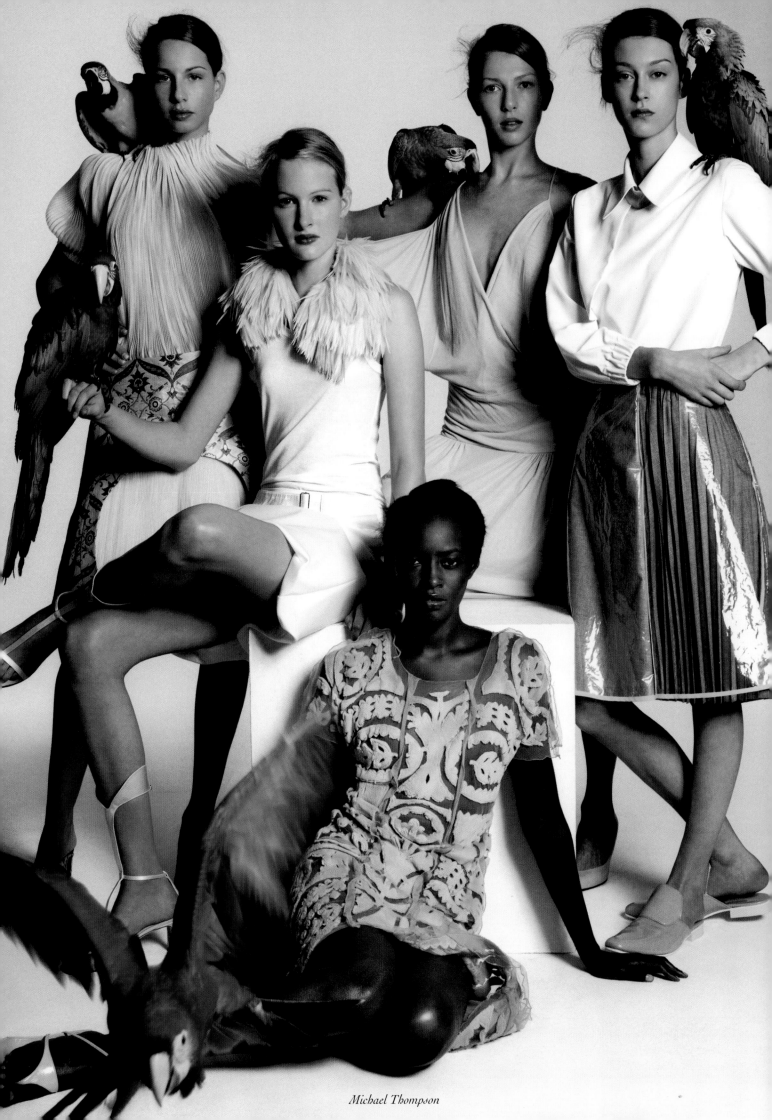

Michael Thompson

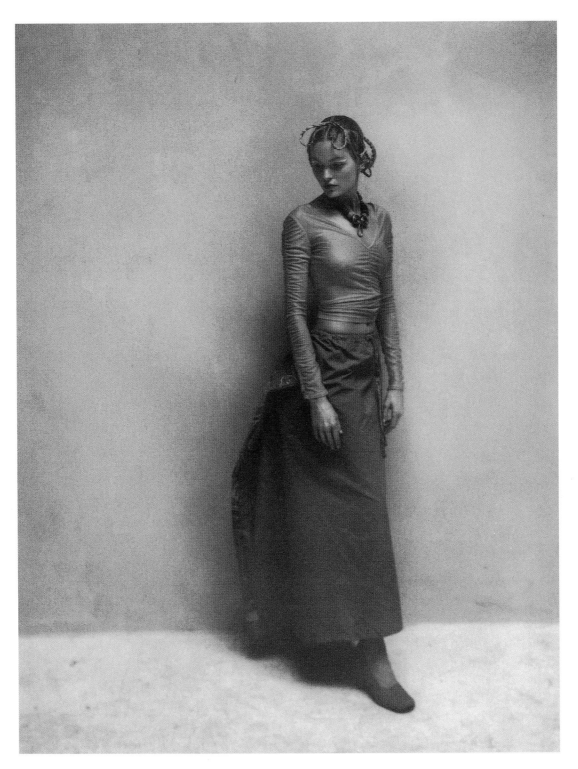

Sanjay Kothari

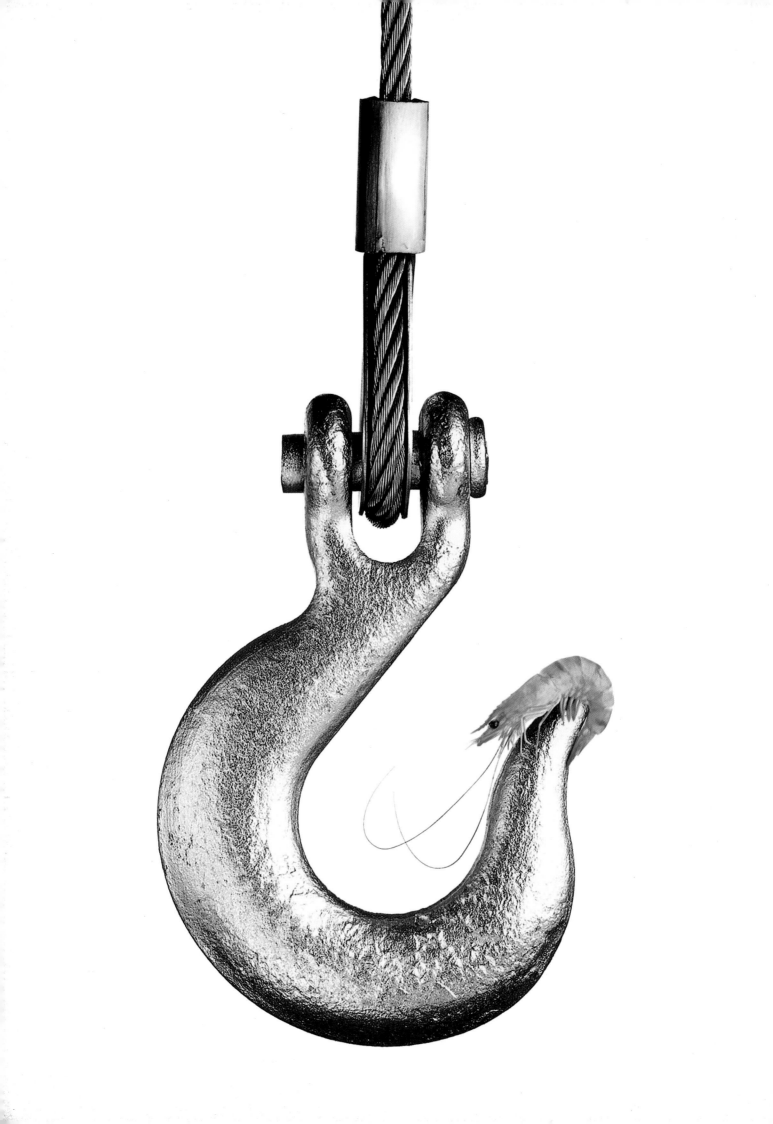

Food

Leon Steele

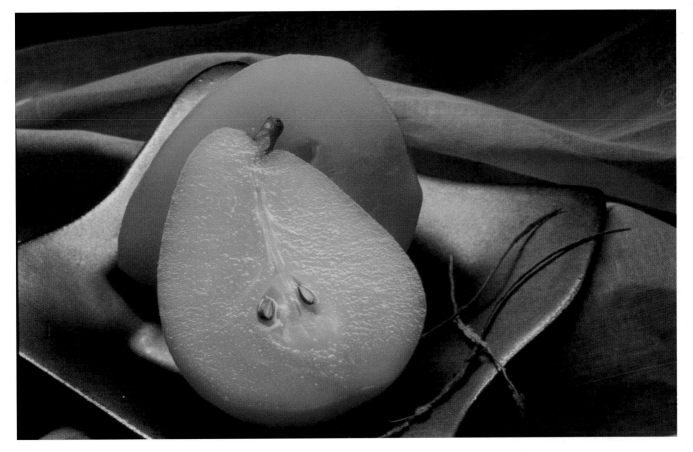

Lisa DeCesare

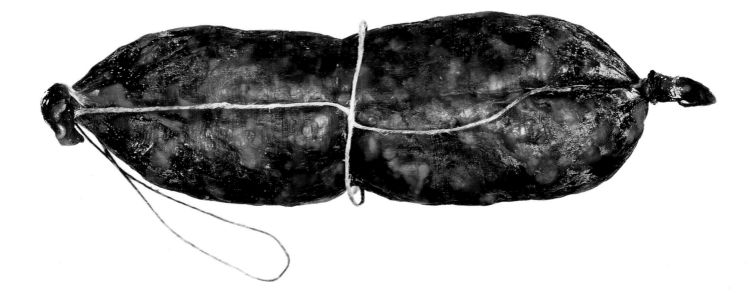

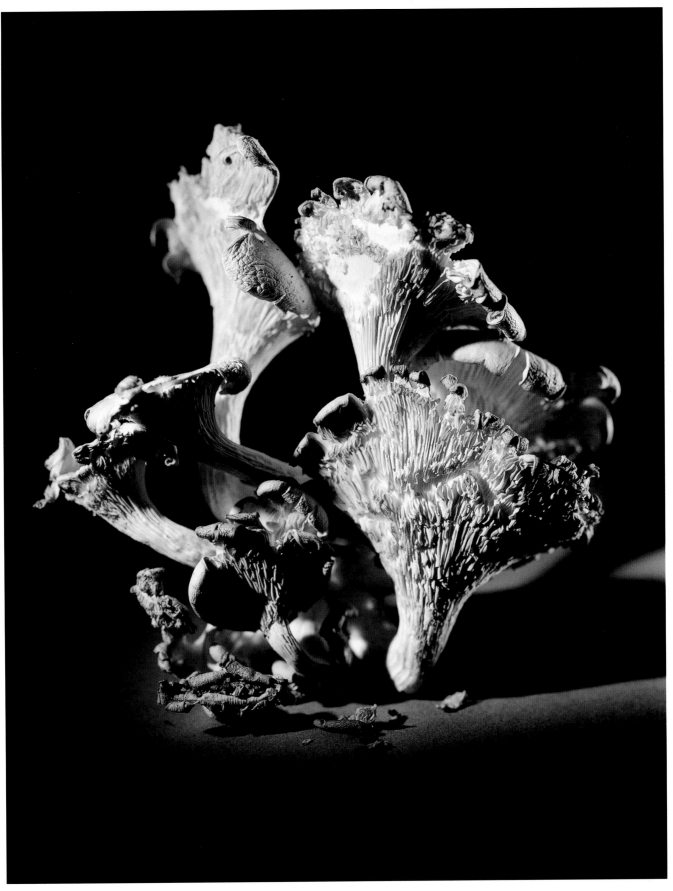

(This spread) Craig Cutler

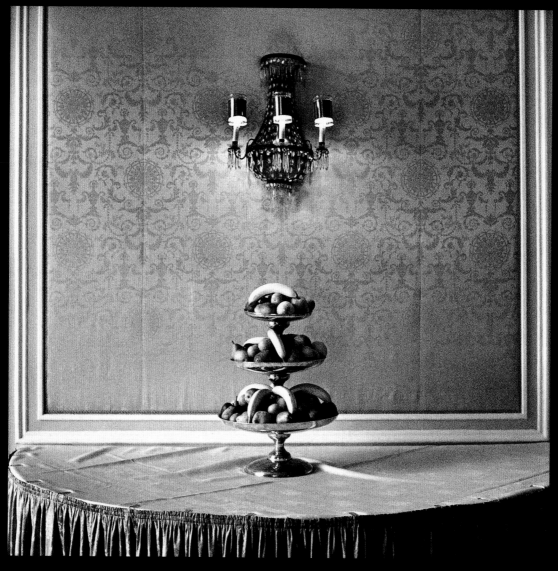

Craig Cutler

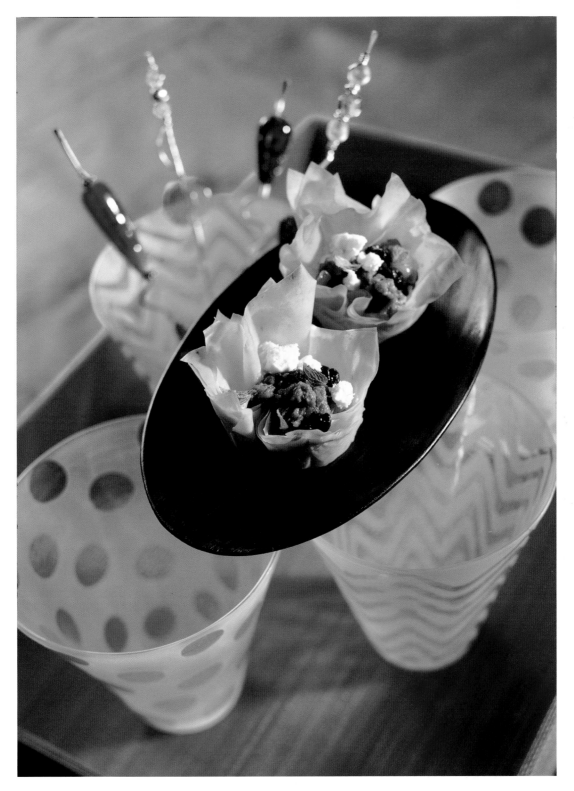

Carin Krasner

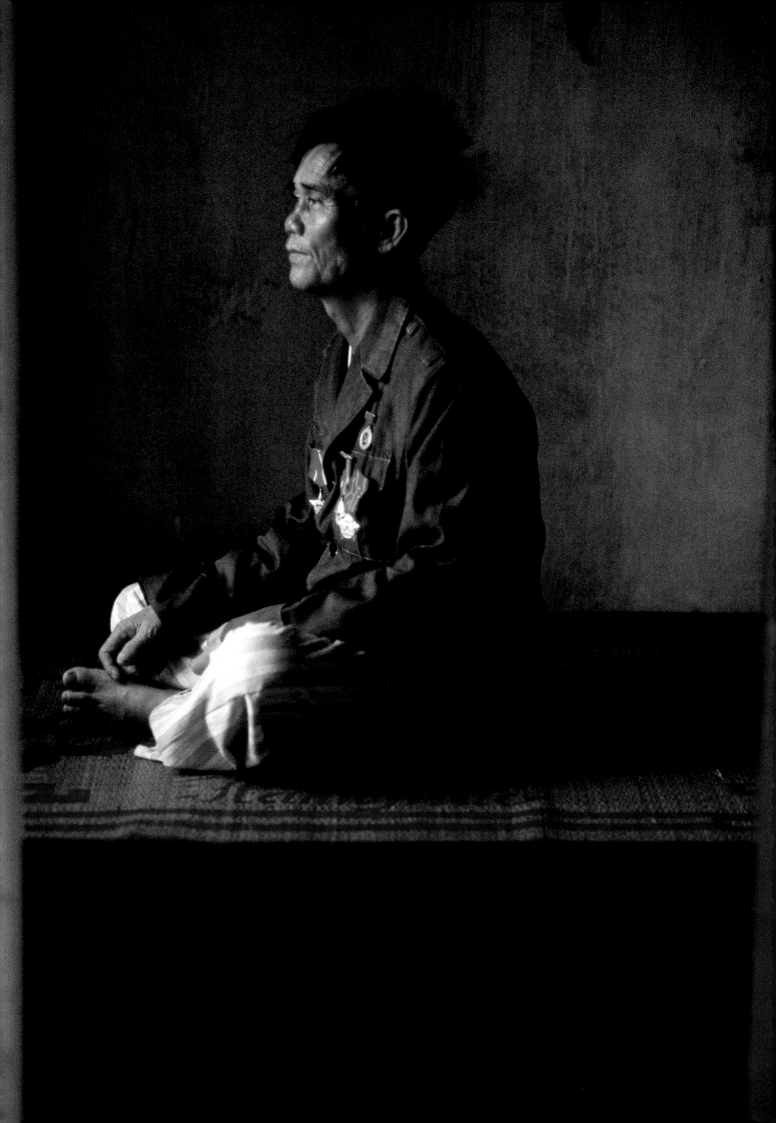

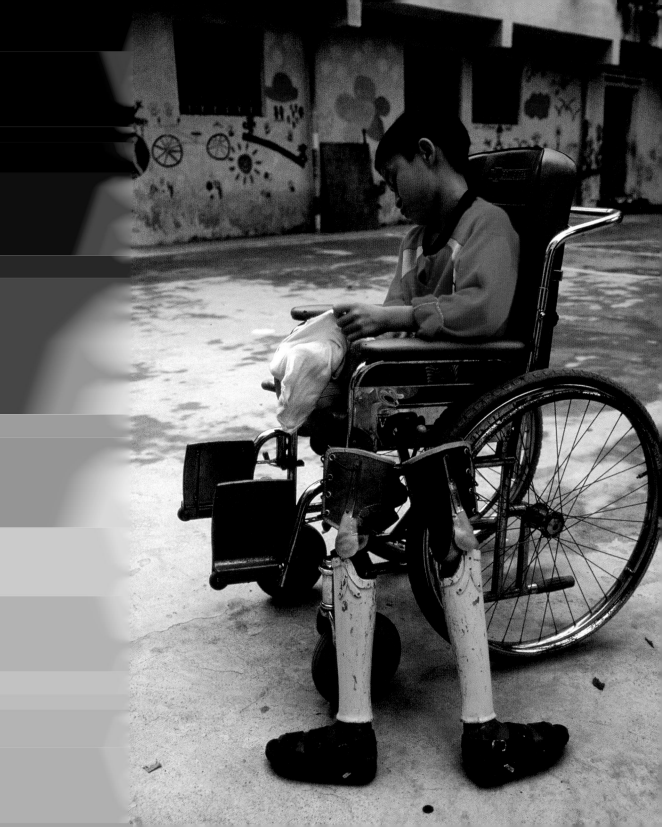

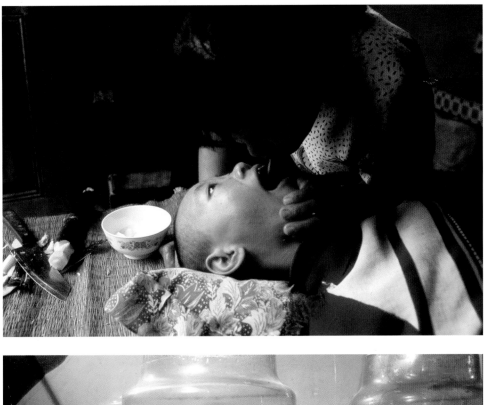

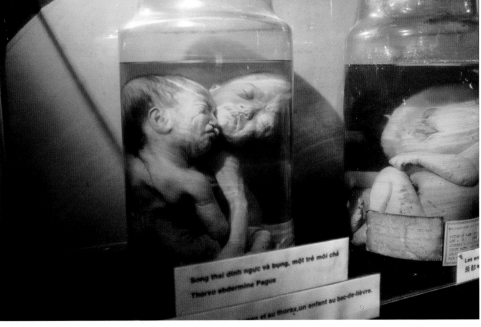

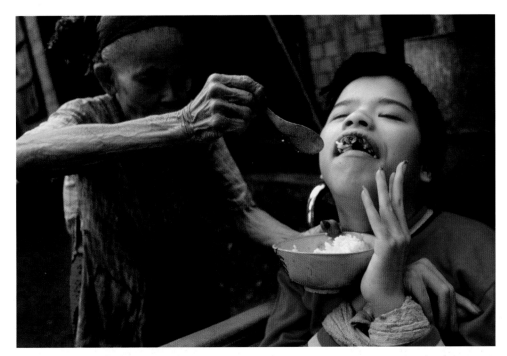

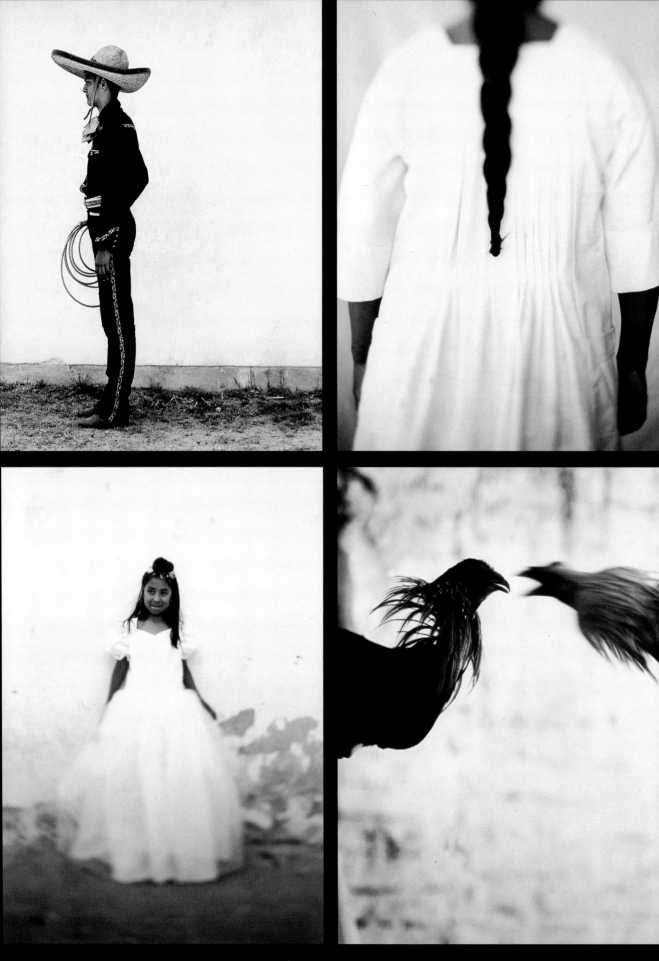

(This spread) Terry Vine

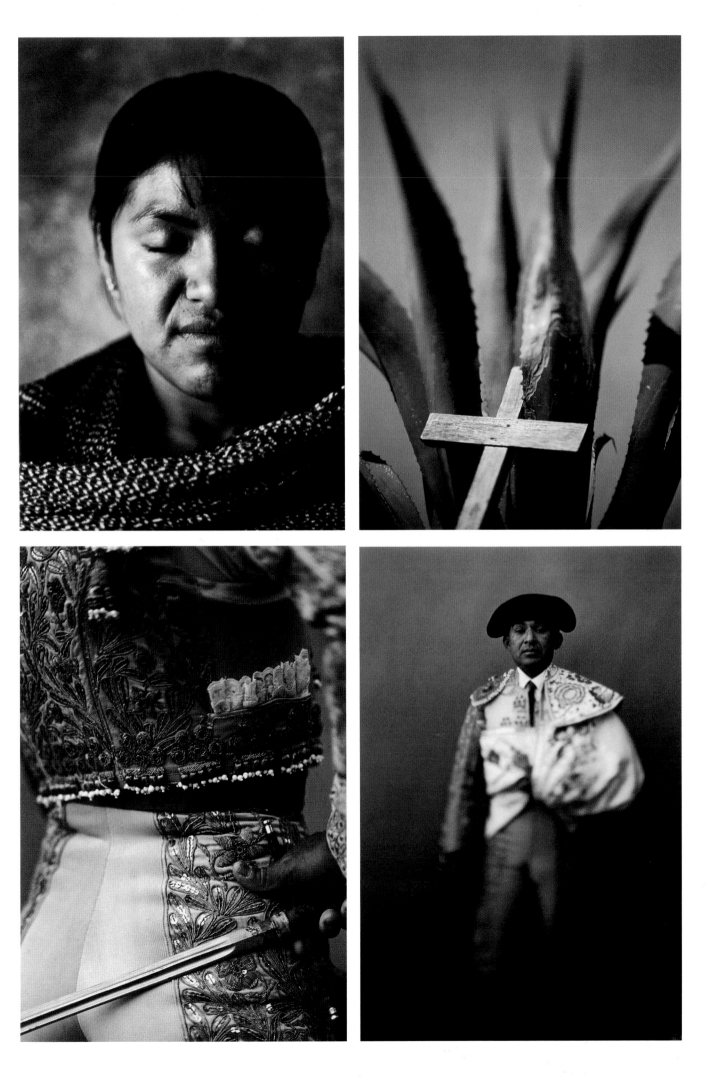

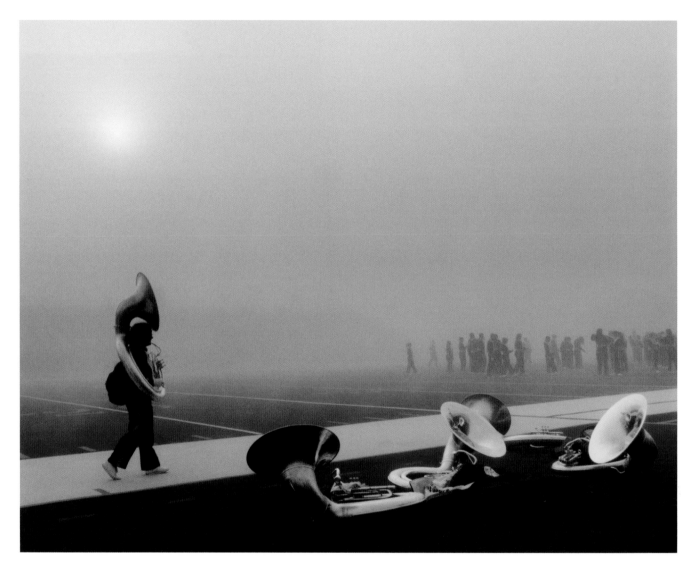

Gary Harwood

Randy Wells

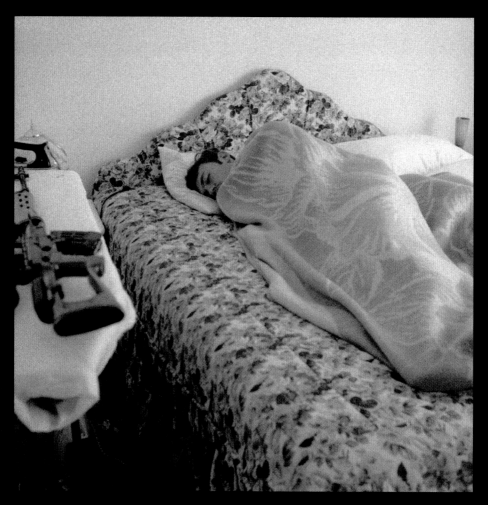

Rachel Cobb

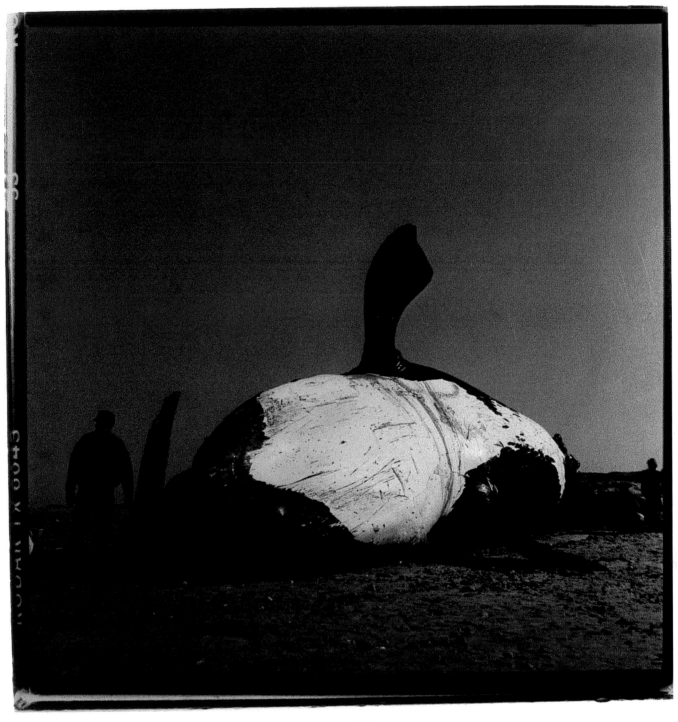

Victor C. Salvo

Landscape

Ludovic Moulin

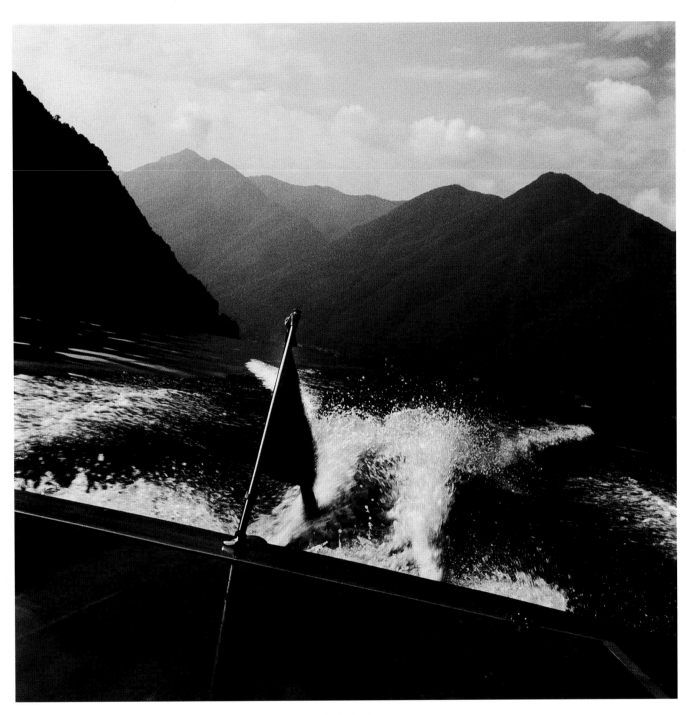

Craig Cutler

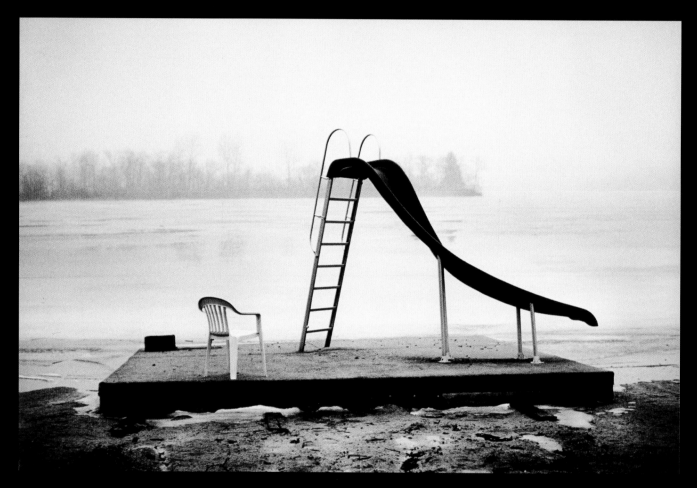

(This spread) Craig Cutler

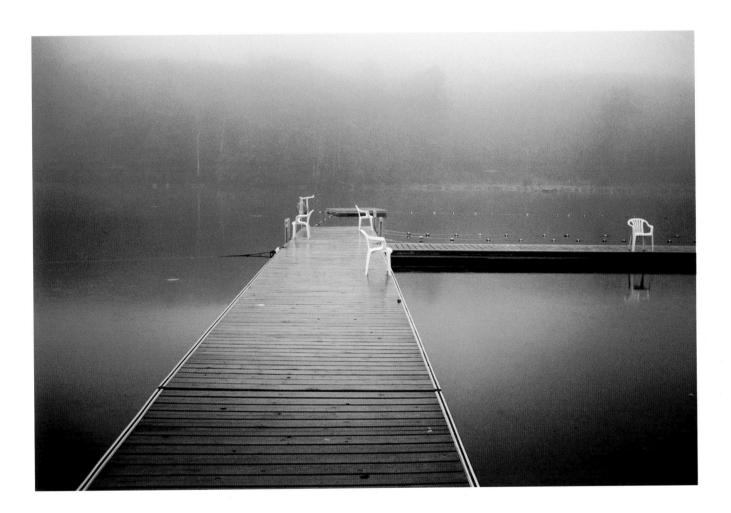

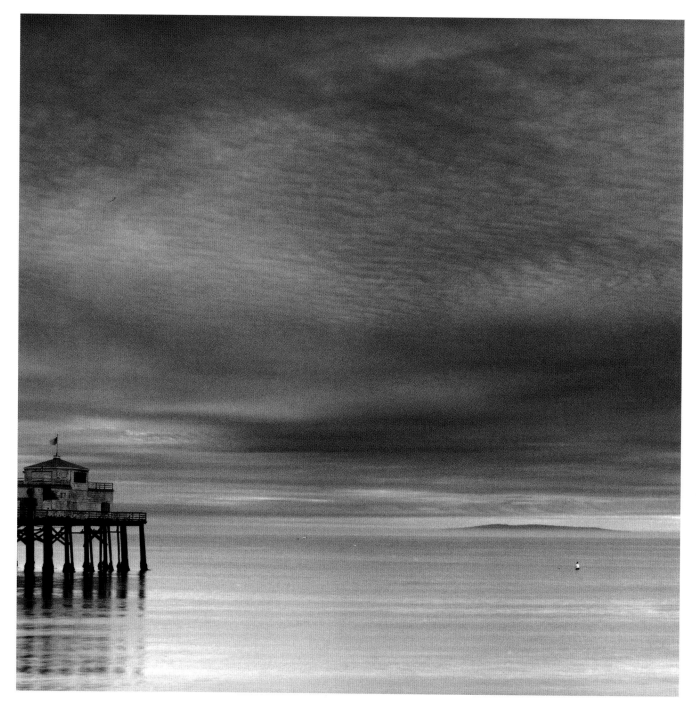

J. Styranka

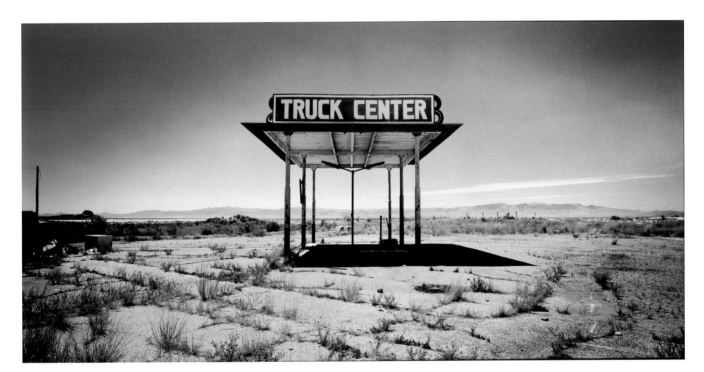

Craig Cutler

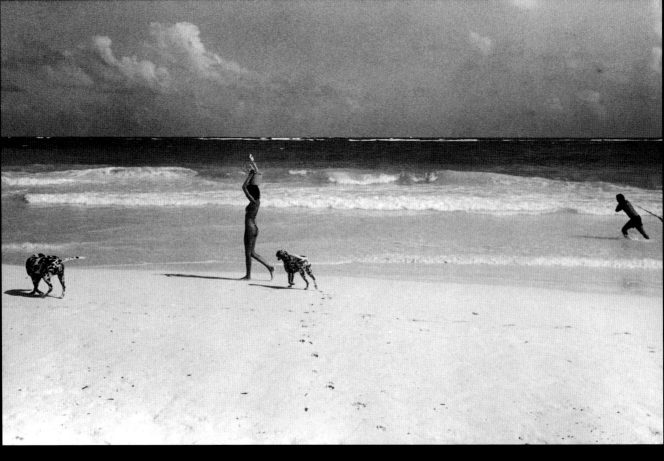

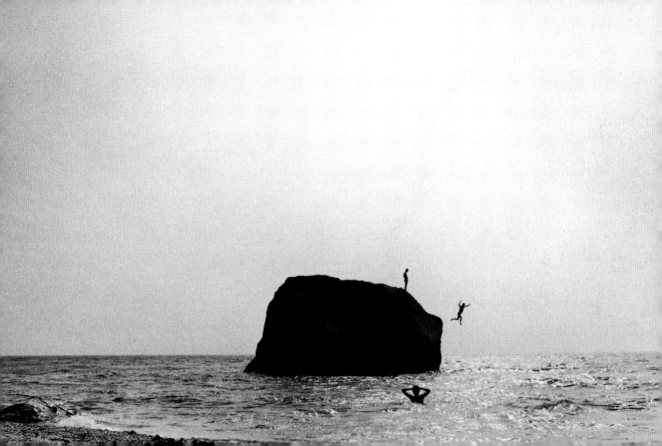

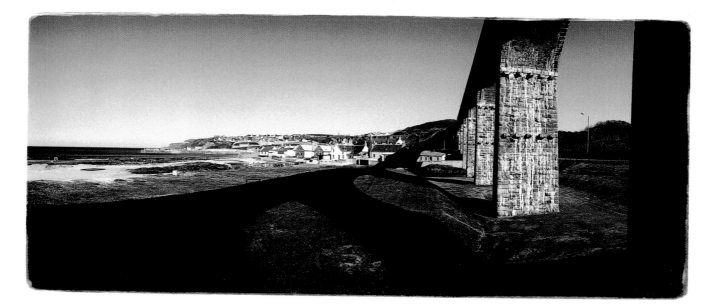

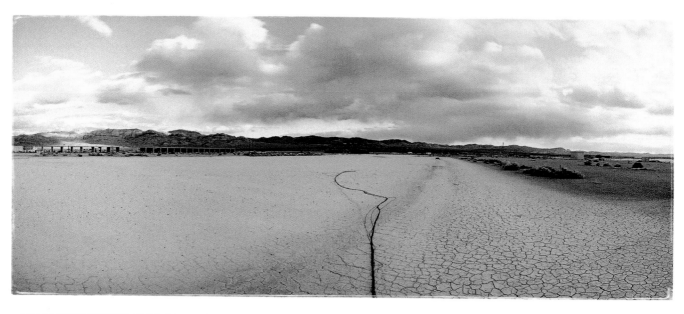

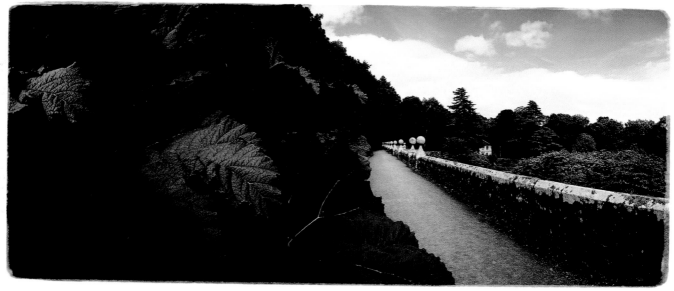

Jan W. Faul

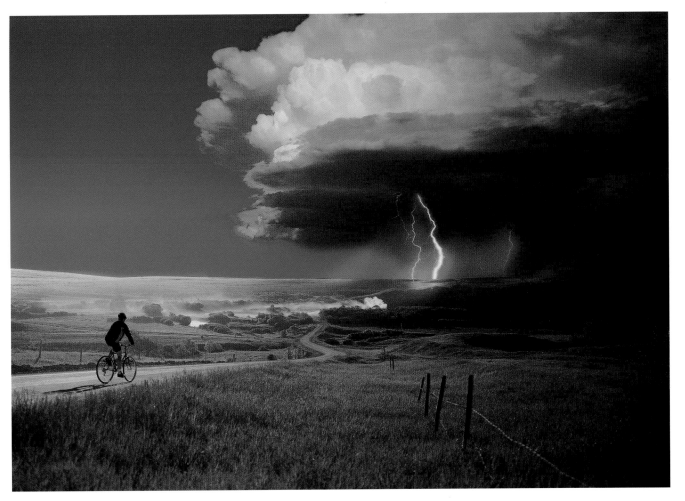

Douglas Walker

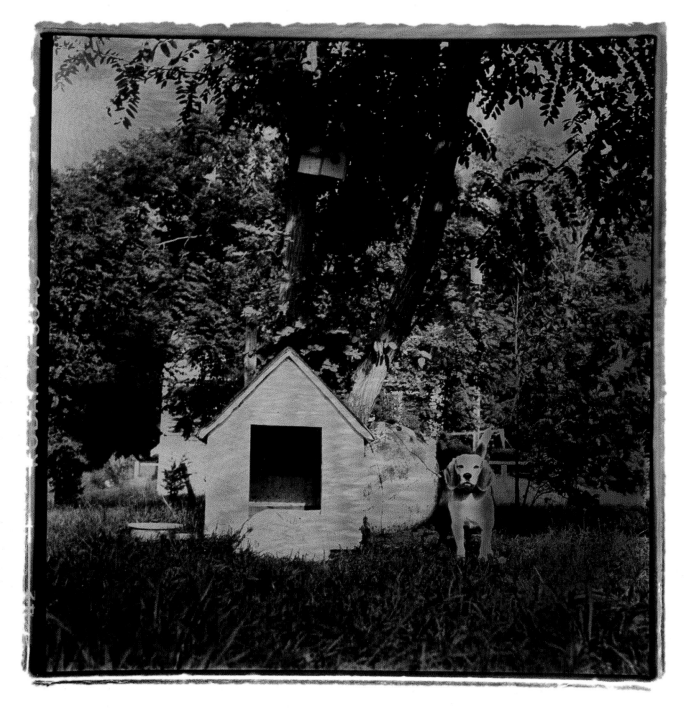

Victor C. Salvo

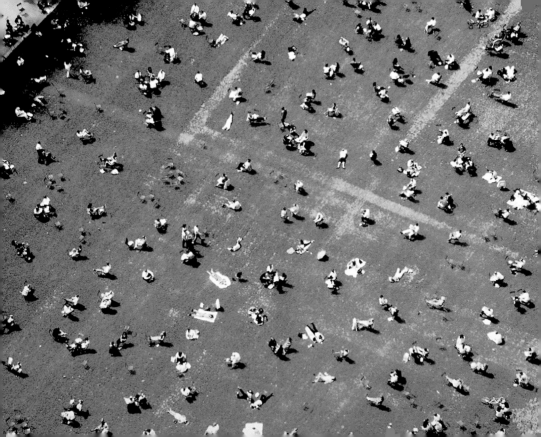

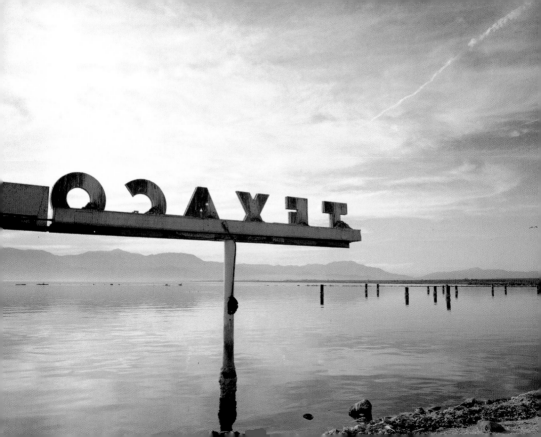

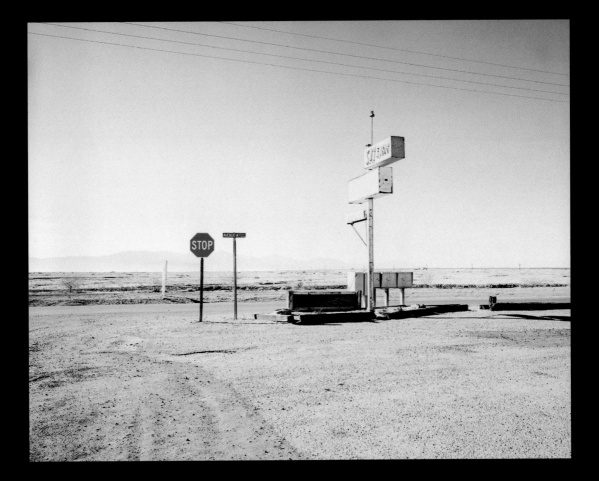

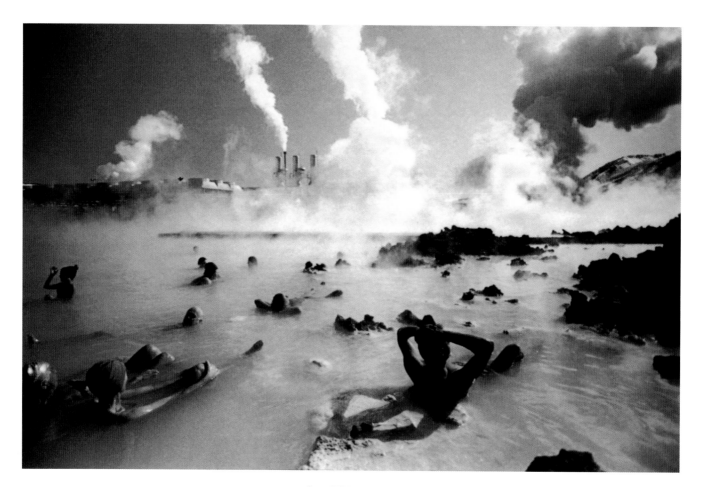

Sean W. Hennessy

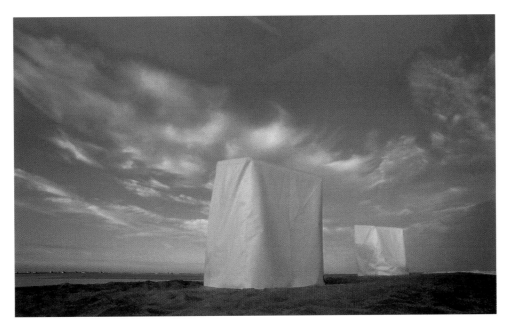

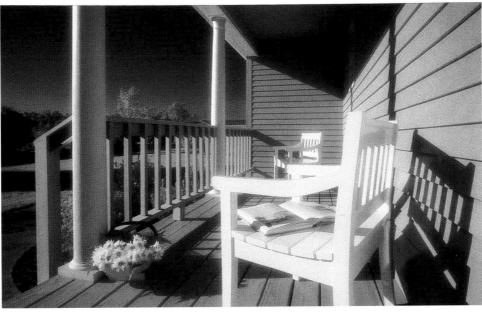

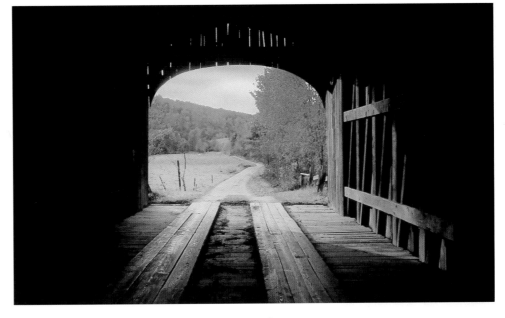

Steven Edson

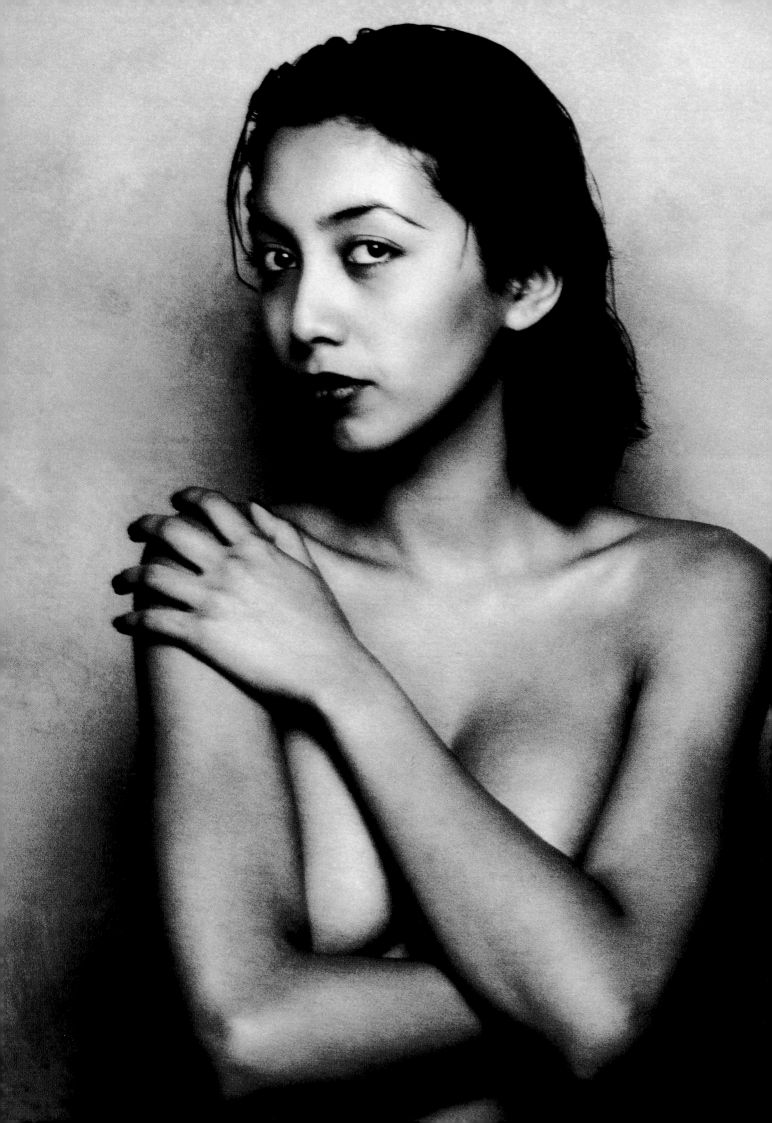

Nudes

Bernhard Quade

Nudes

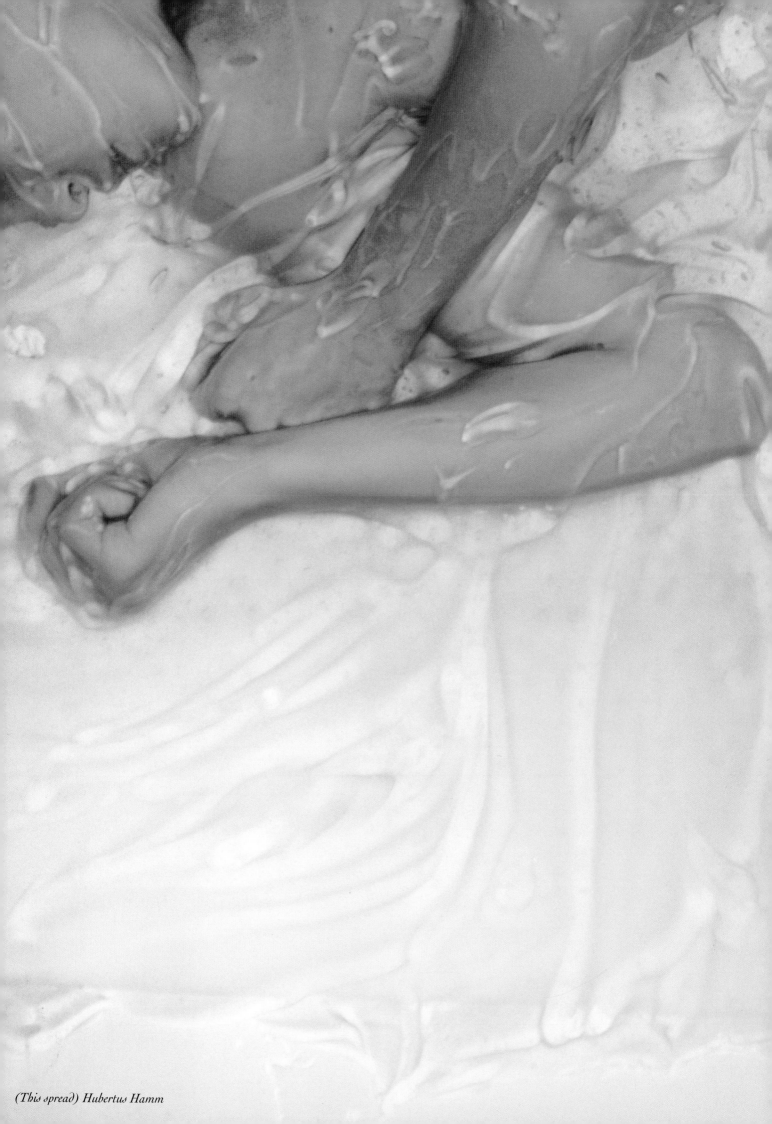

(This spread) Hubertus Hamm

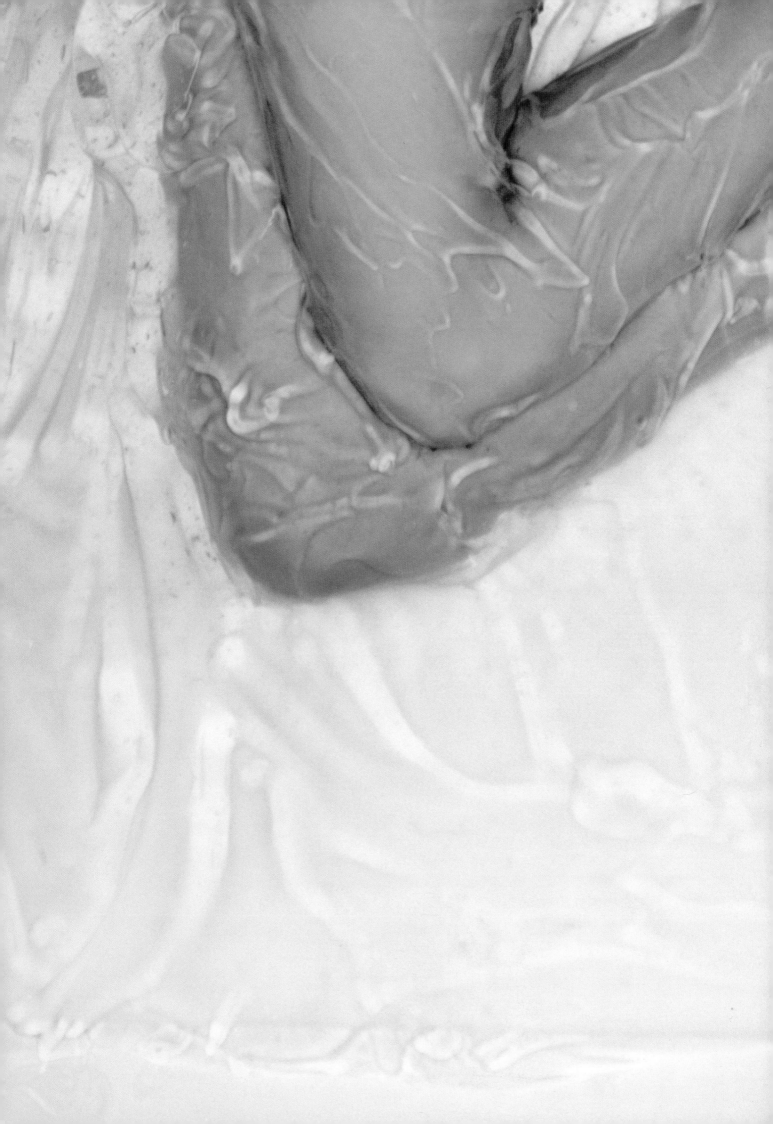

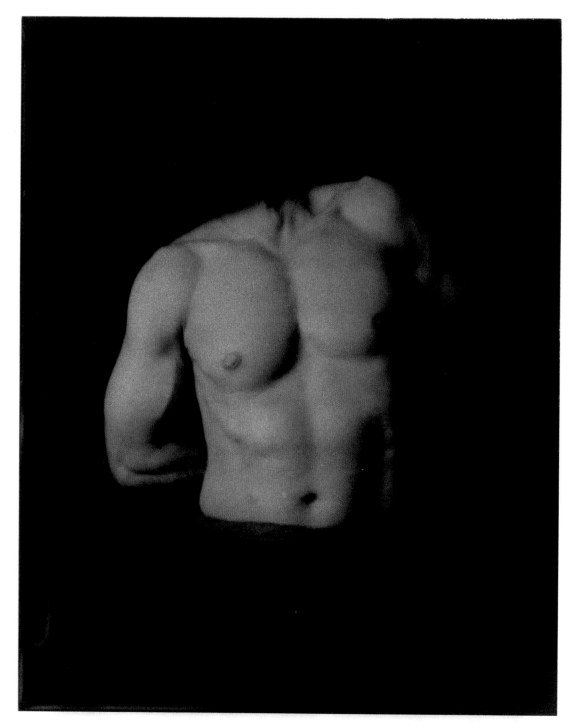

Jayne Hinds Bidaut

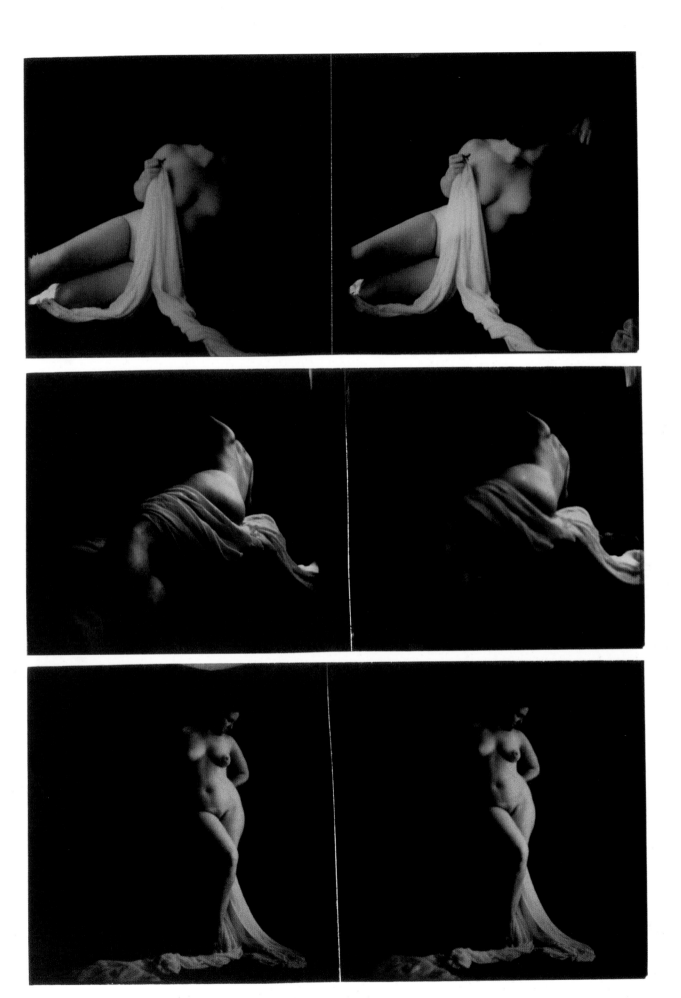

Jayne Hinds Bidaut

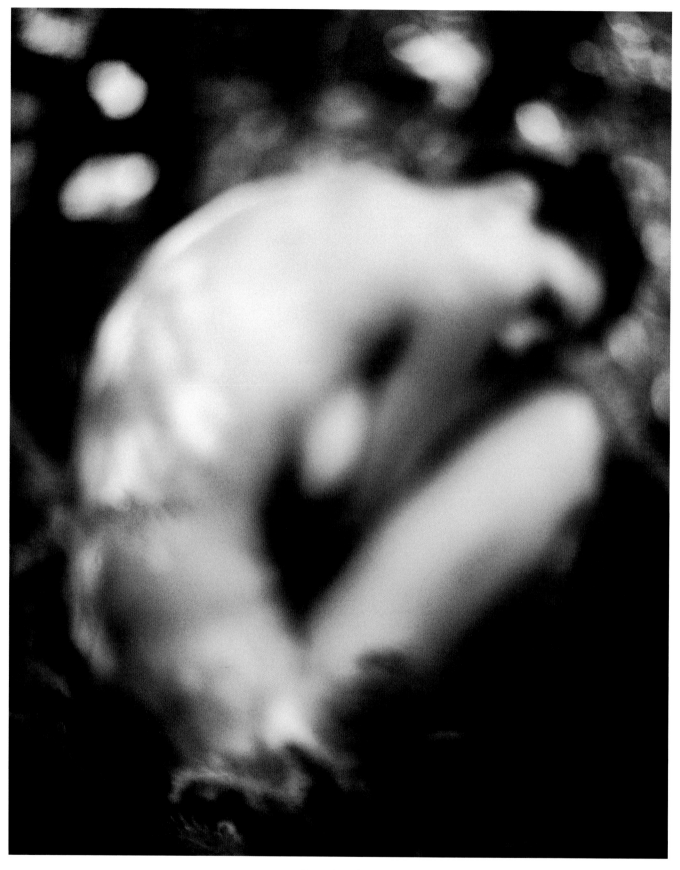

Gonzalo Rufatt

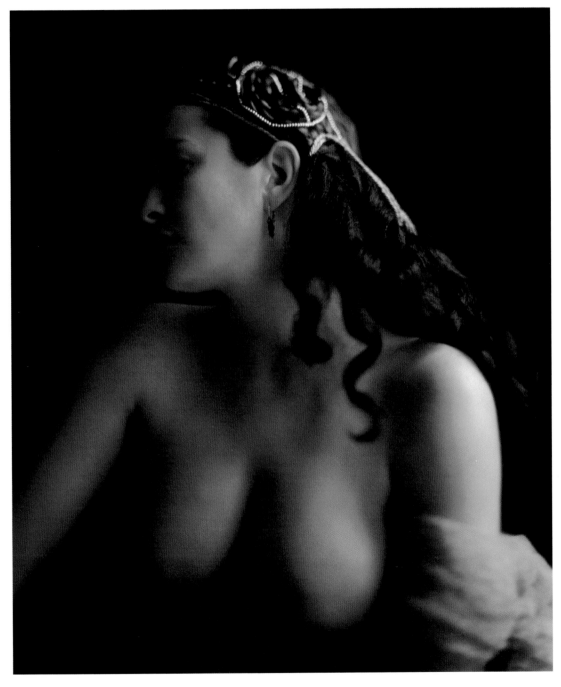

Jim Erickson

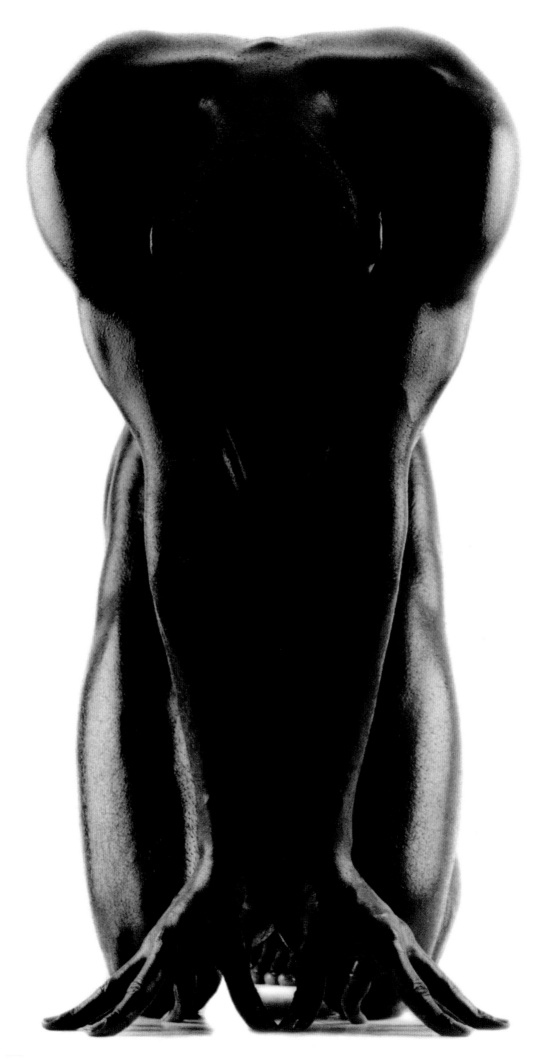

Howard Schatz

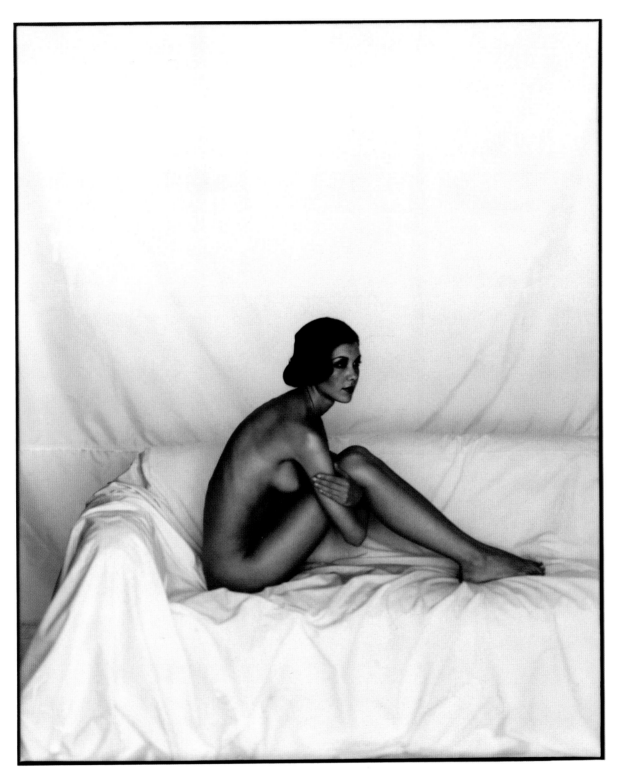

Frank Wartenberg

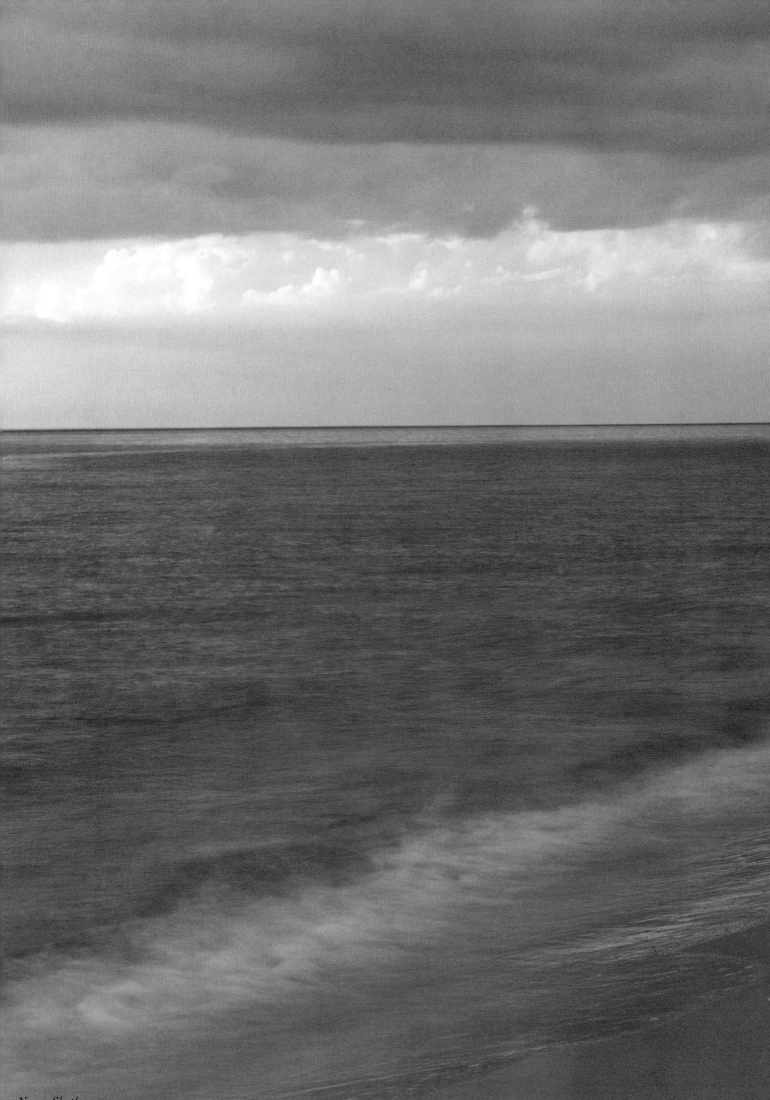

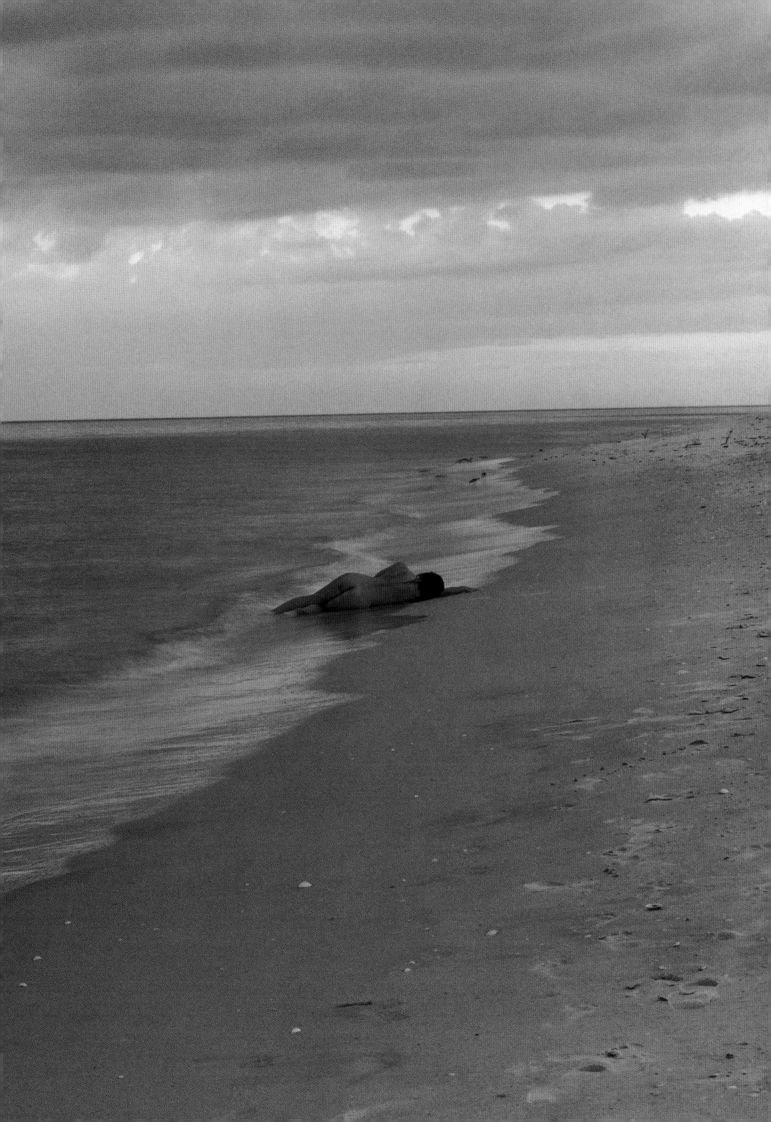

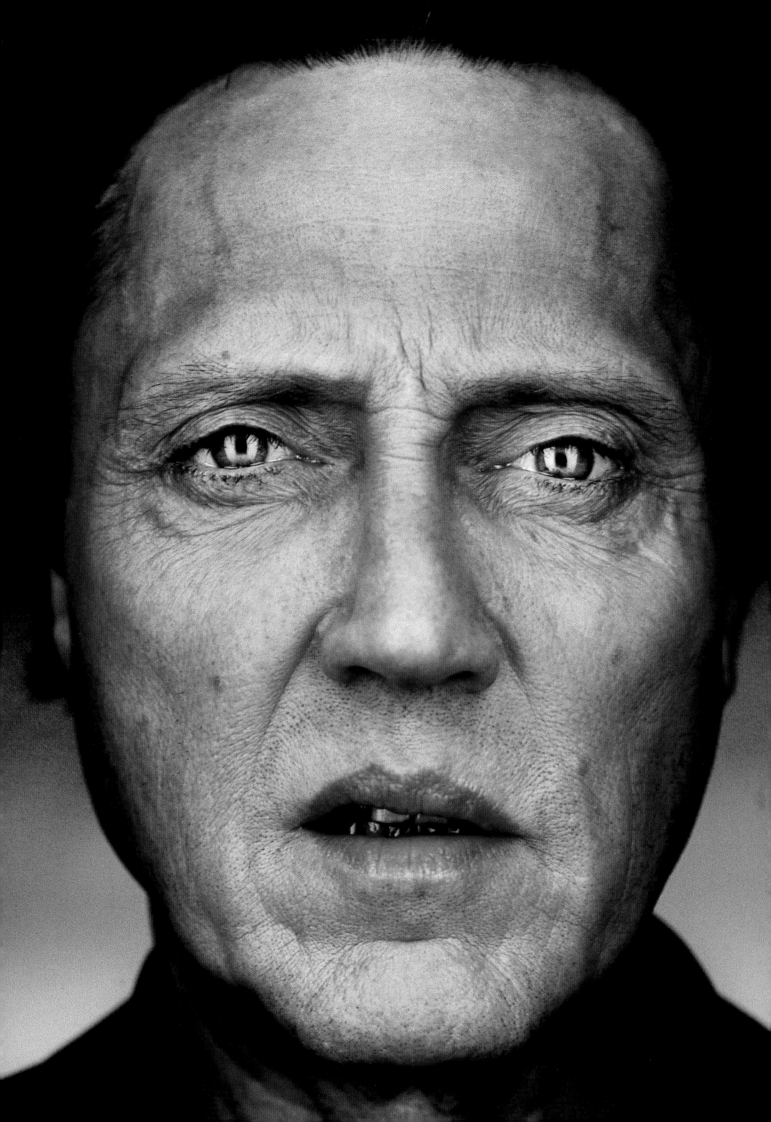

People

Martin Schoeller

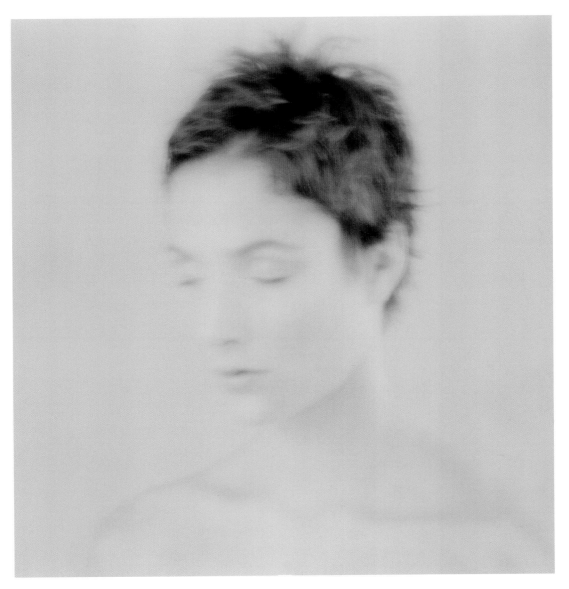

OSE Huit 10 Photography

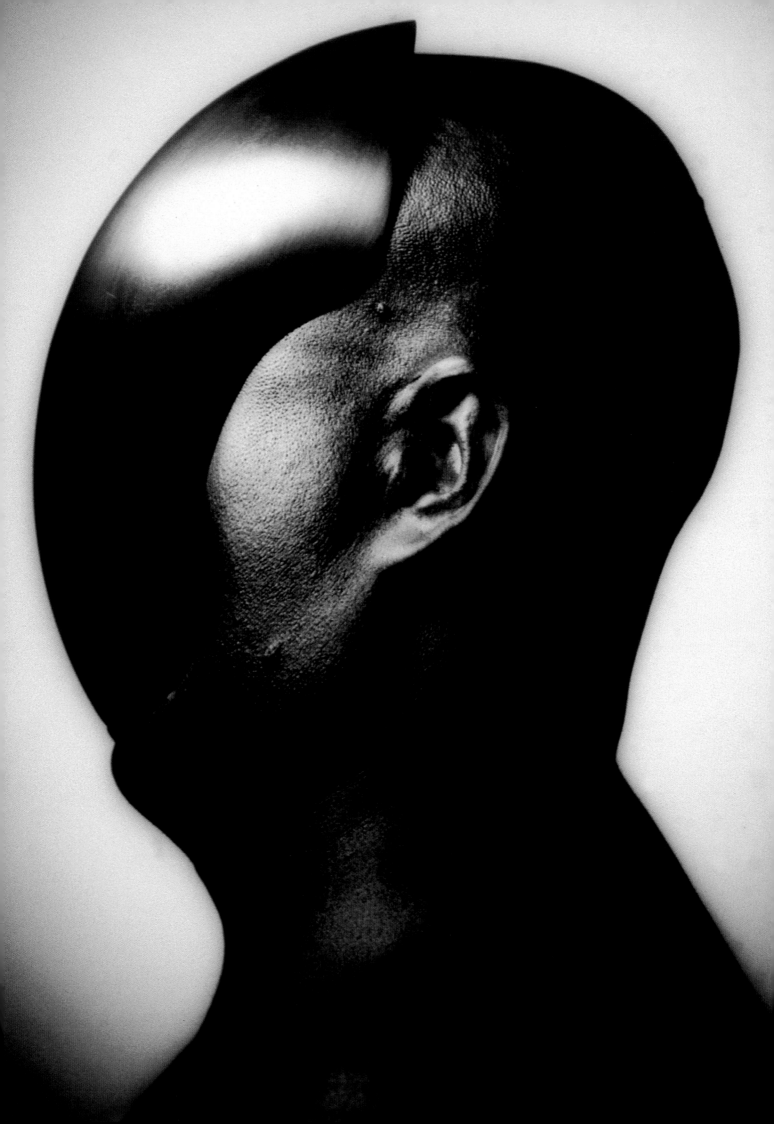

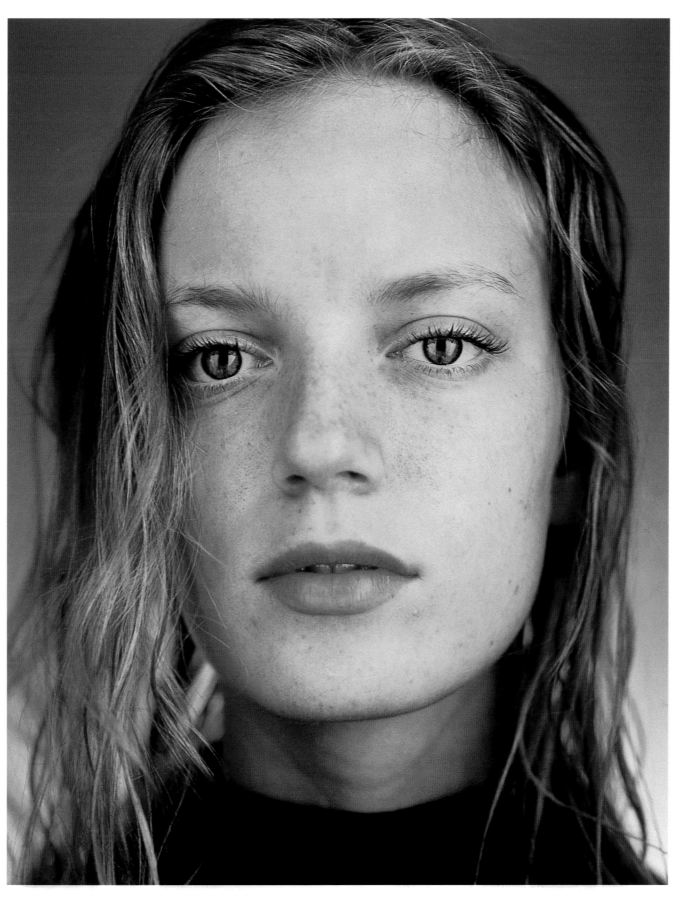

(Opposite page) Bob Carey (This page) Martin Schoeller

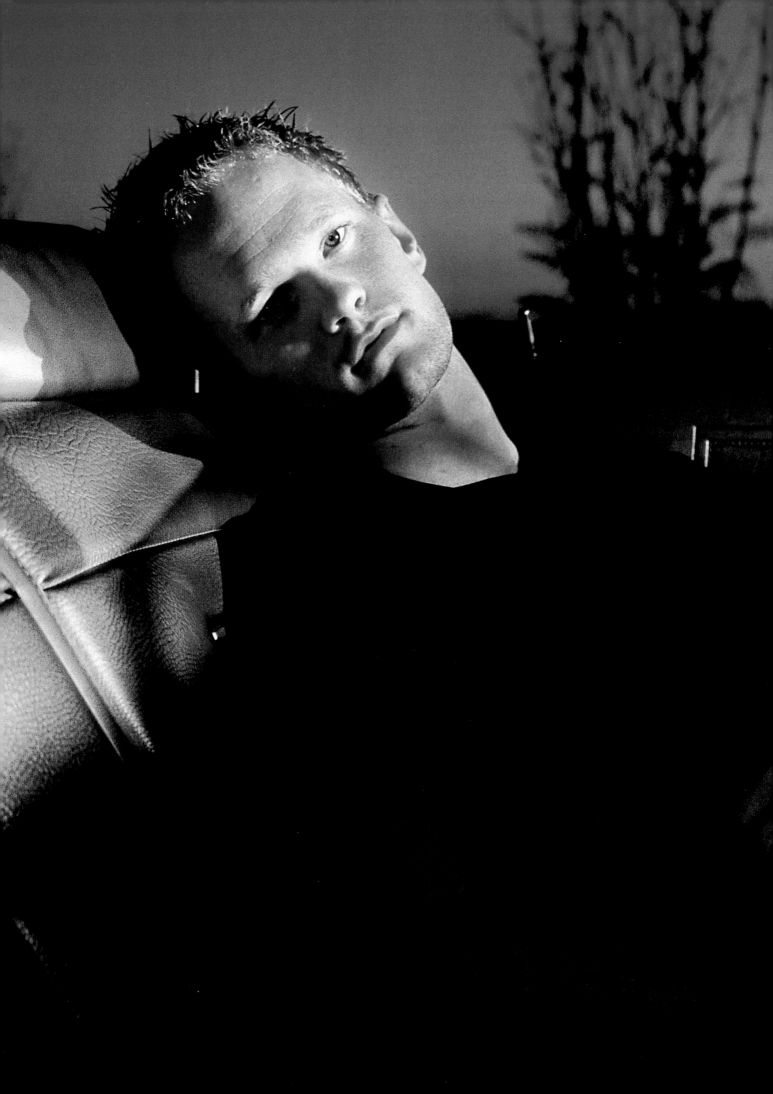

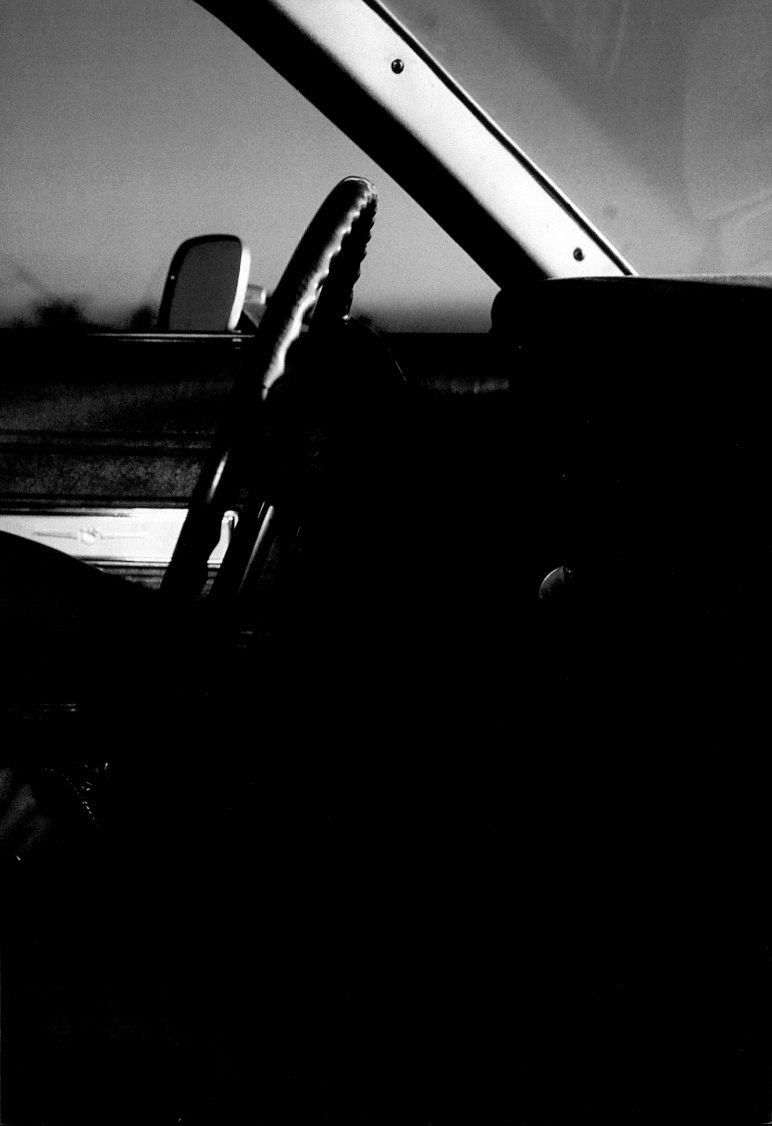

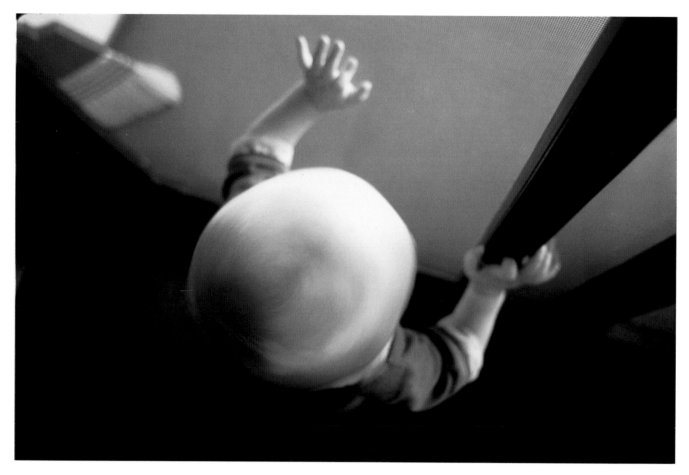

(This spread) Lonnie Duka Photography

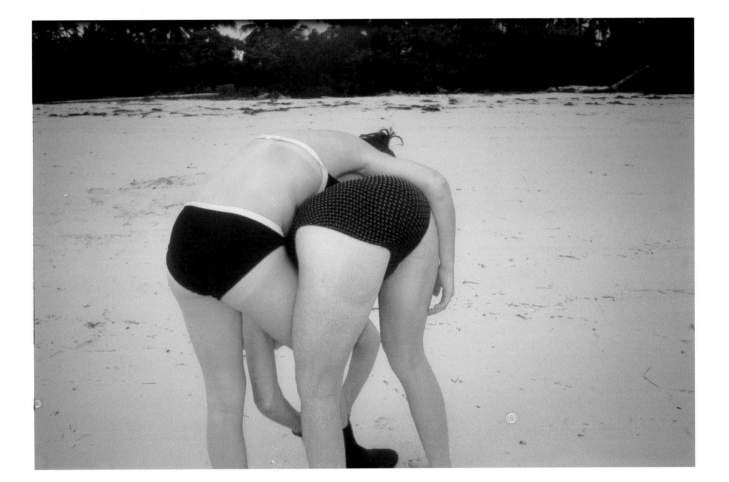

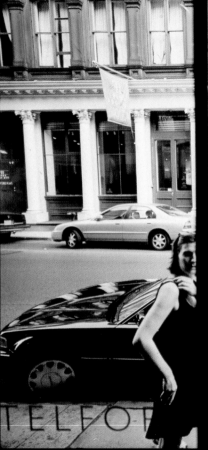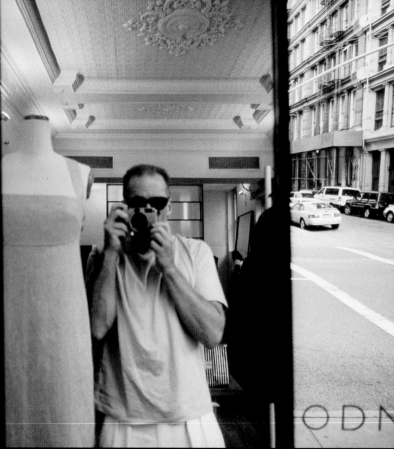

Ludovic Moulin

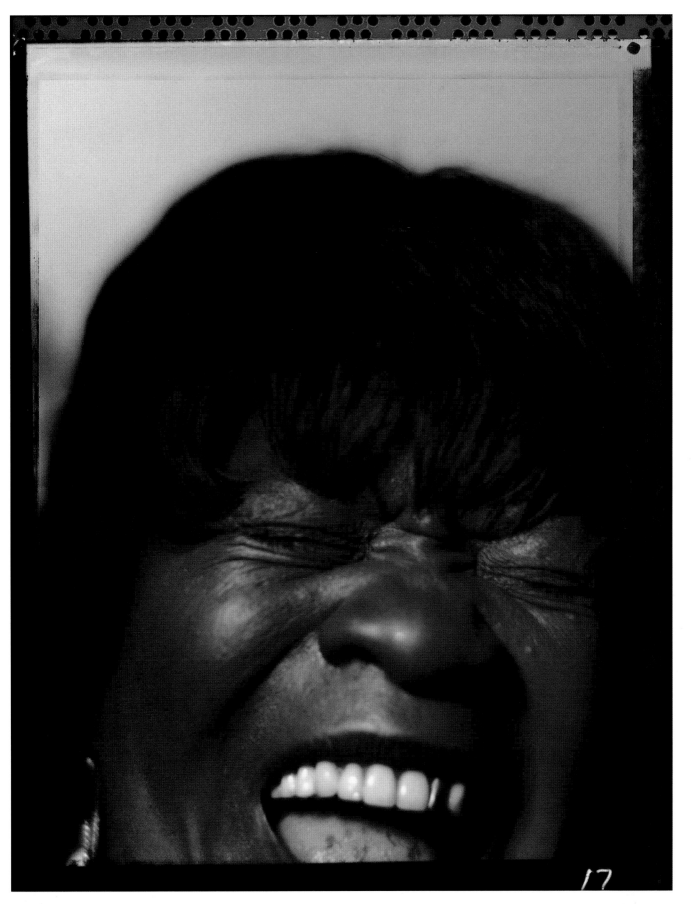

Paul Elledge

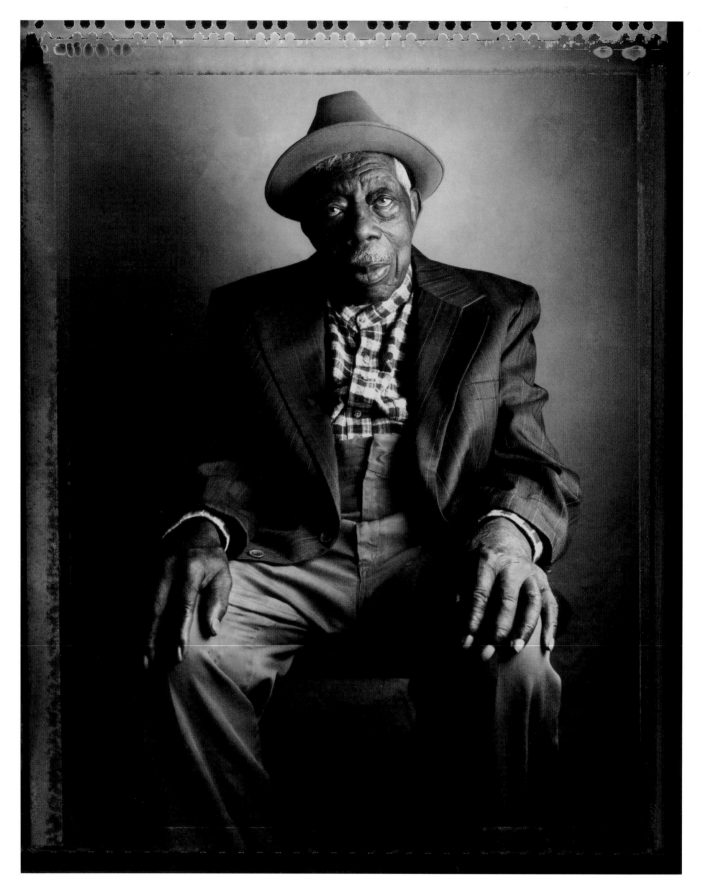

(This spread) Michael O'Brien

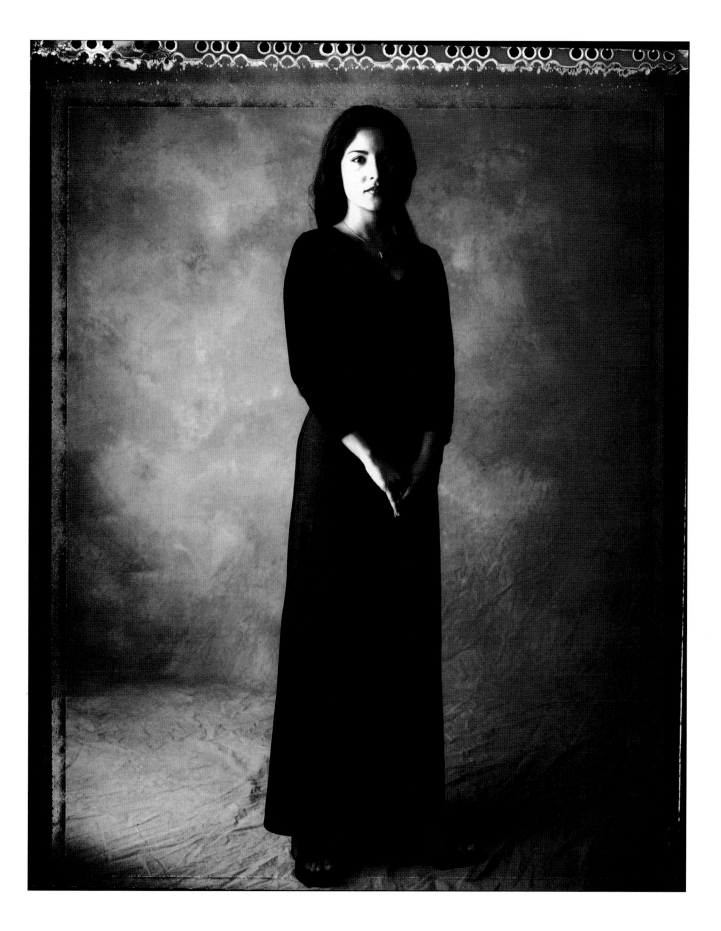

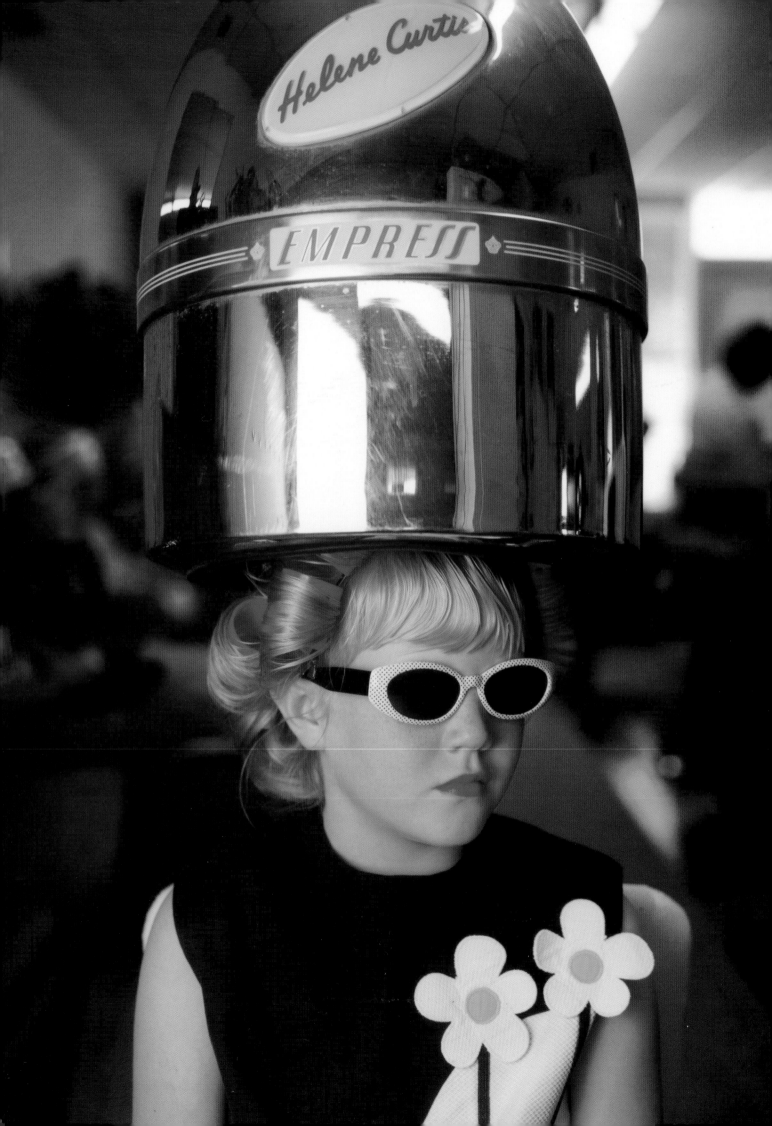

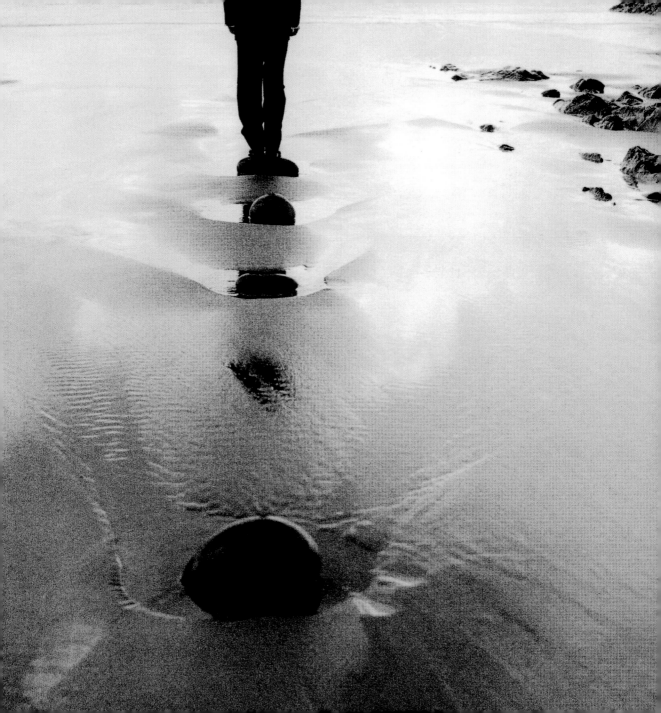

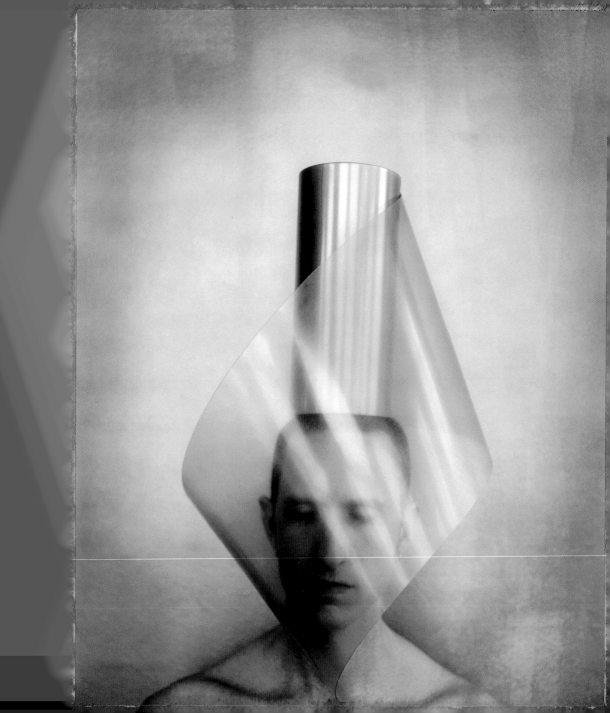

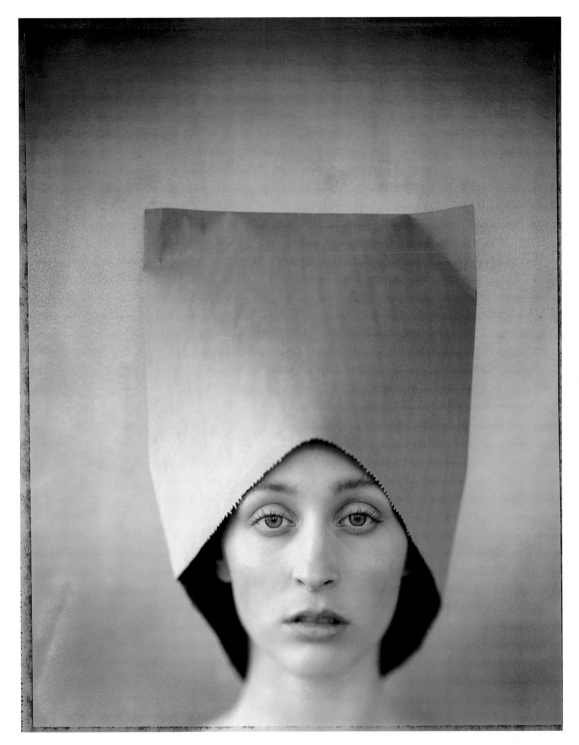

(This spread) Jeff Stephens

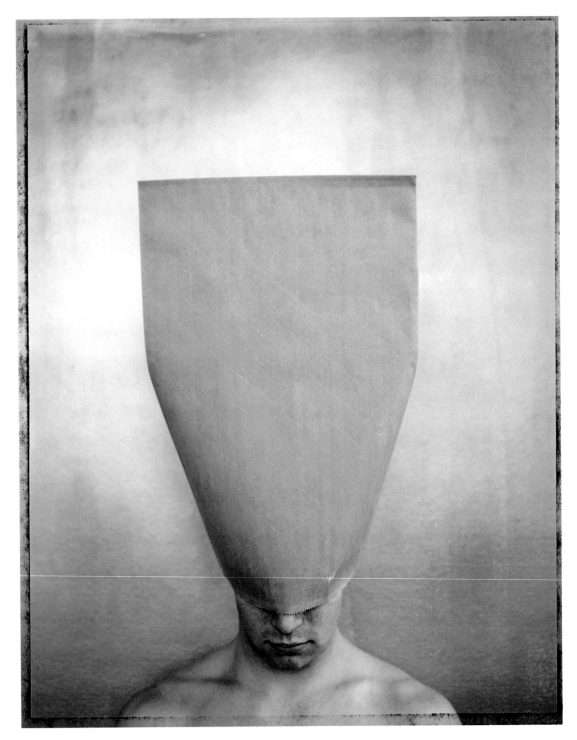

(This spread) Jeff Stephens

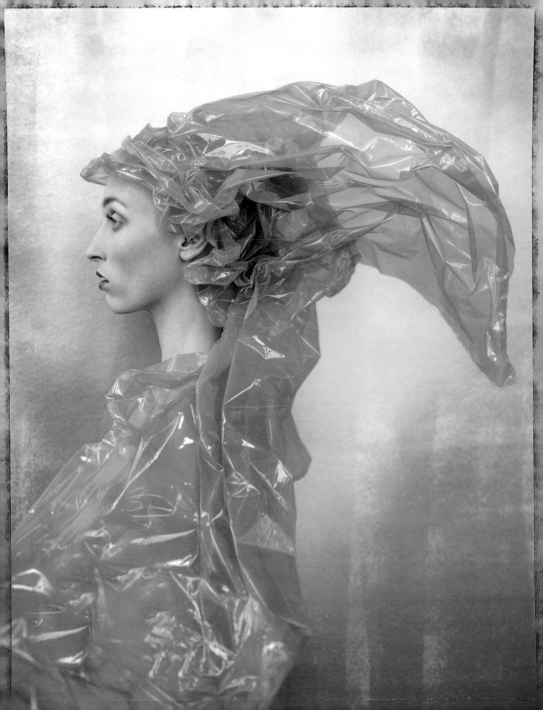

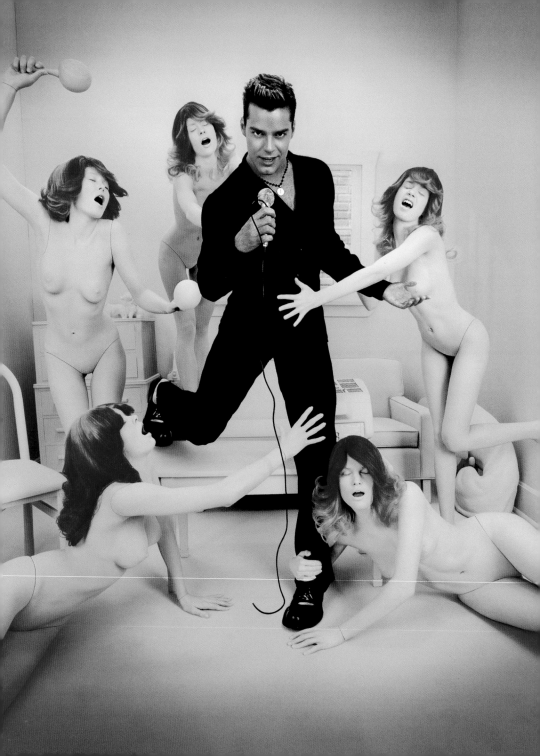

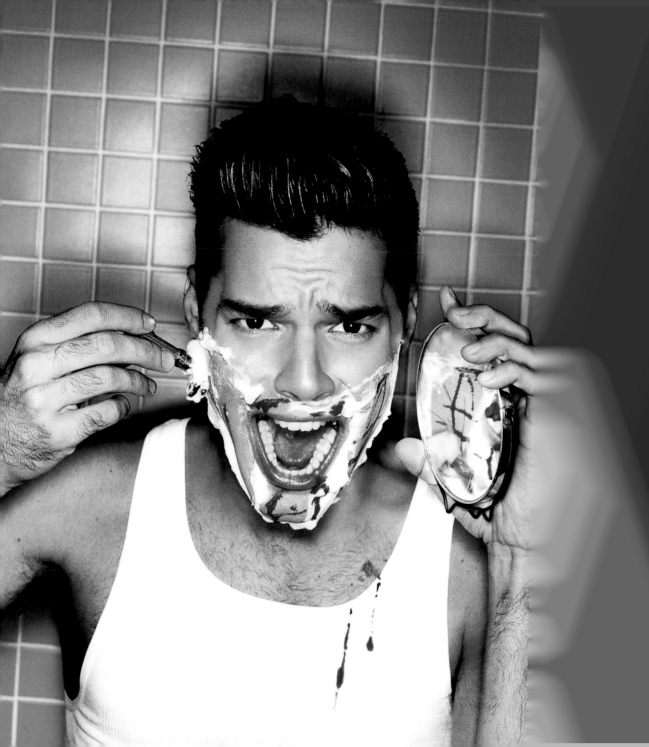

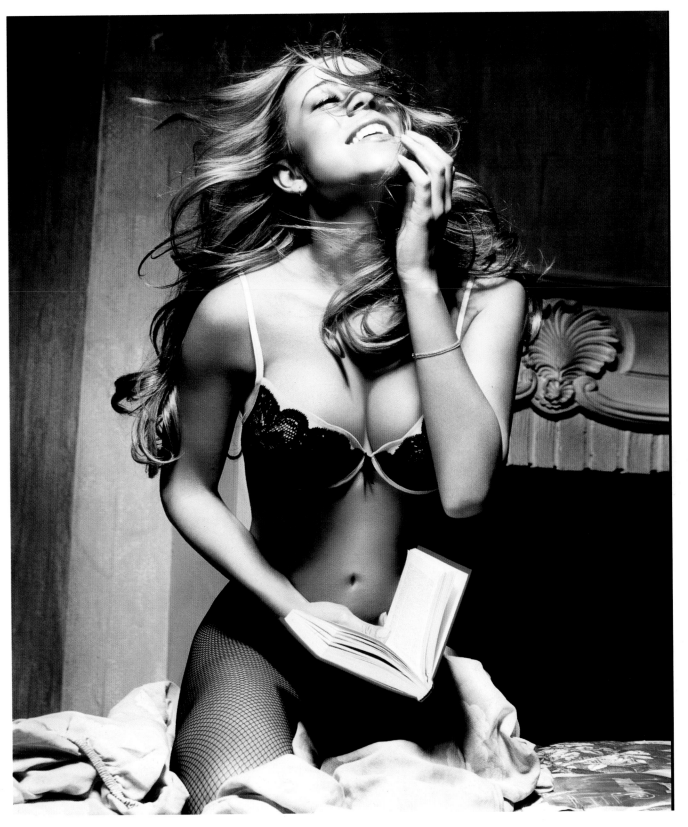

David LaChapelle

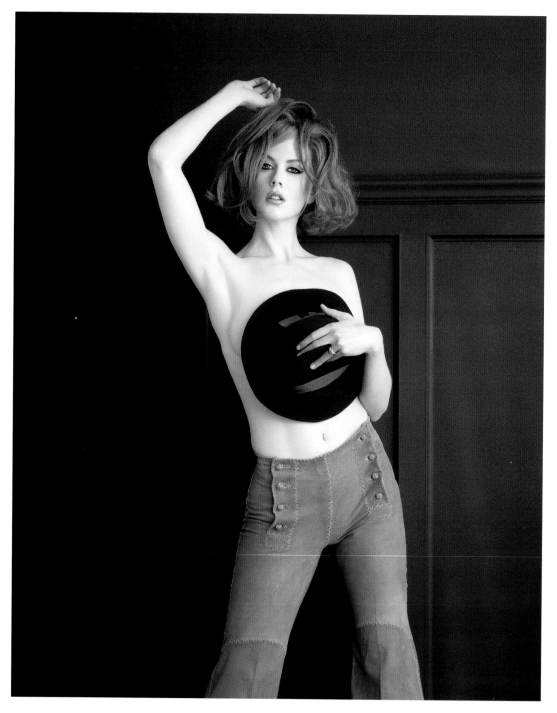

(This spread) Herb Ritts

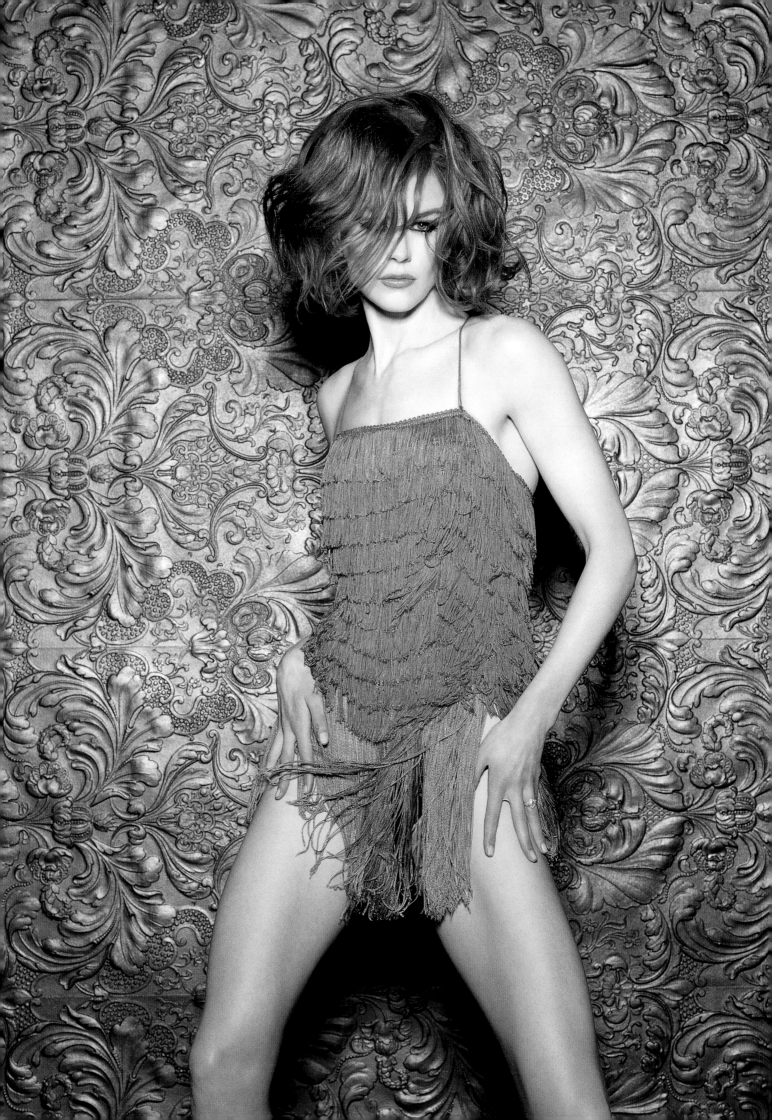

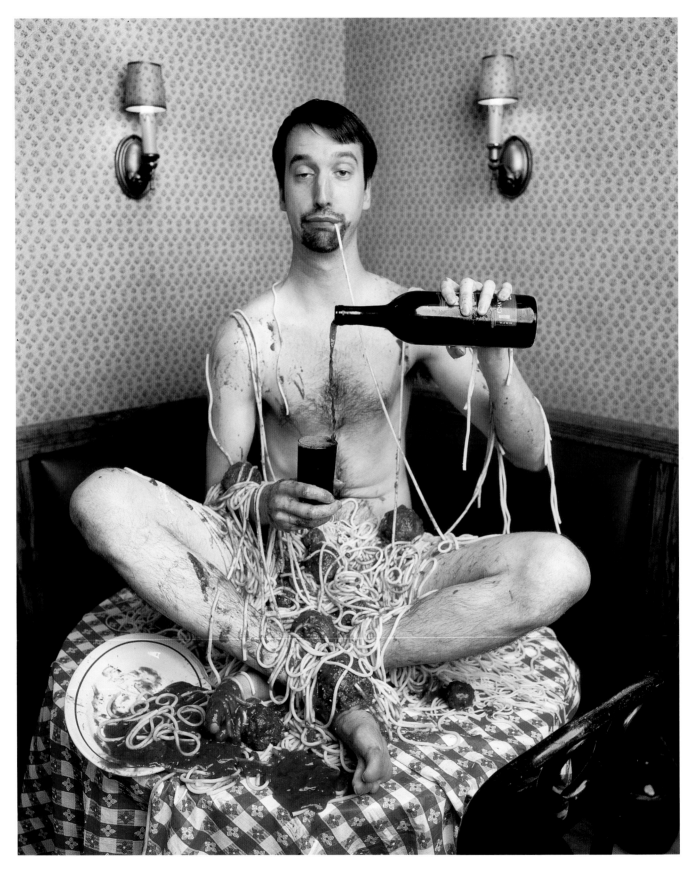

(This spread) Mark Seliger

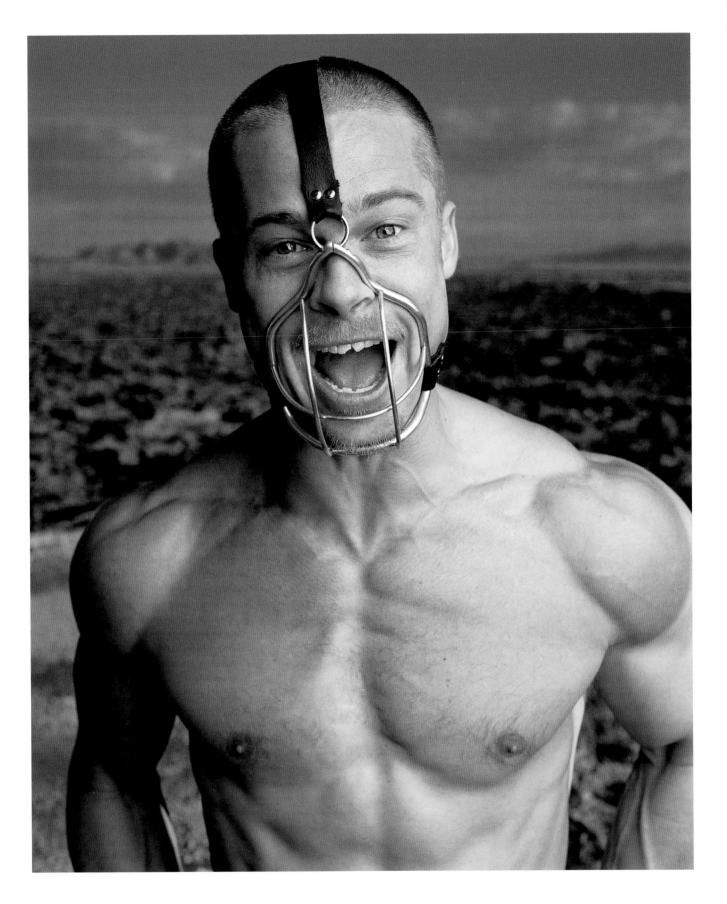

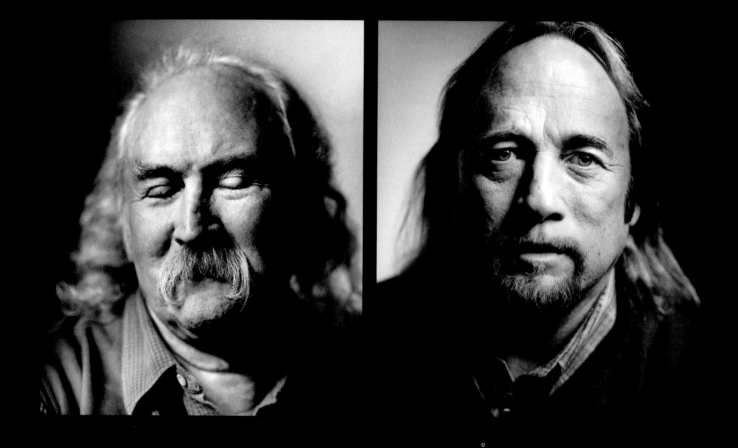

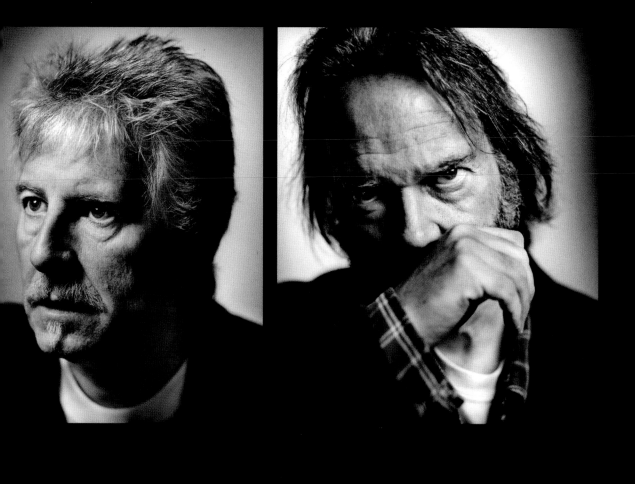

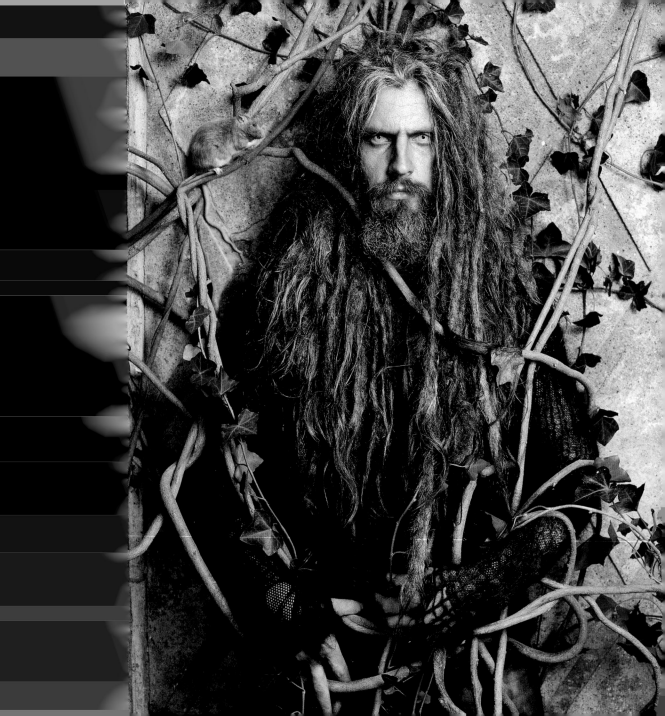

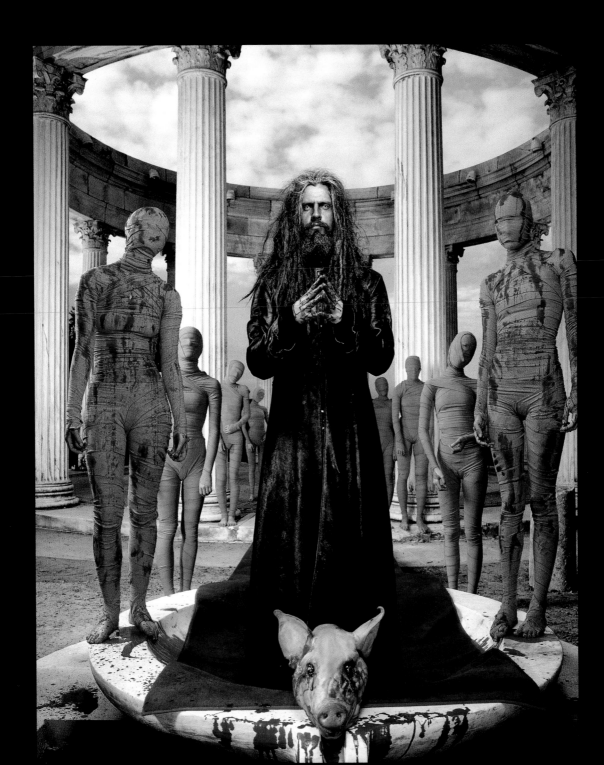

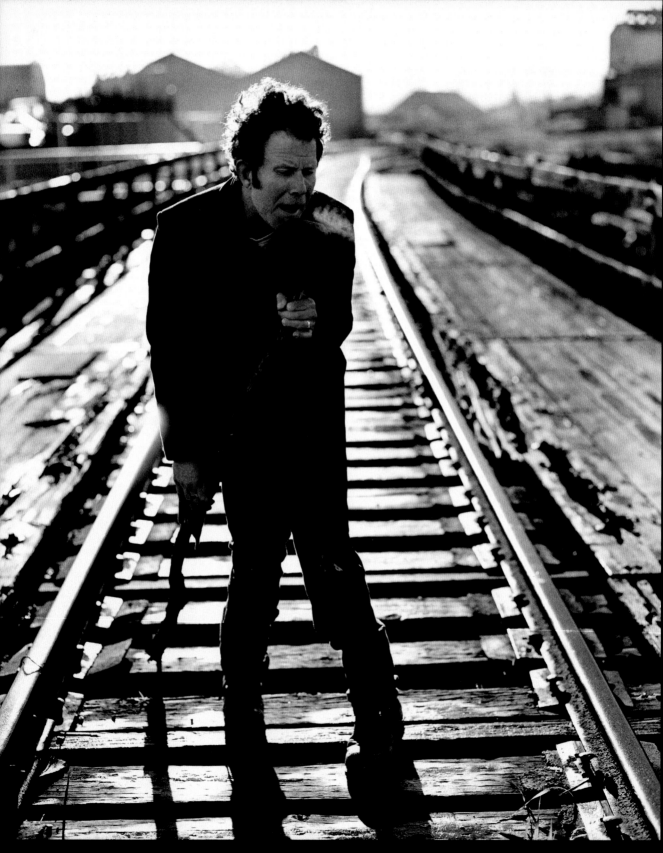

(This spread) *Mark Seliger*

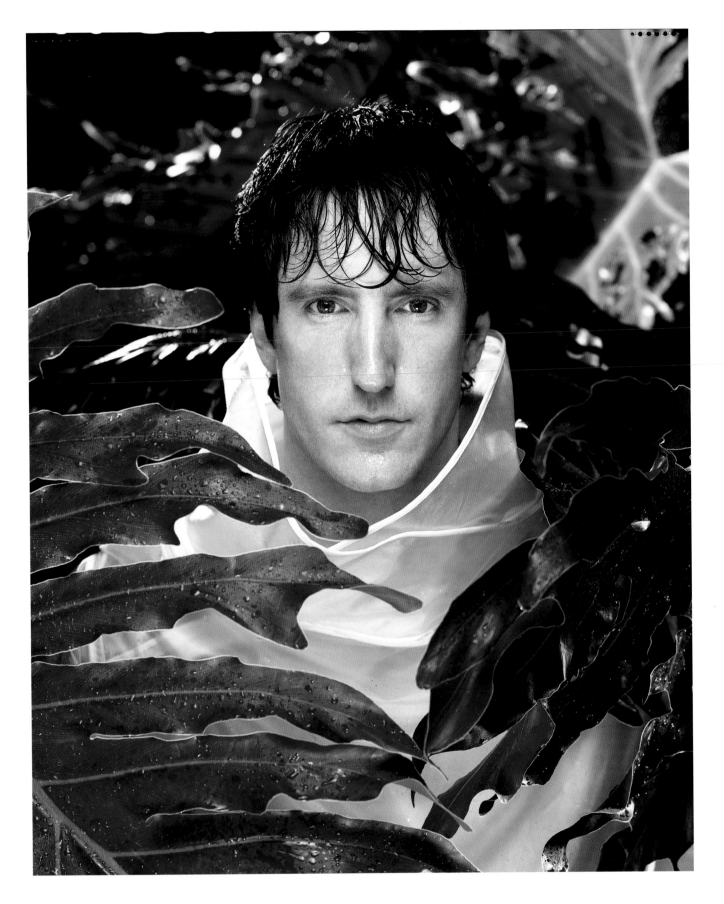

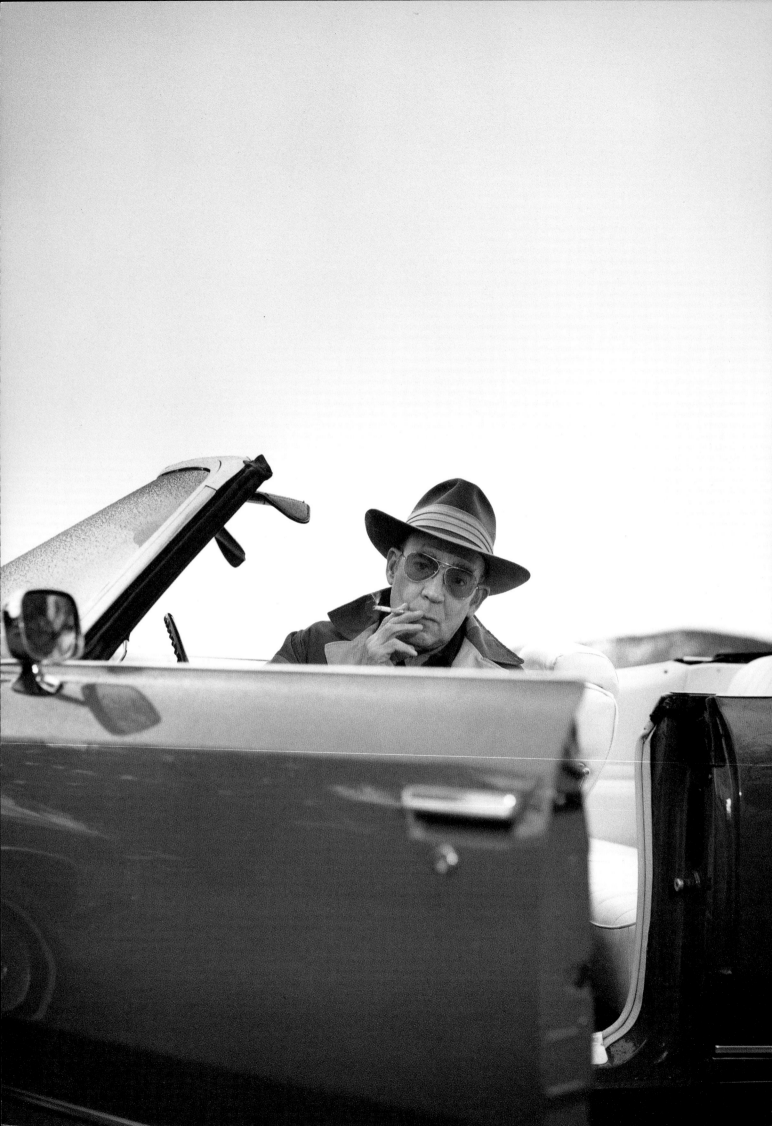

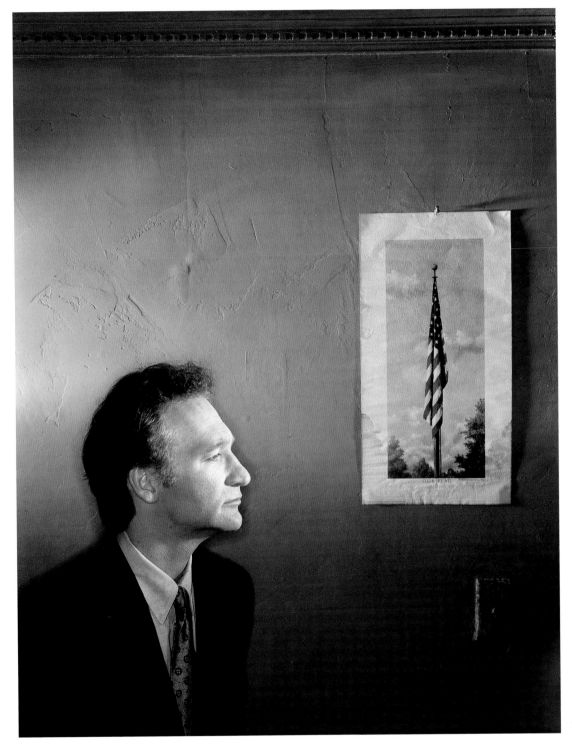

(This spread) Dan Winters

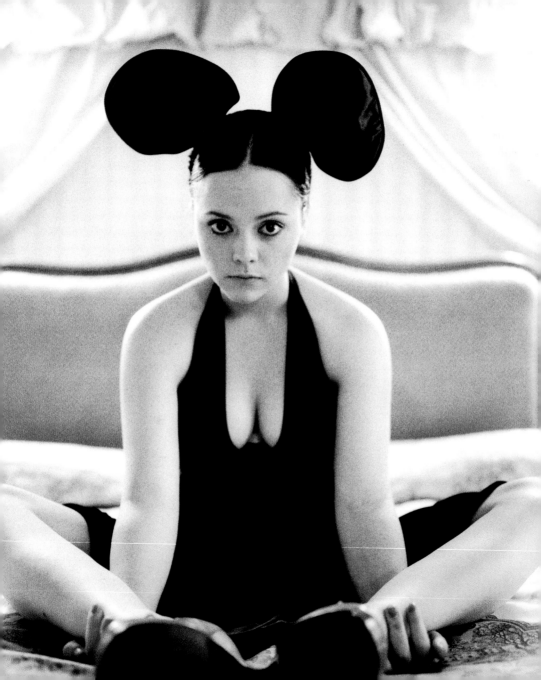

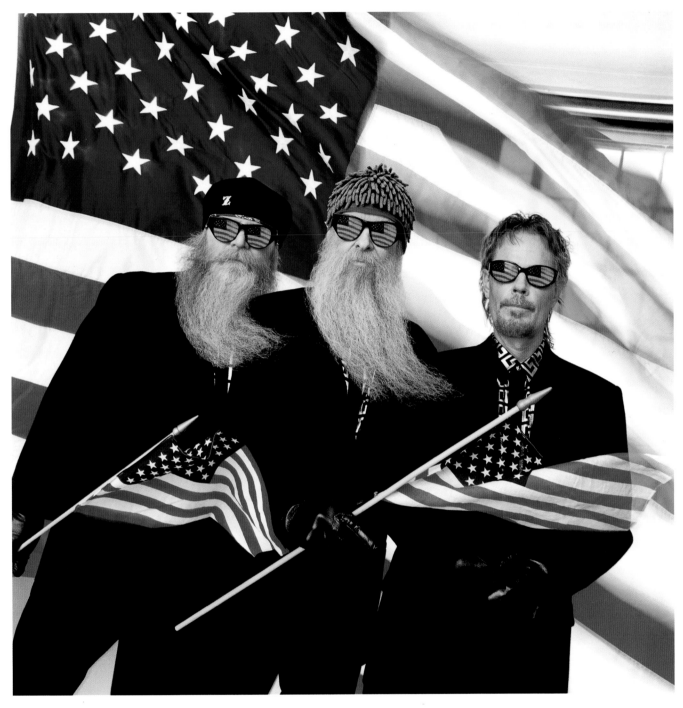

Mary Ellen Mark

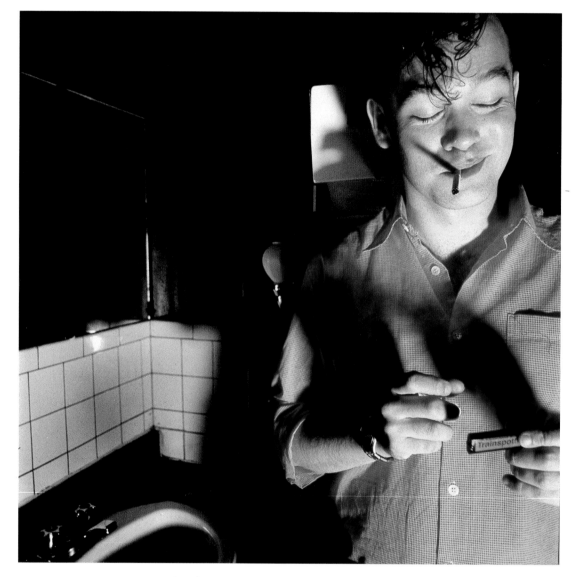

(This page) Bryce Duffy, (Opposite page) Craig Cutler

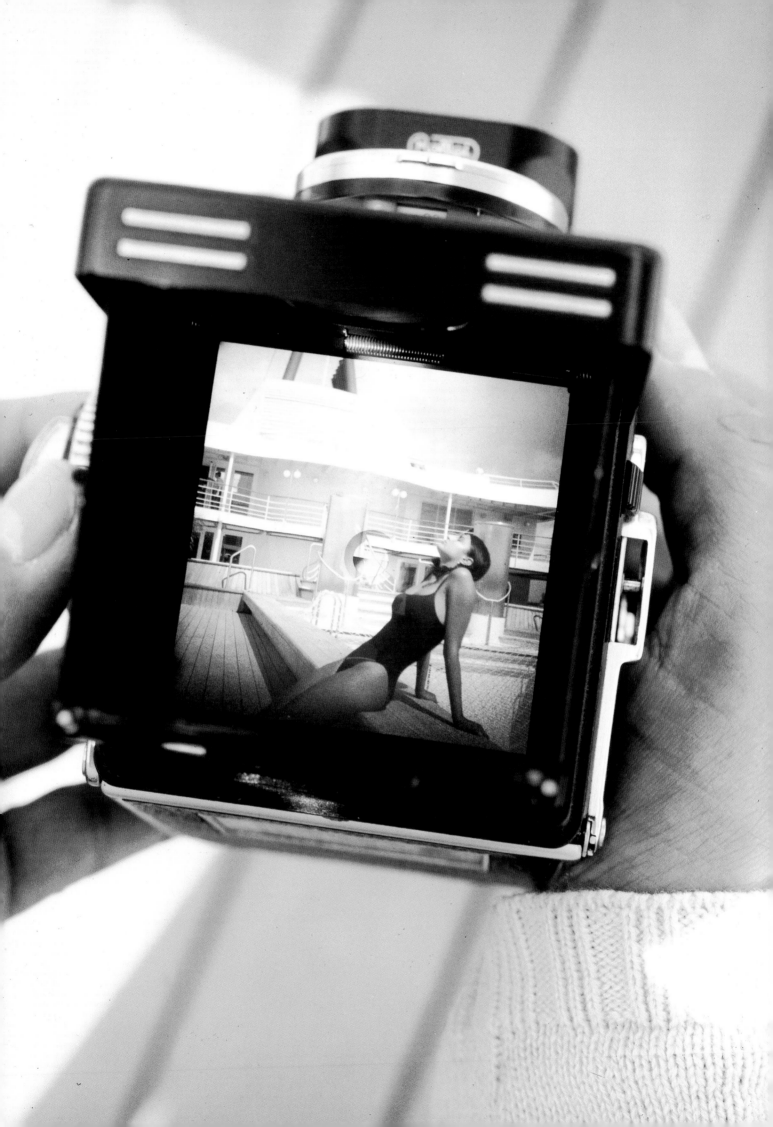

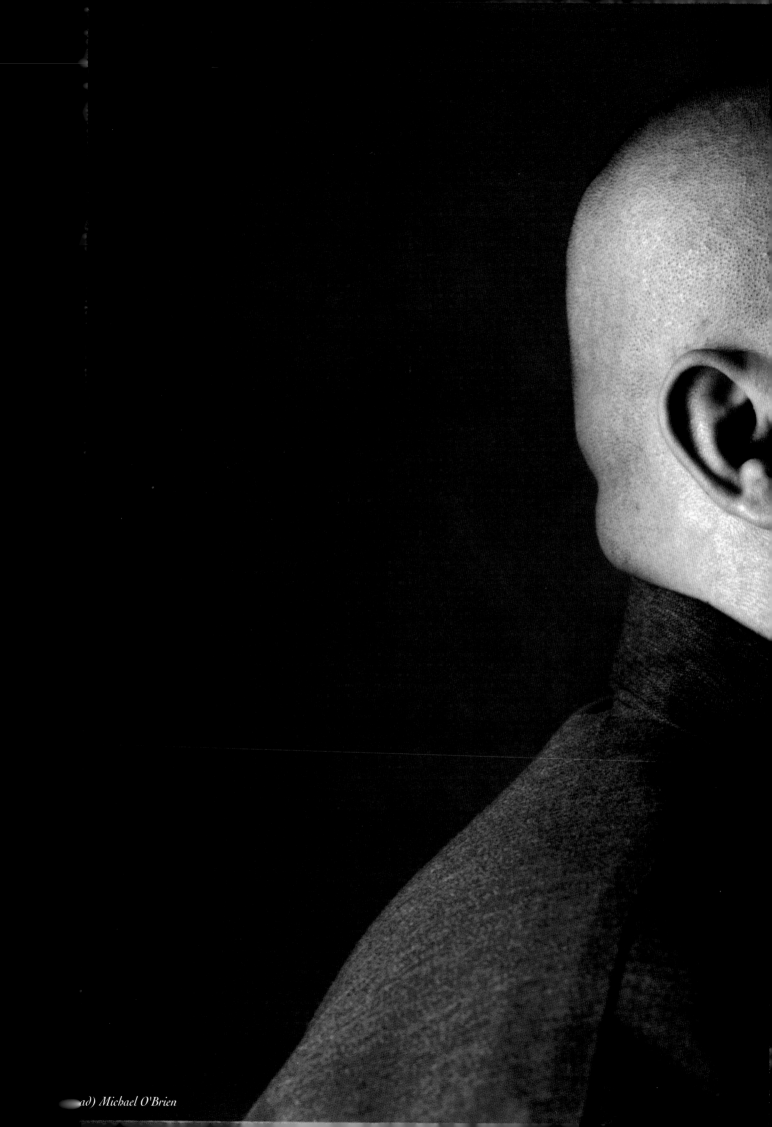

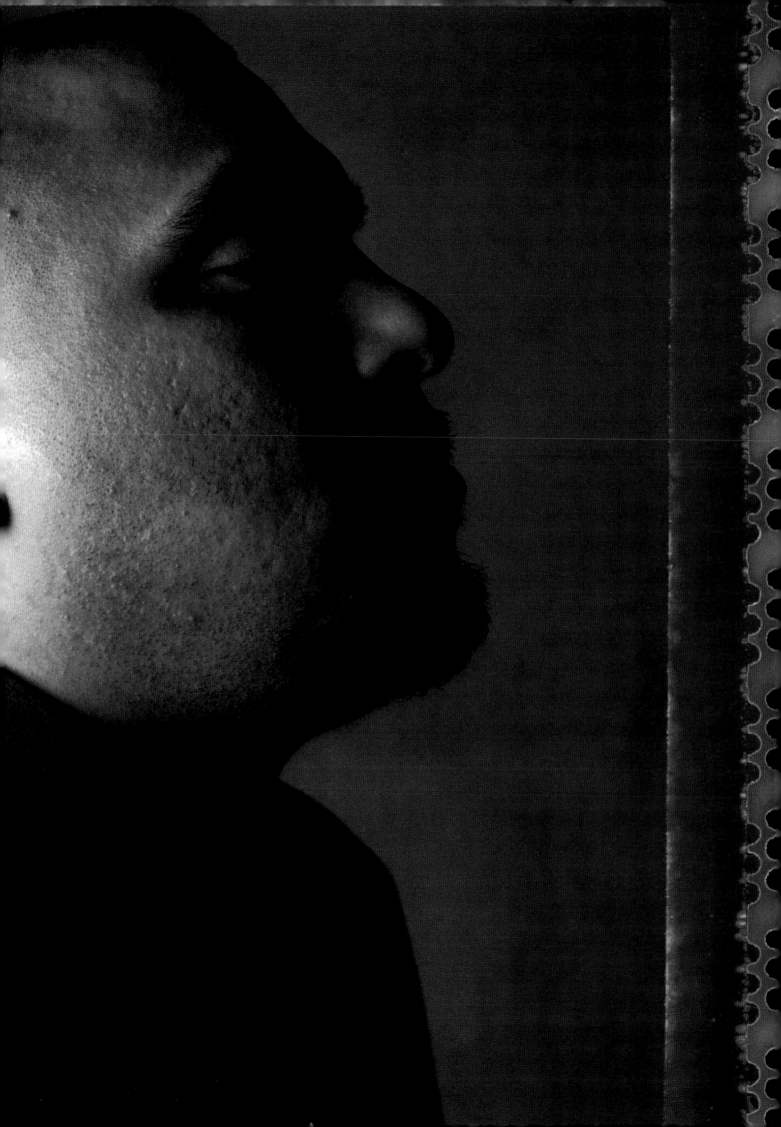

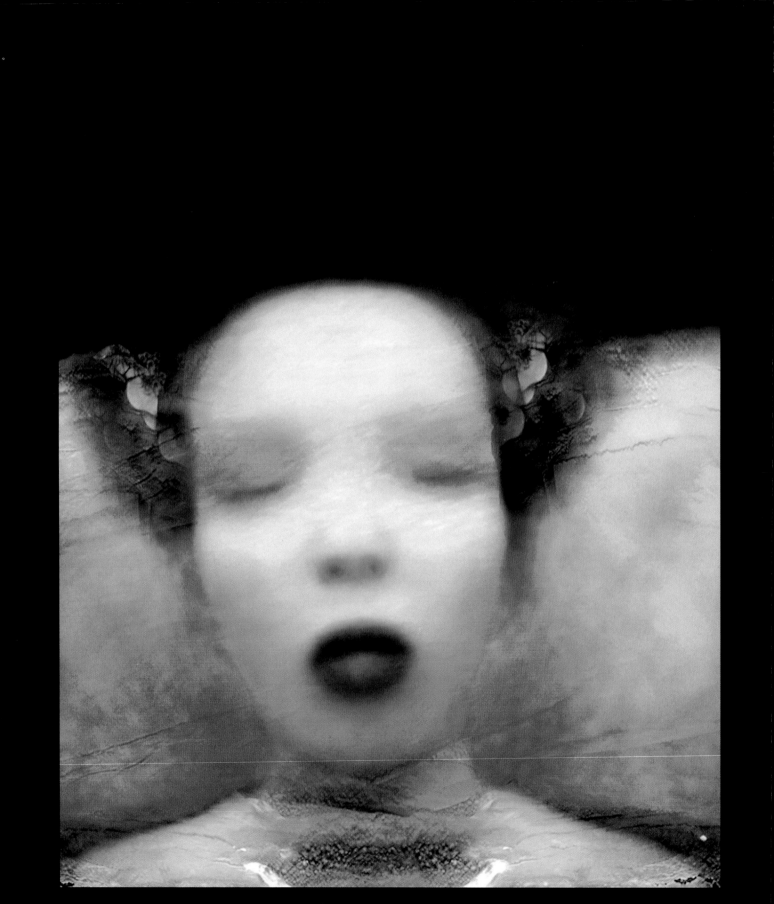

(This spread) Roxann Arwen Mills

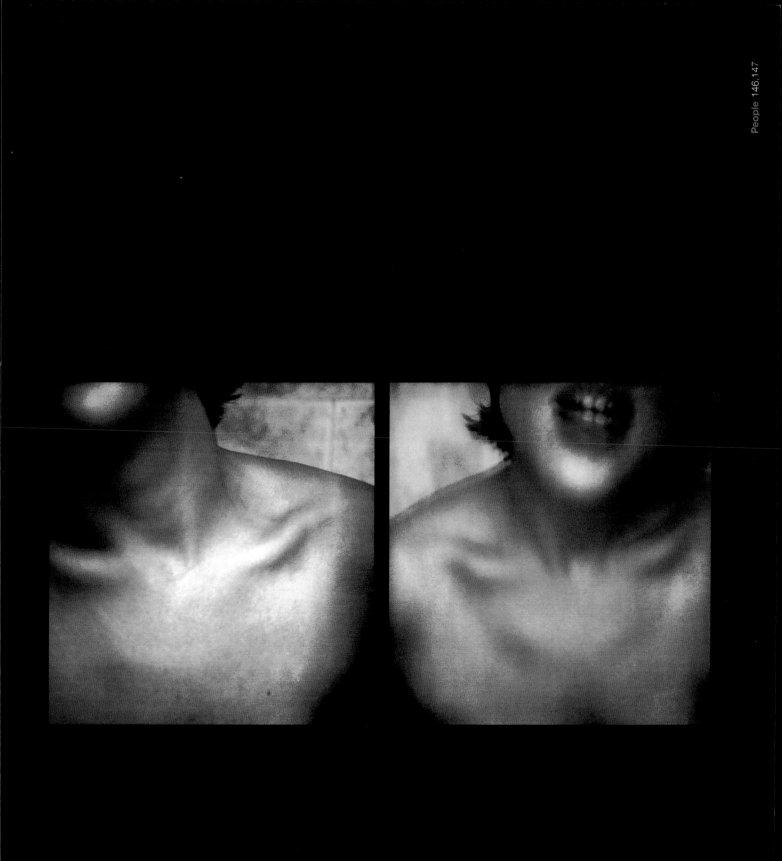

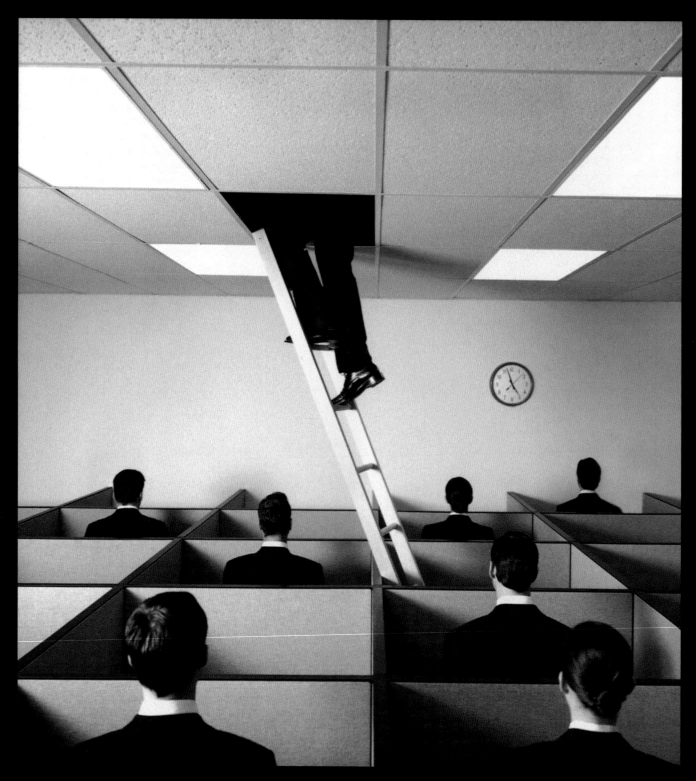

(This spread) Colin Faulkner

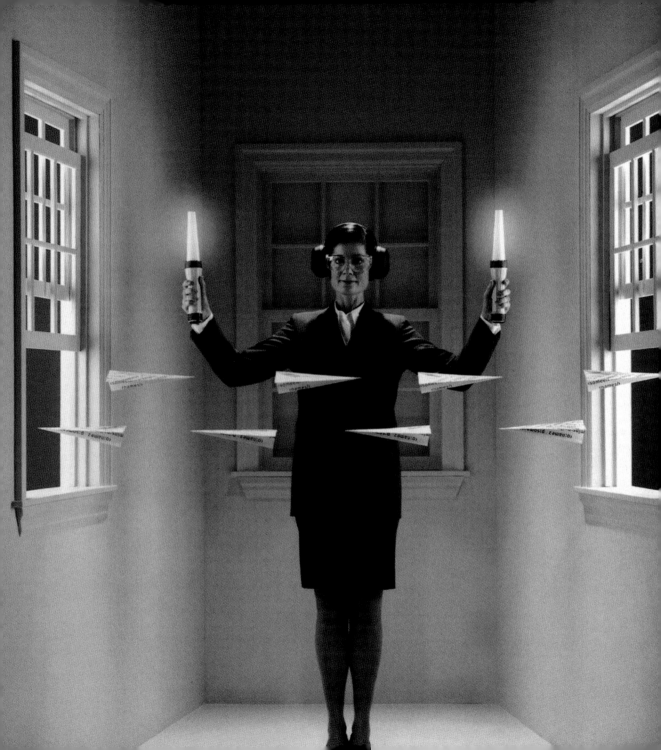

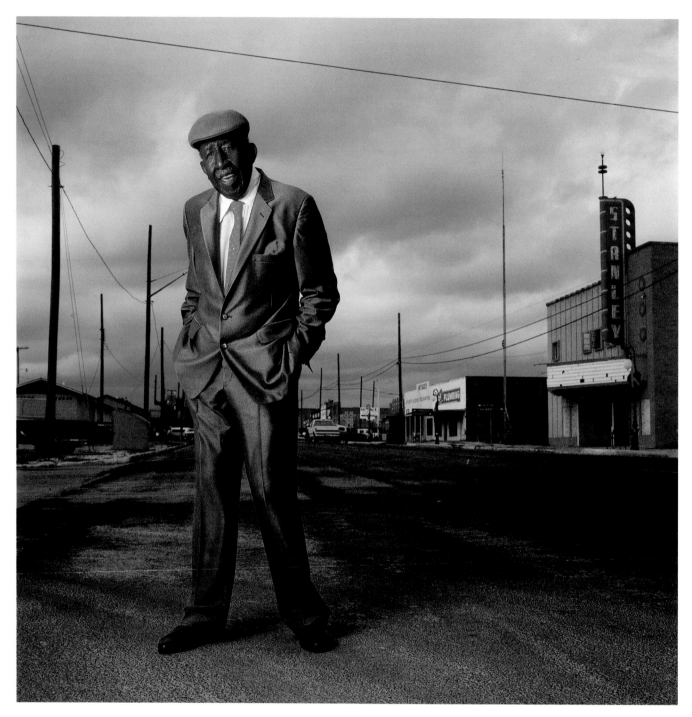

(This spread) Michael O'Brien

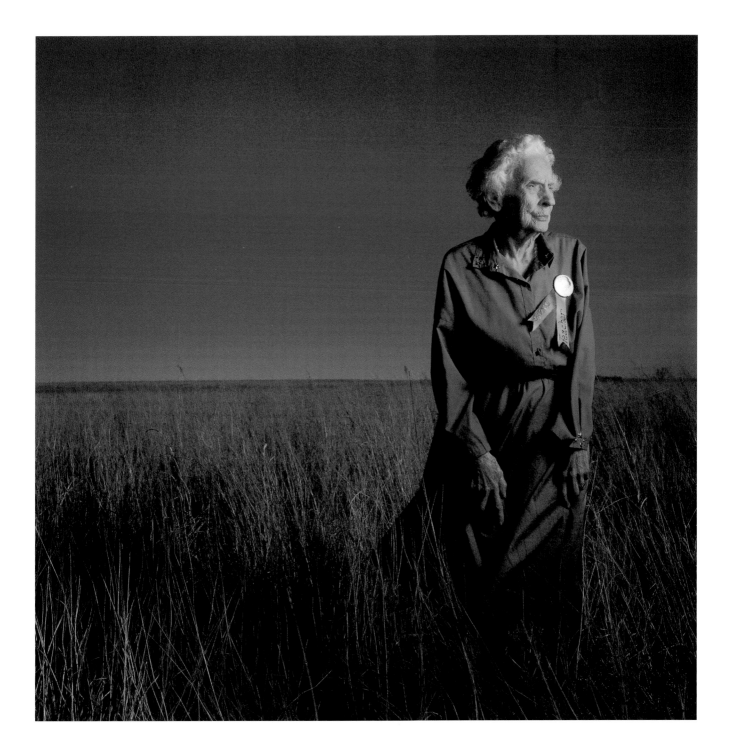

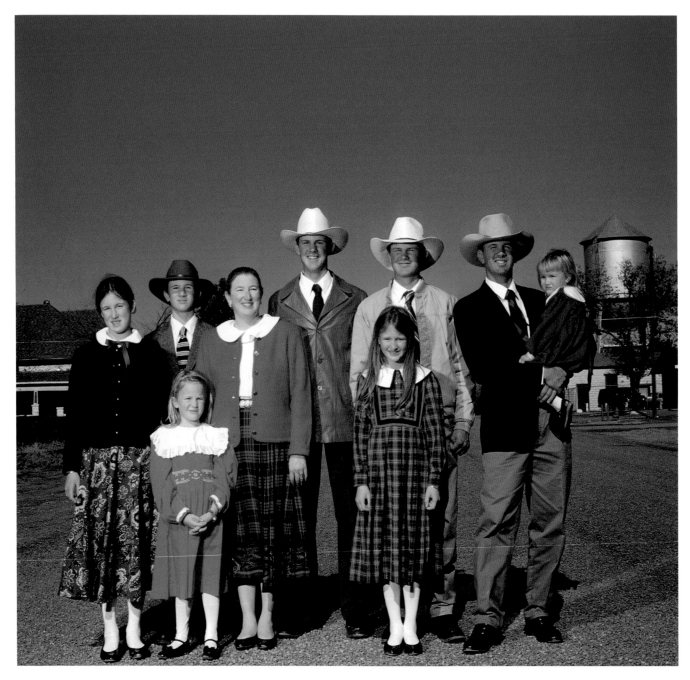

Michael O'Brien

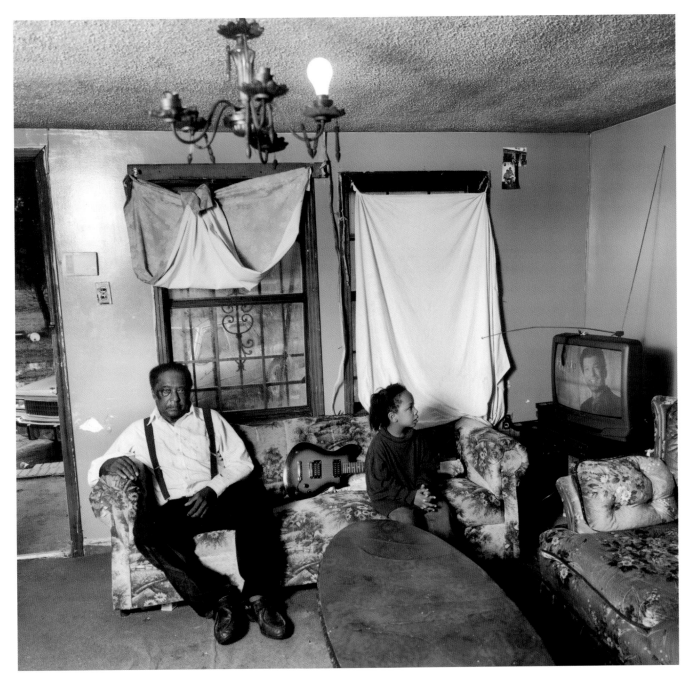

Jonathan Torgovnik

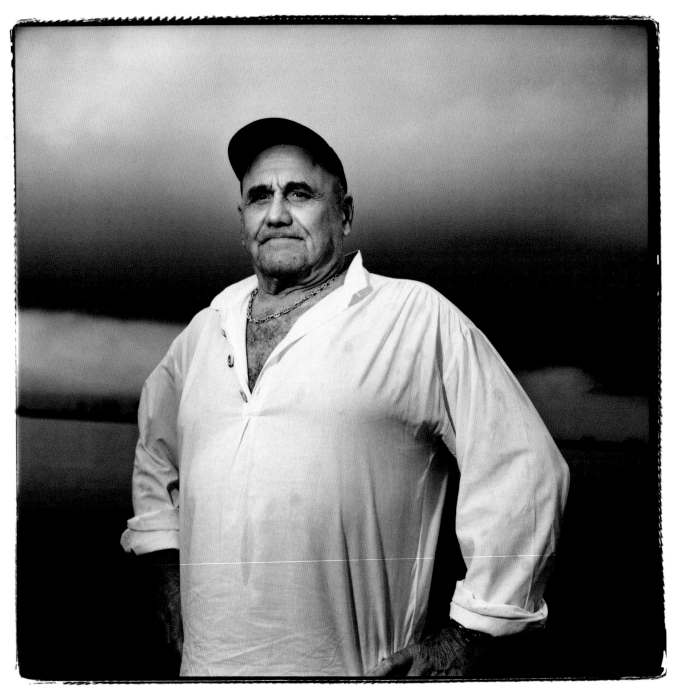

Chris Callas

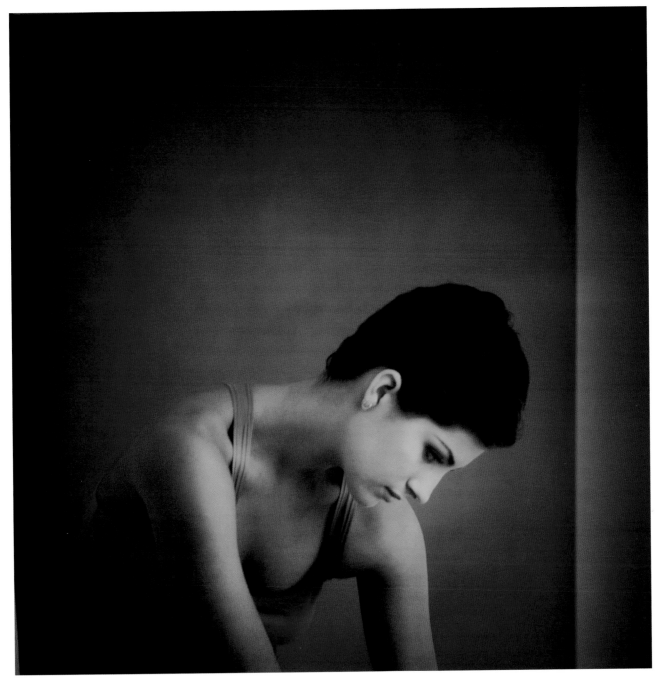

Parish Kohanim

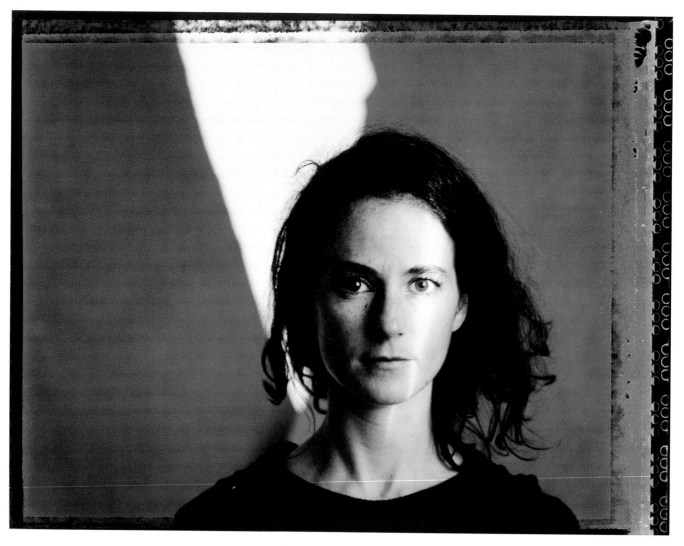

(This spread) Rosanne Olson

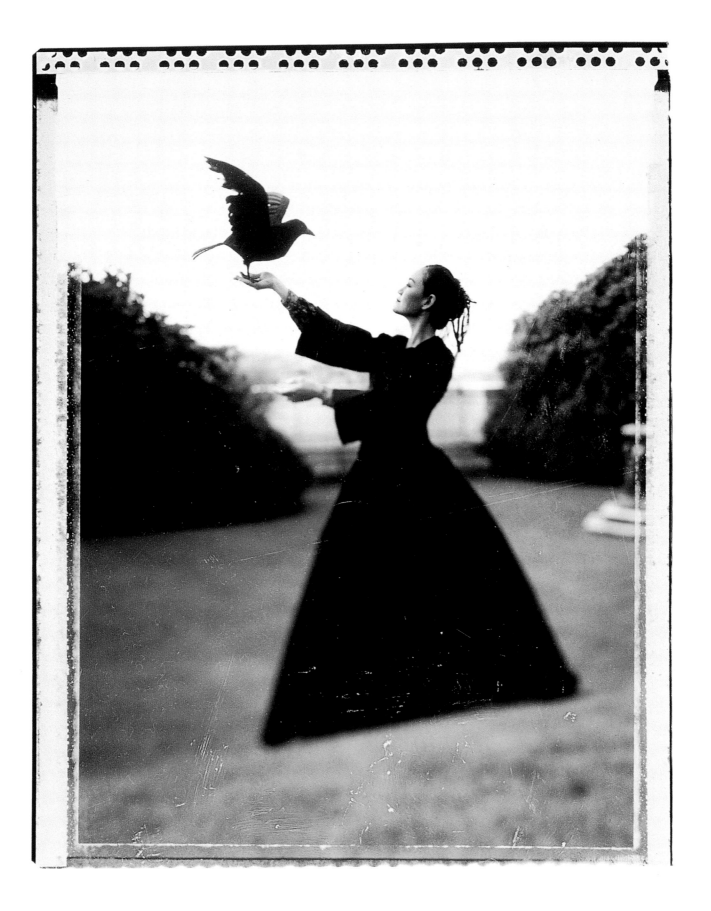

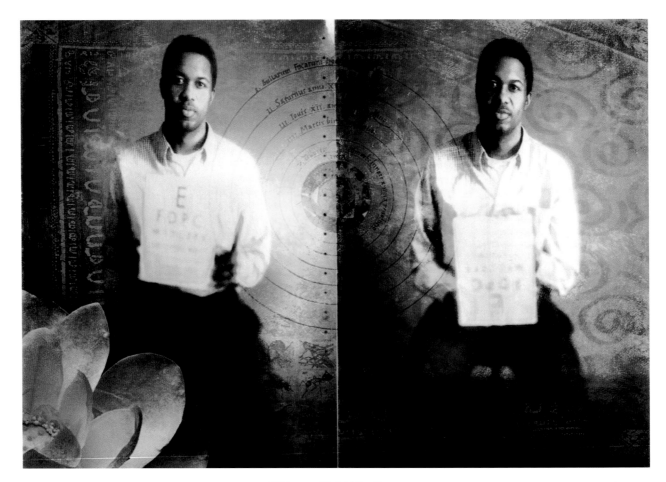

(This spread) Melody Cassen

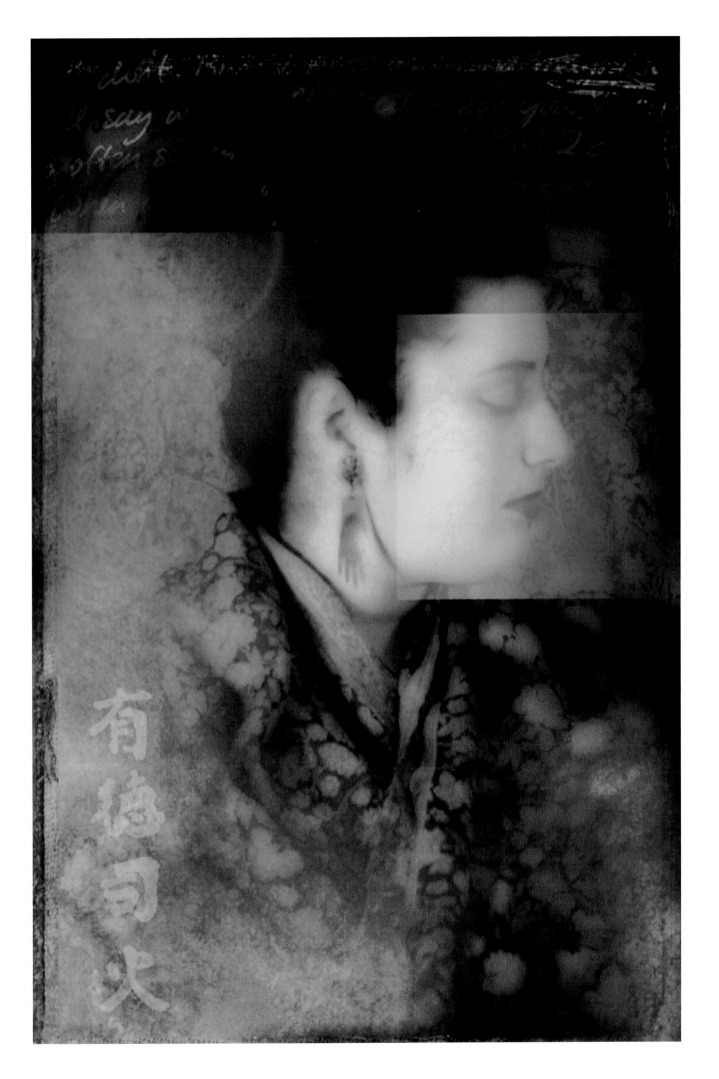

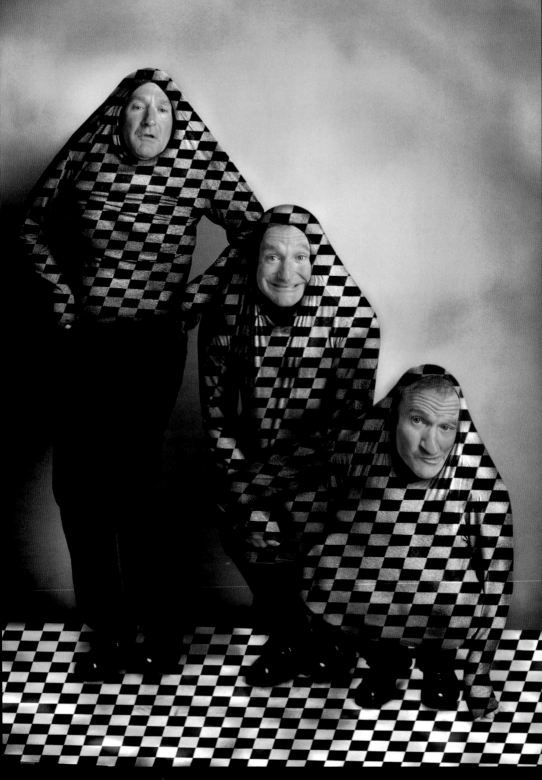

(This spread) Gerald Bybee

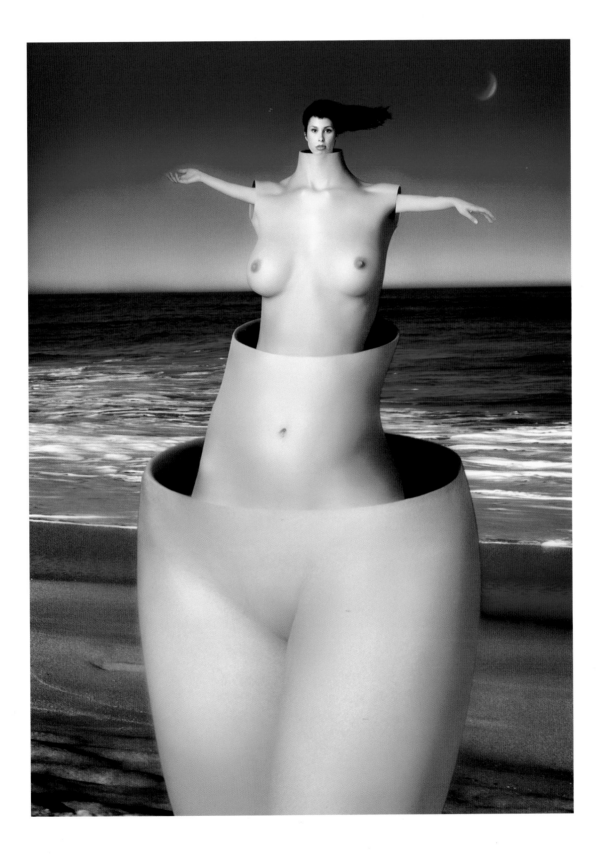

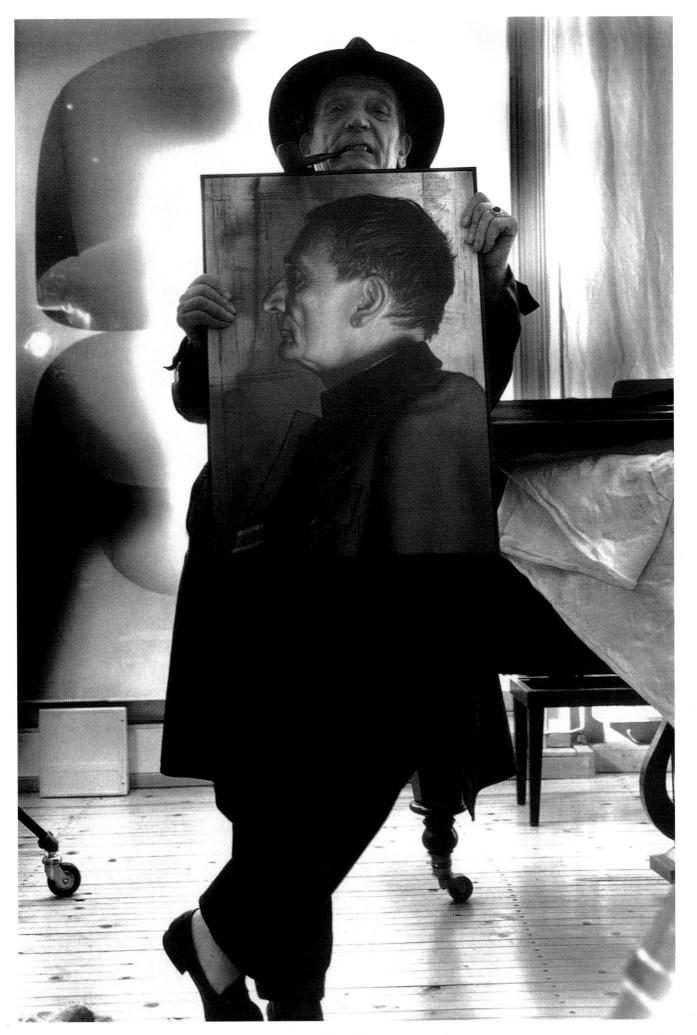

Dieter Blum

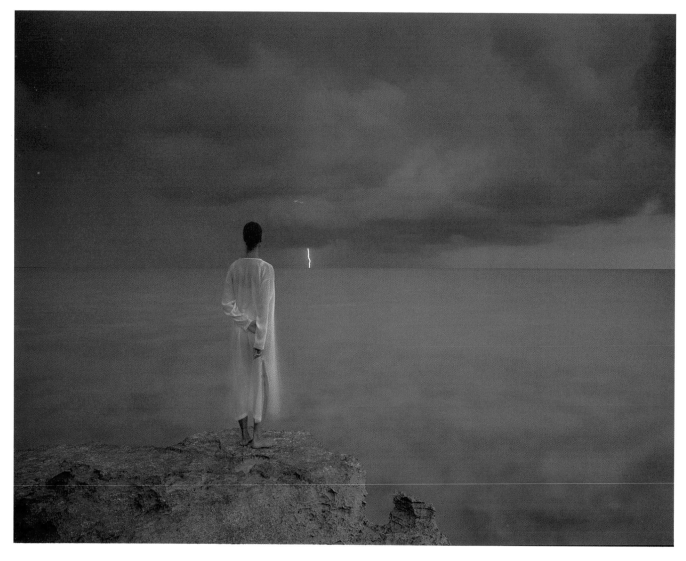

Stephen Wilkes

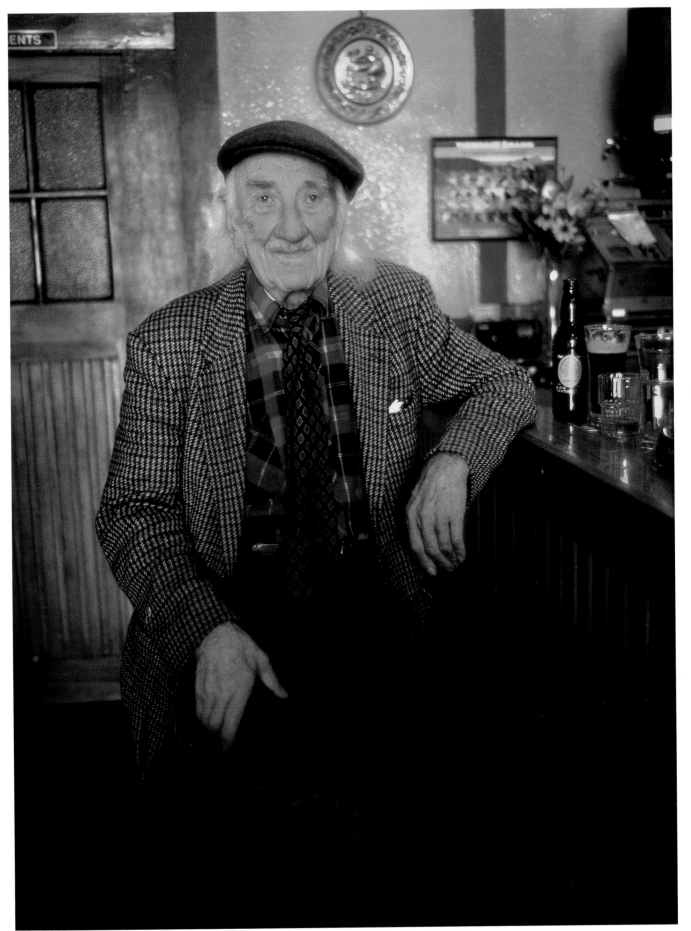

Charles Harris

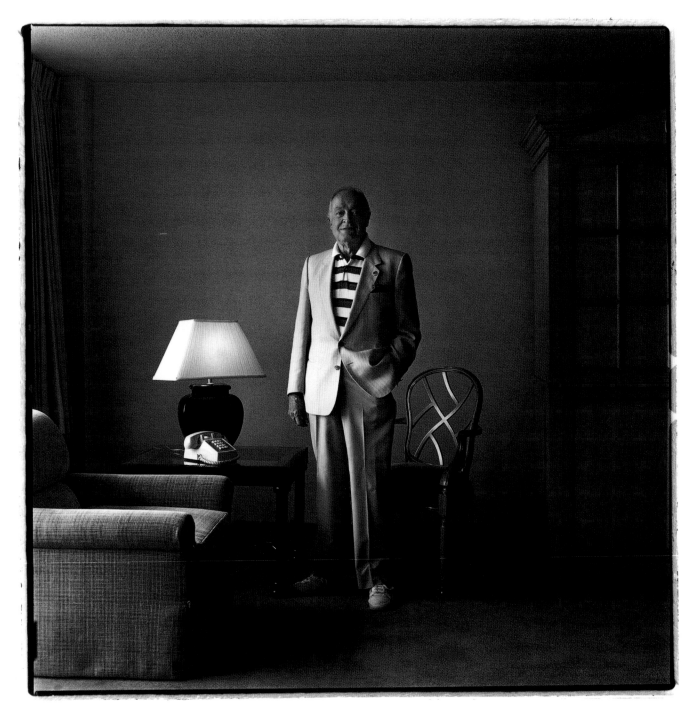

James Salzano

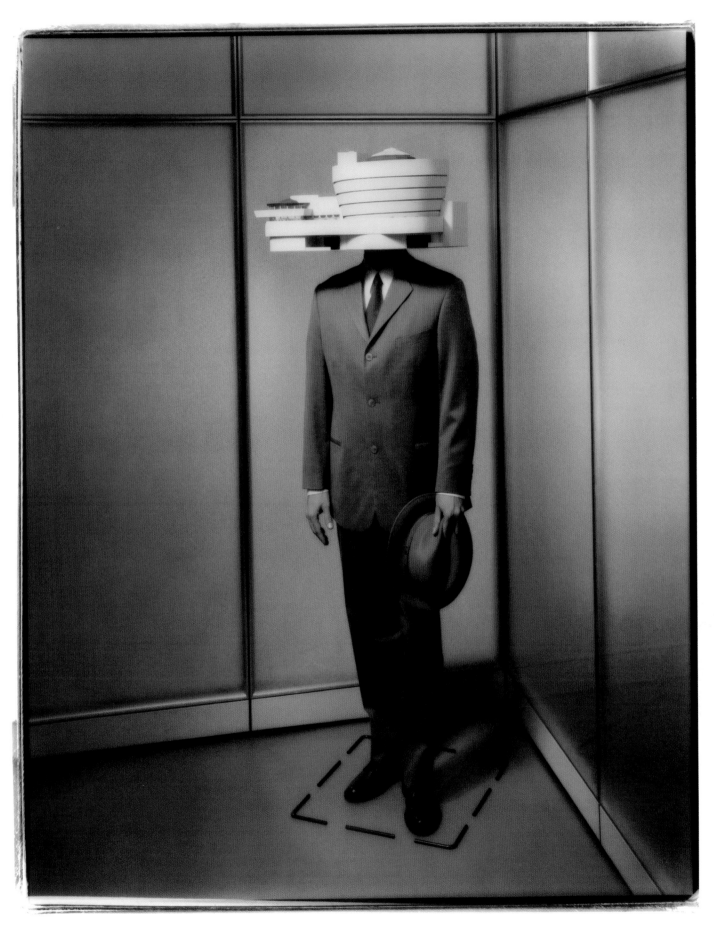

Hugh Kretschmer

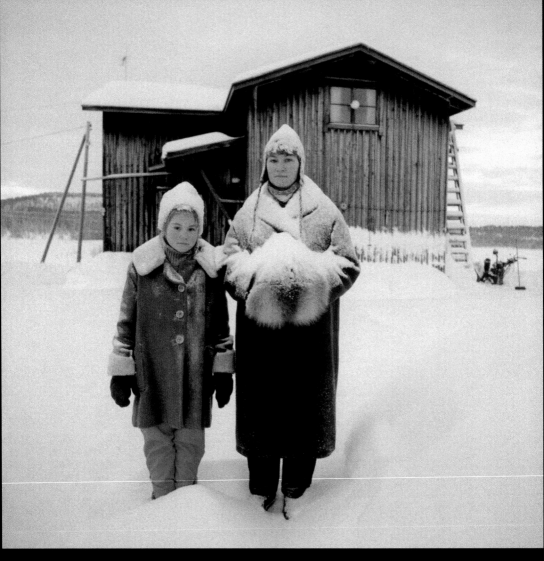

Markku Lahdesmaki

Yuri Dojc

Products

Marcus Swanson

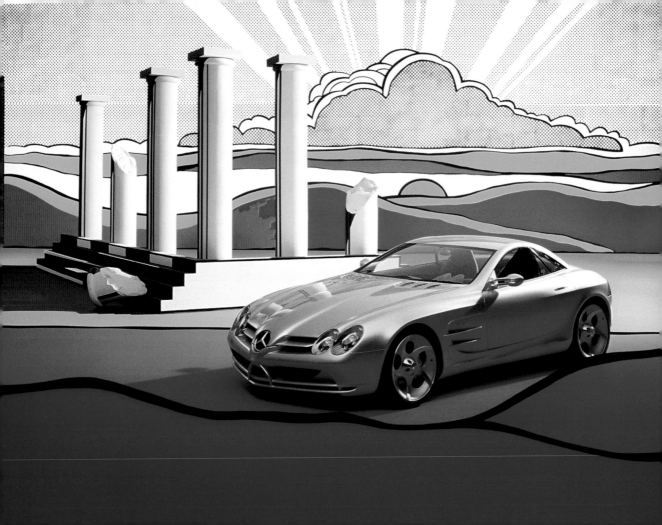

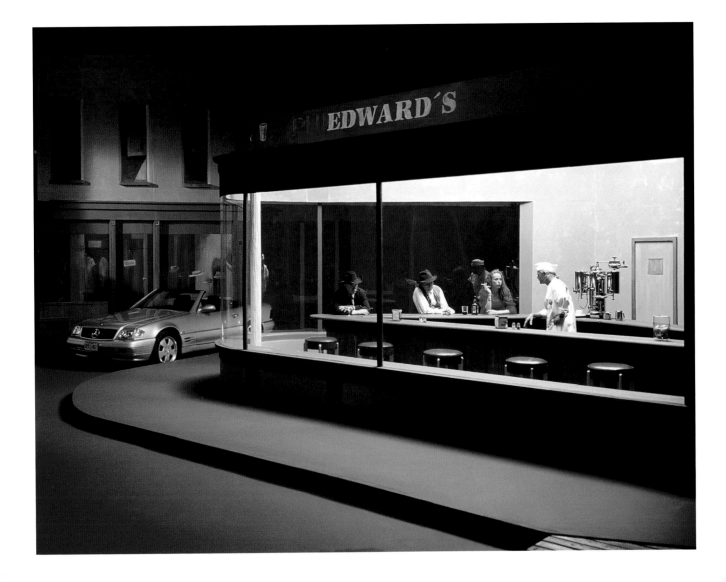

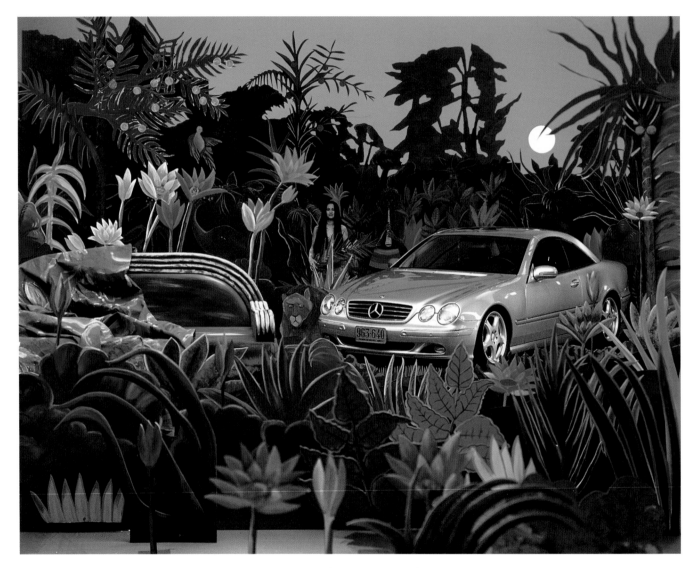

(This spread) Dietmar Henneka

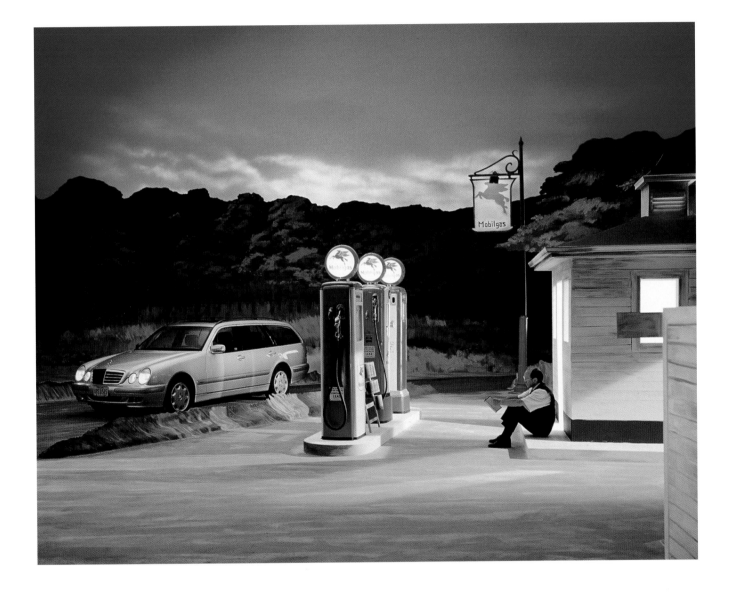

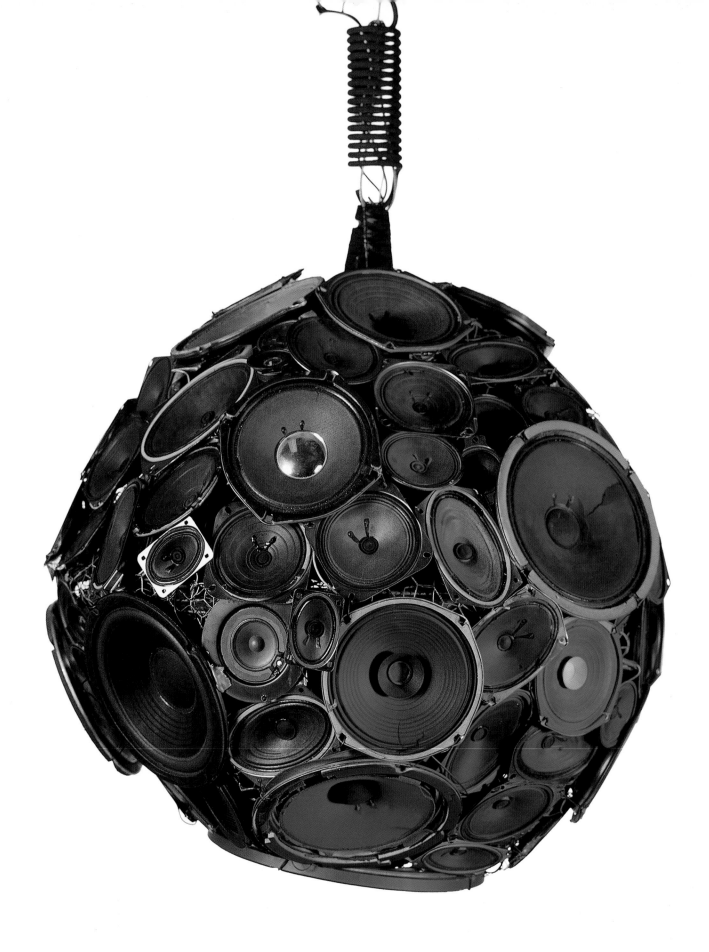

Alex Williams

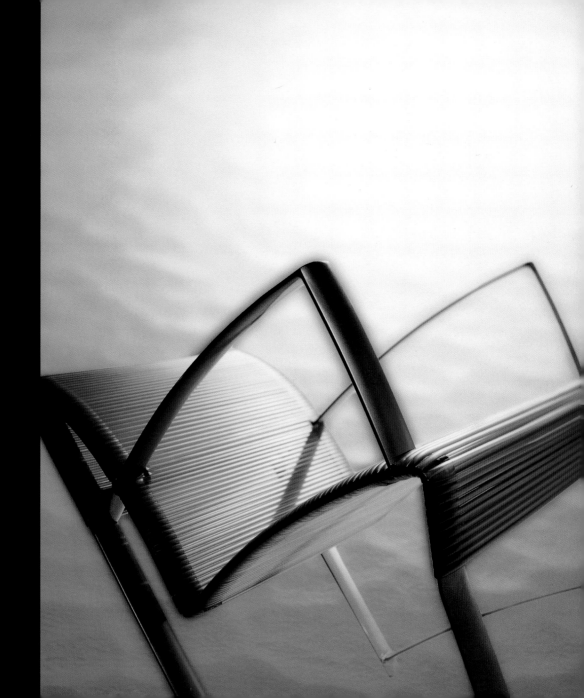

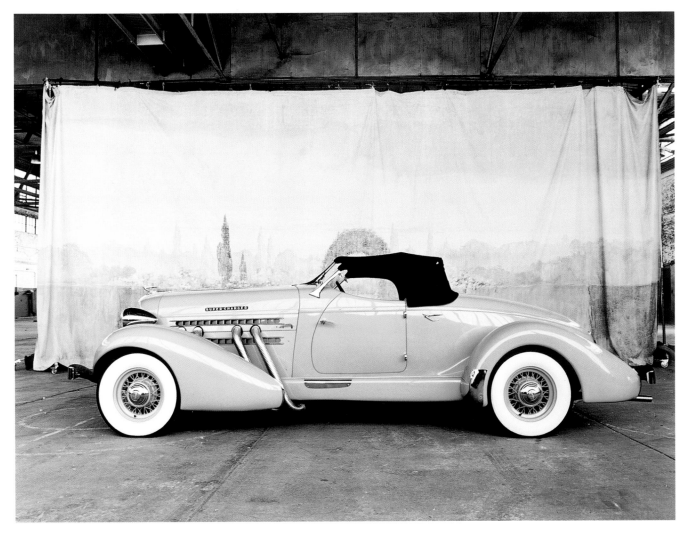

Craig Cutler

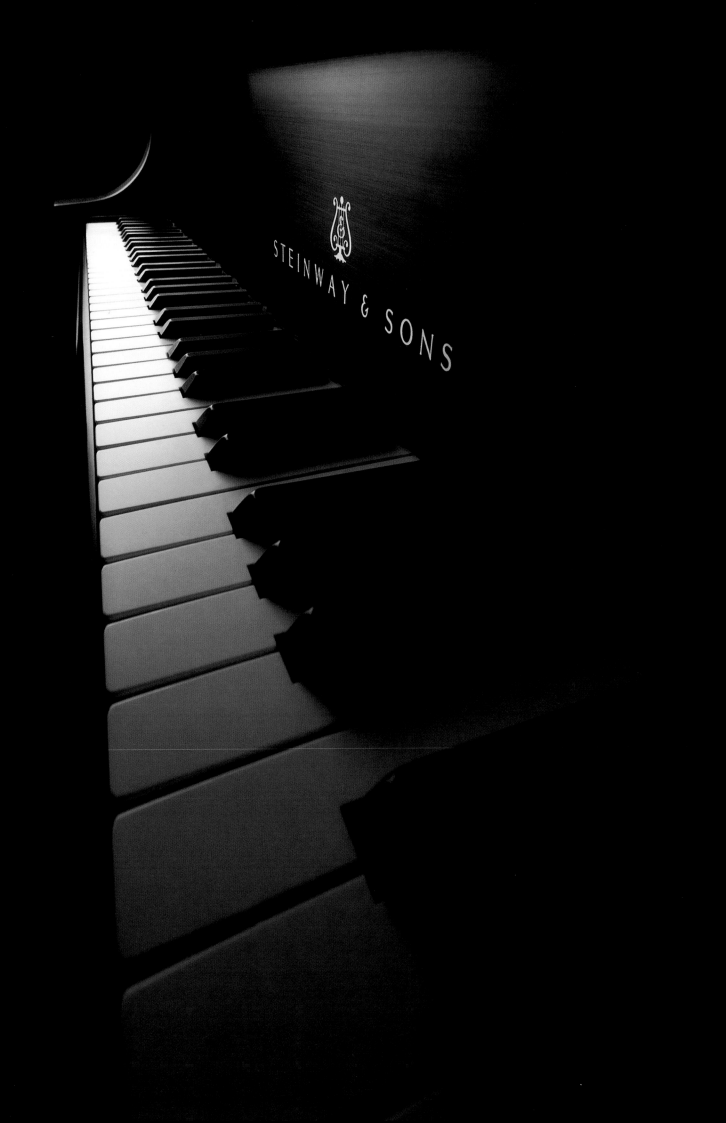

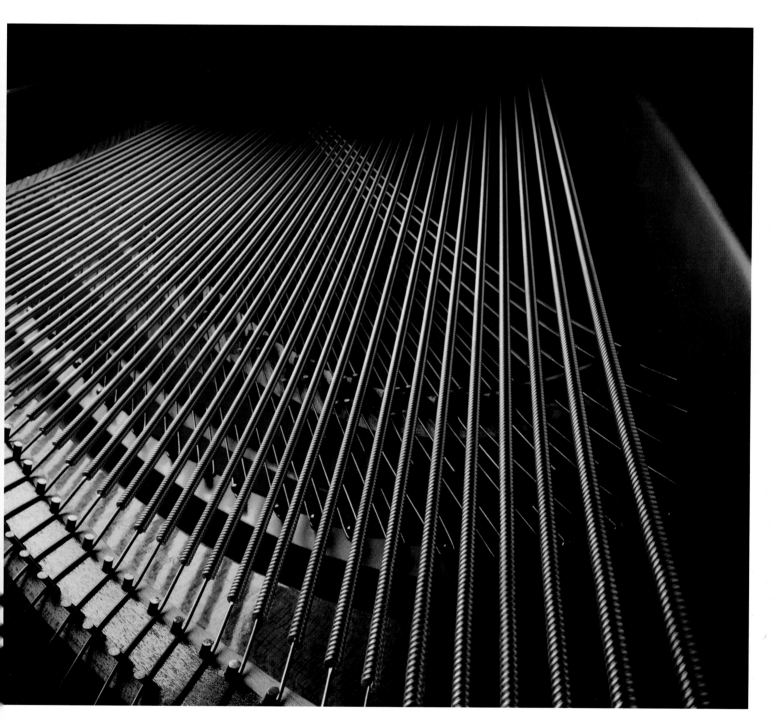

(This spread) Mark Laita

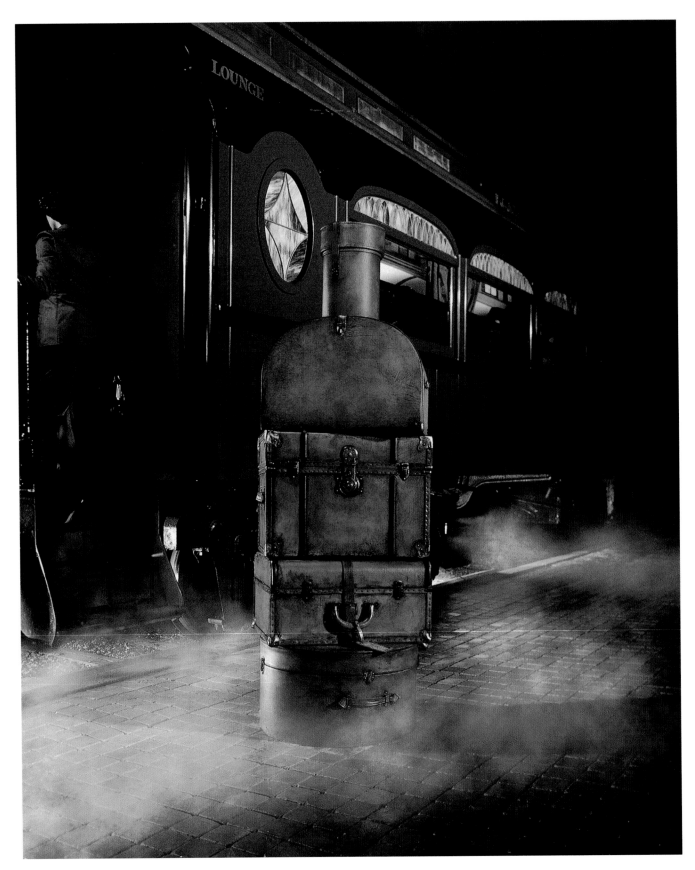

Steve Bronstein

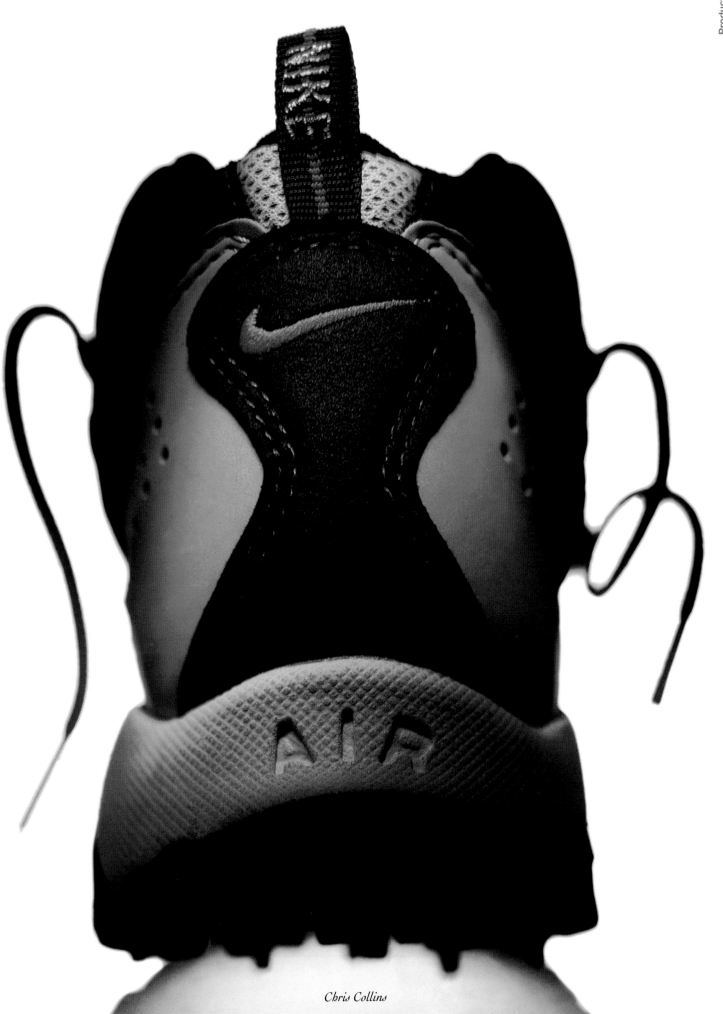

Chris Collins

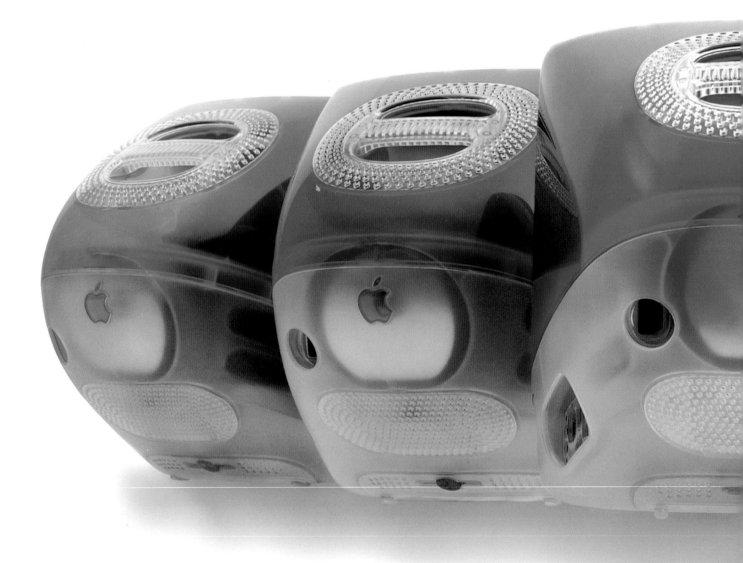

(This spread) Mark Liata

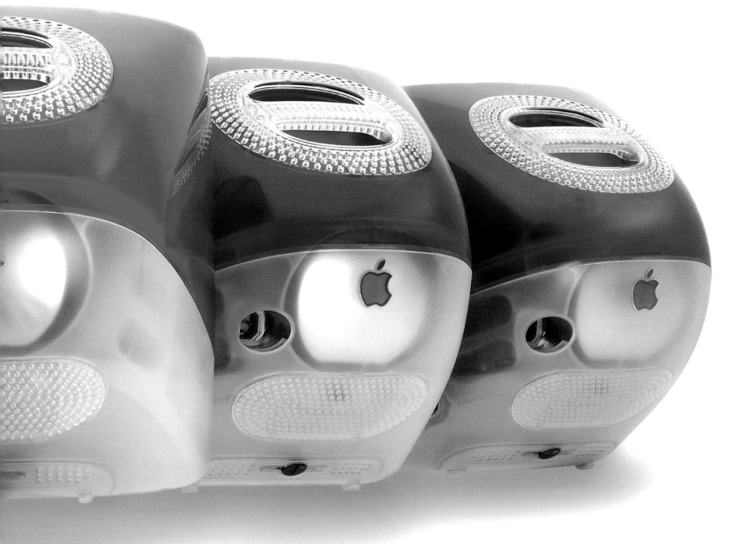

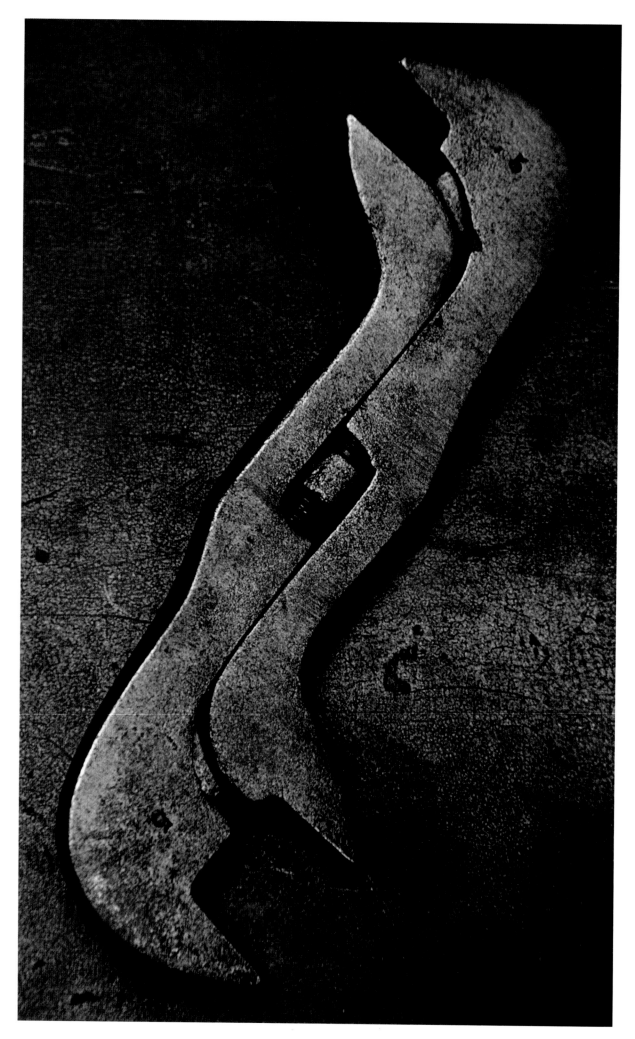

Eric Axene

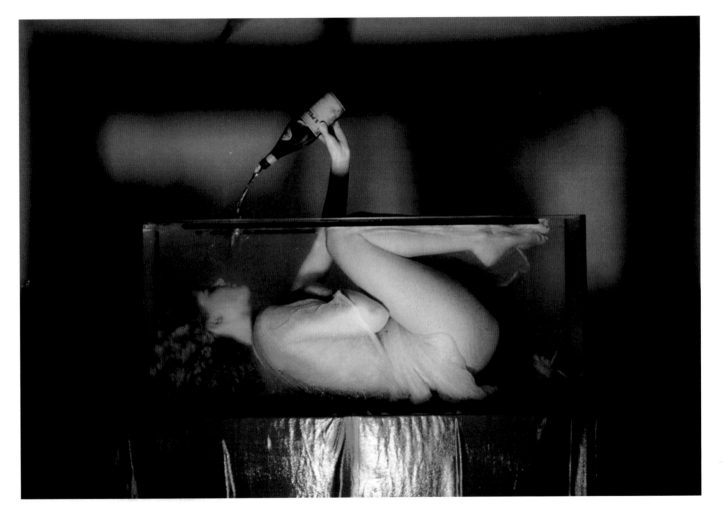

Bryce Bennett

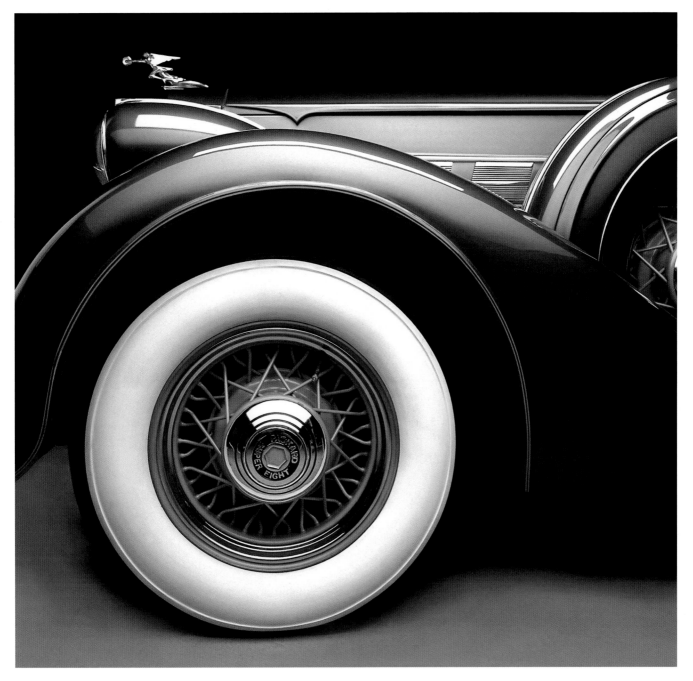

Paul Sinkler

Sports

David Emmite

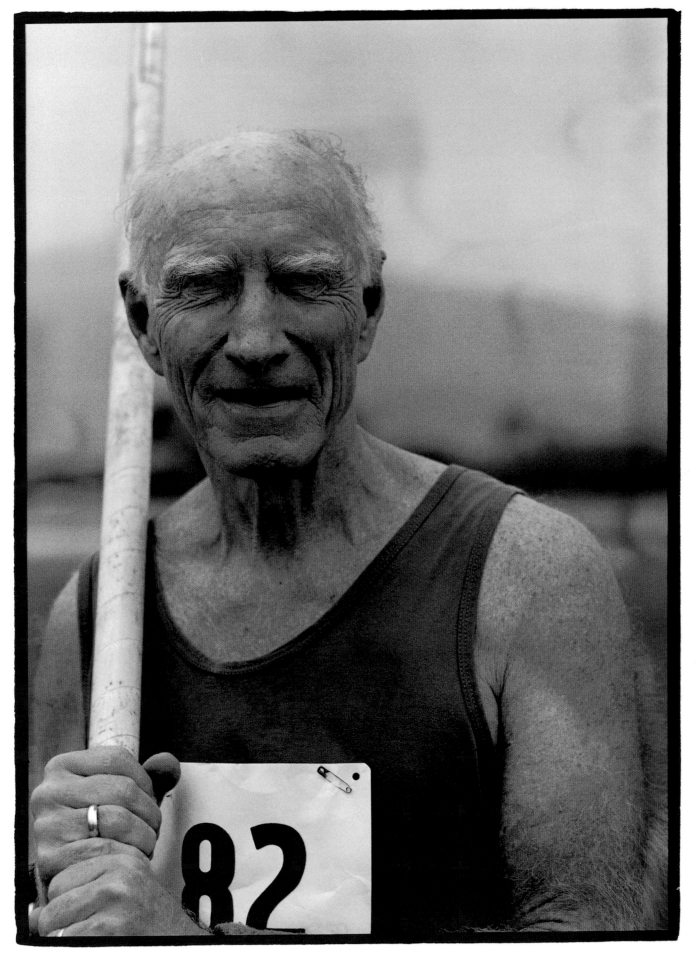

Marshall Harrington

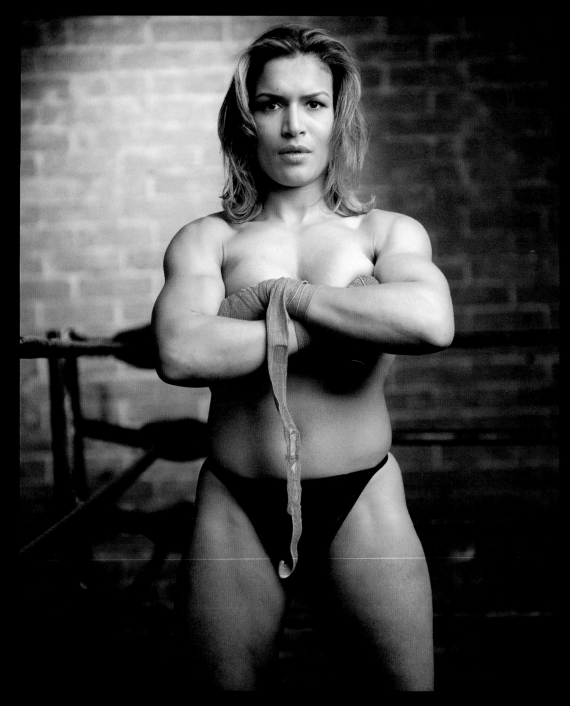

Mark Seliger

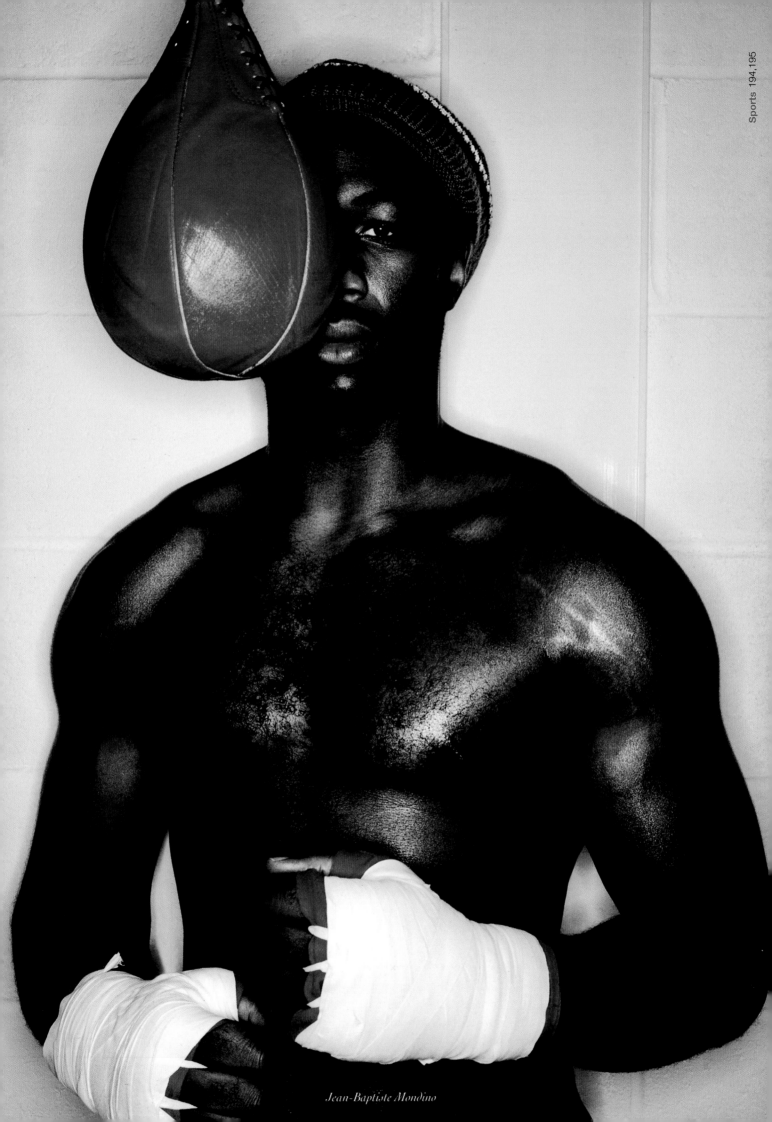

Jean-Baptiste Mondino

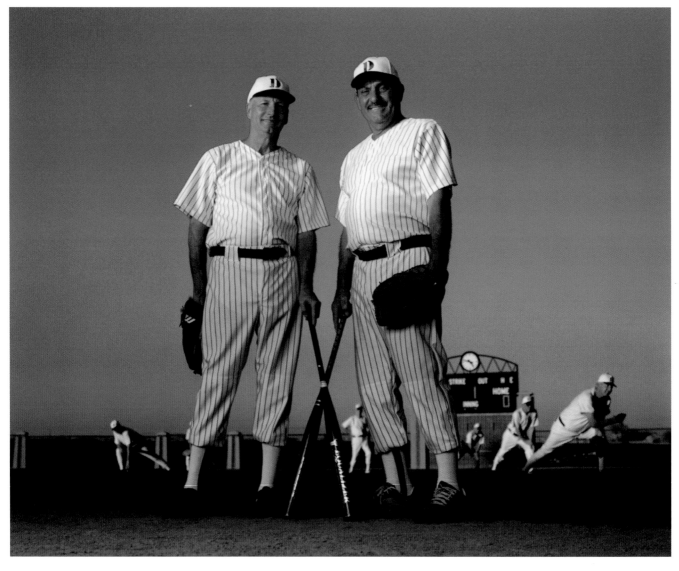

James Salzano

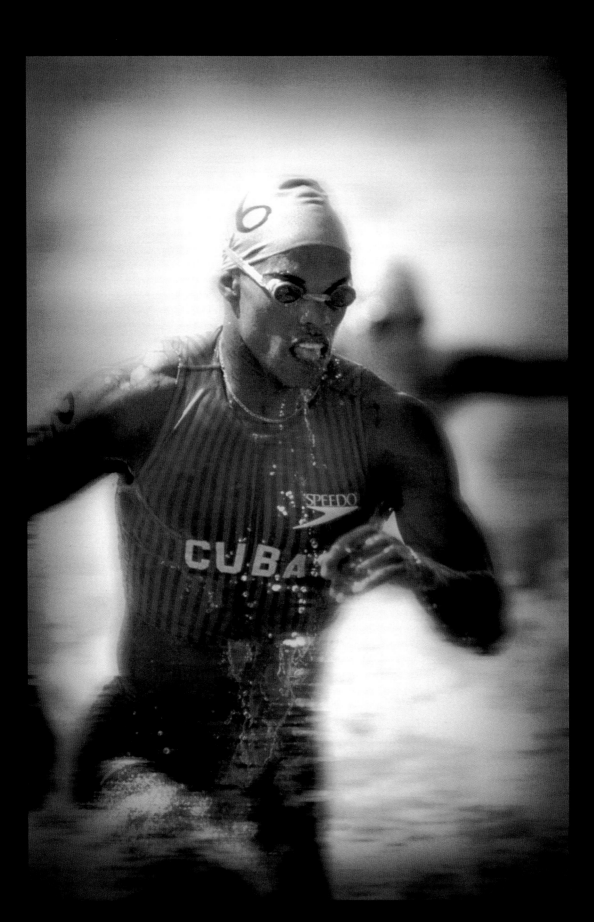

Chris Gordaneer

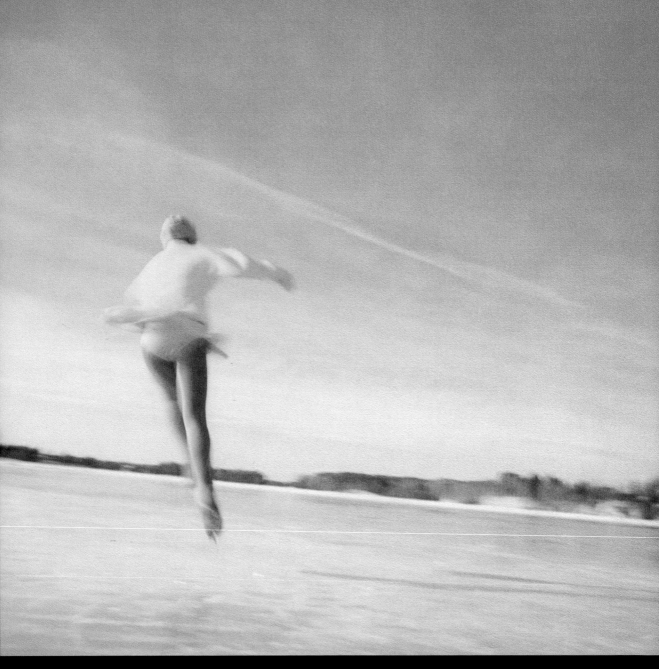

Markku Lahdesmaki

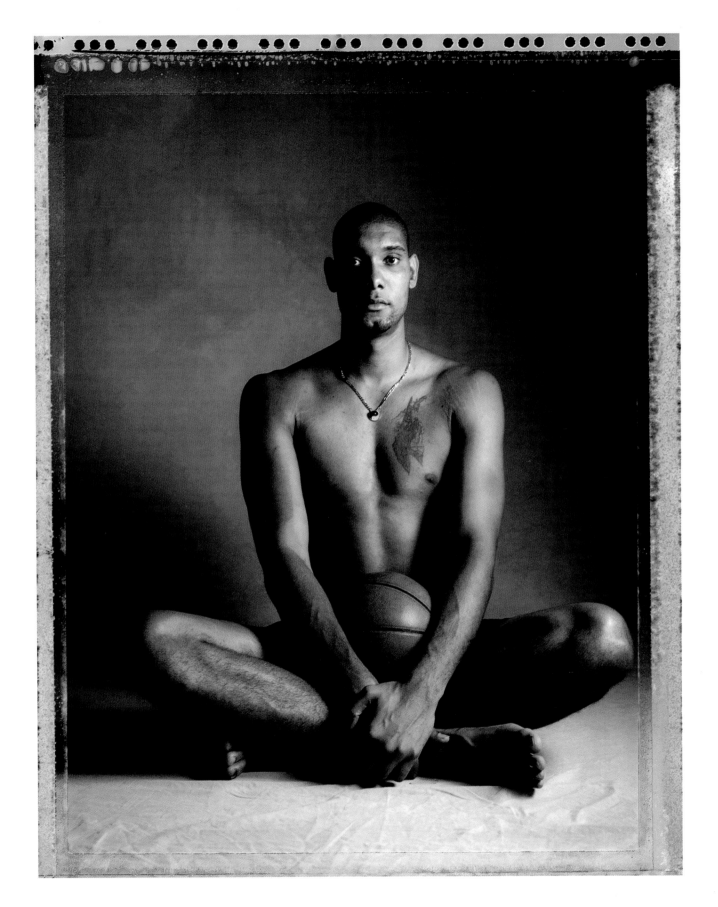

Michael O'Brien

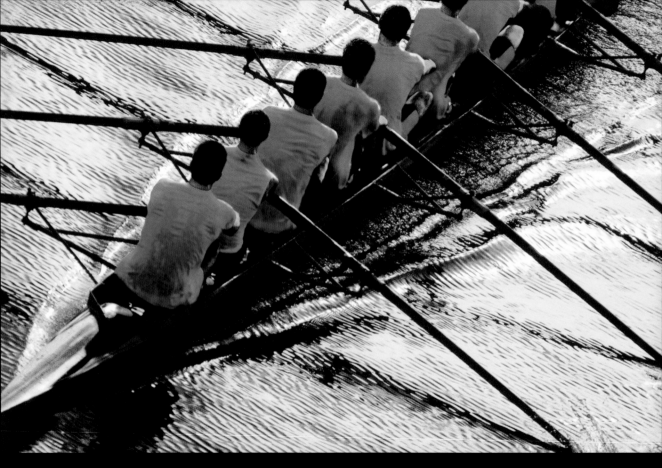

Greg Pease

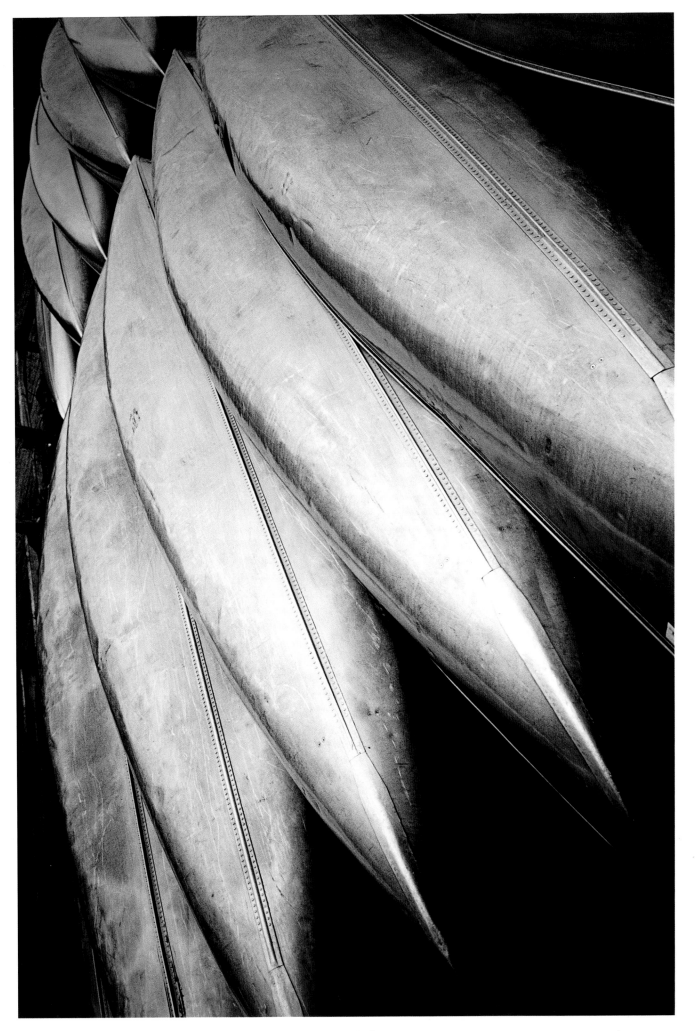

Craig Cutler

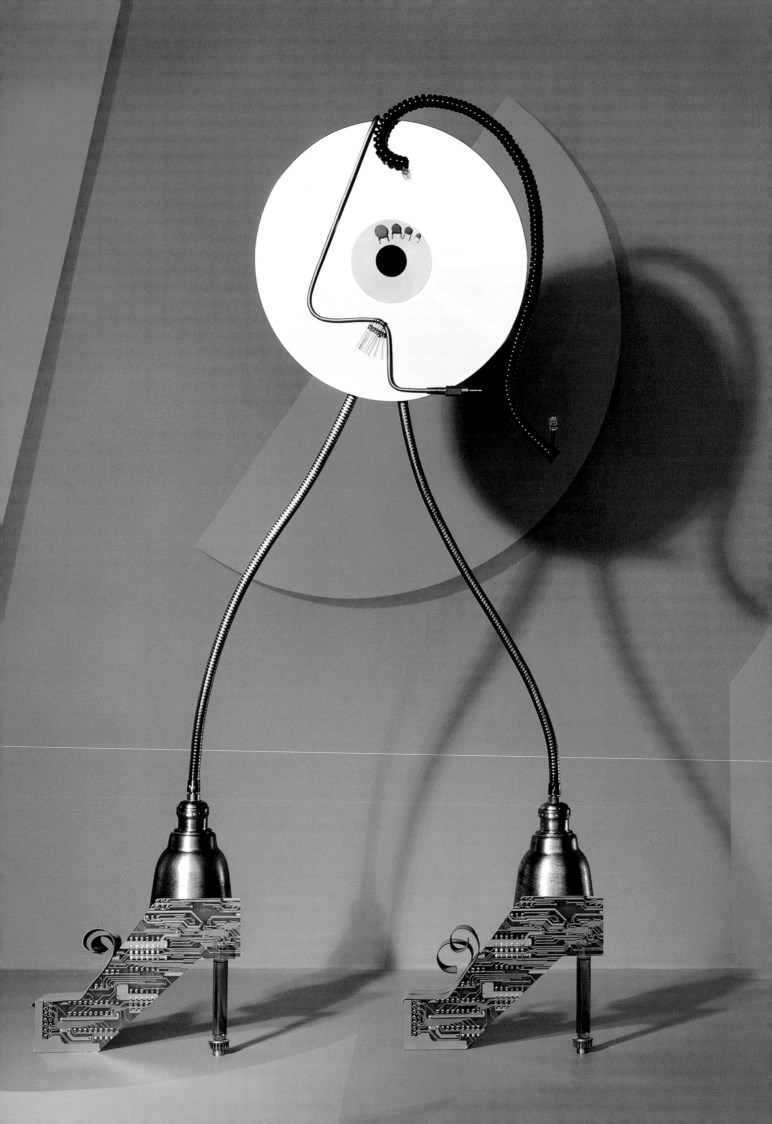

Still Life

Hugh Kretschmer

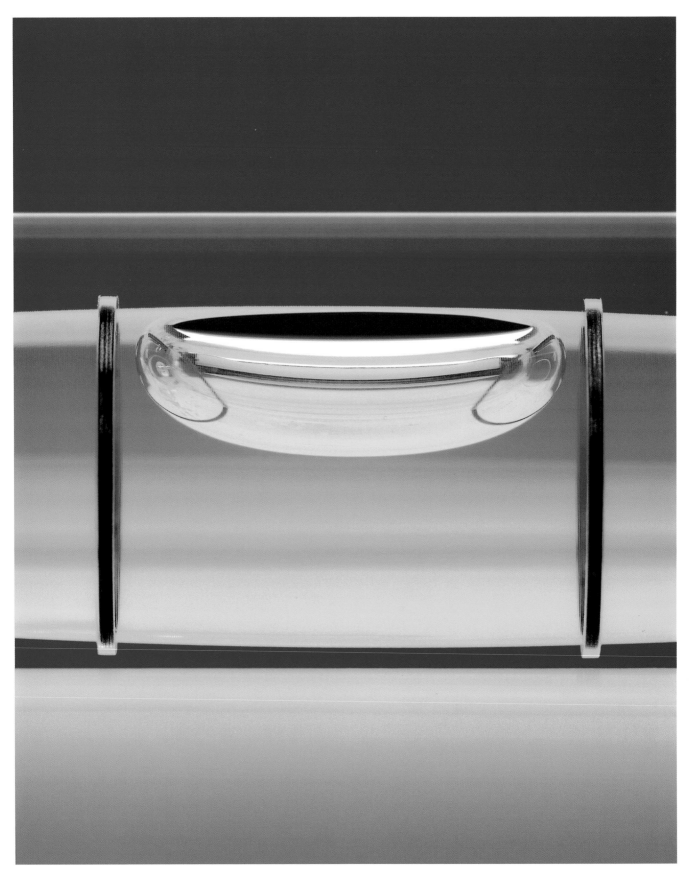

(This spread) Daniel Naylor

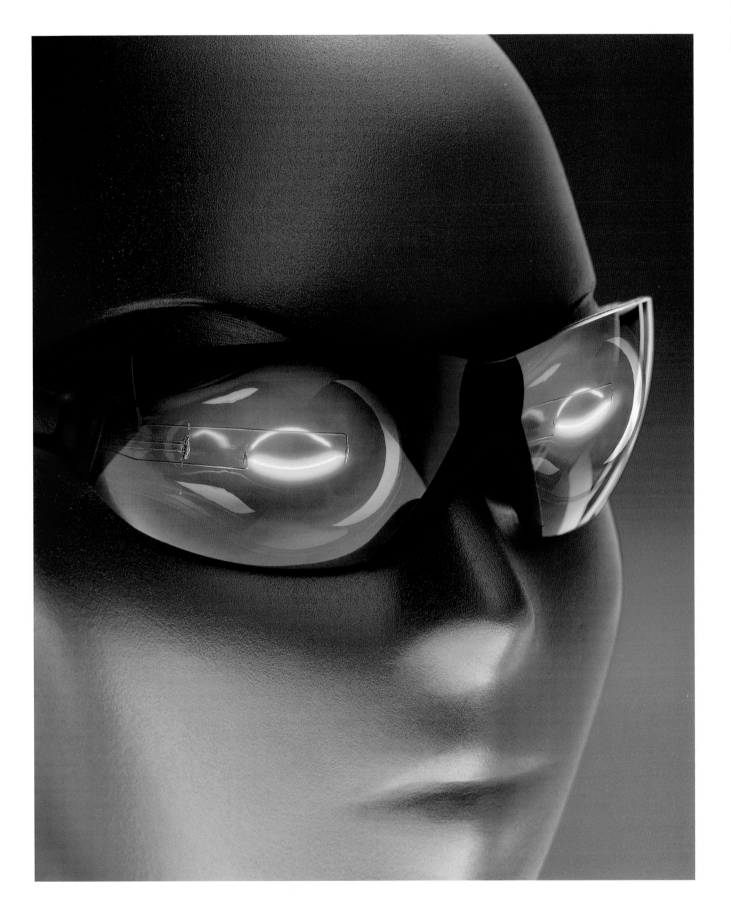

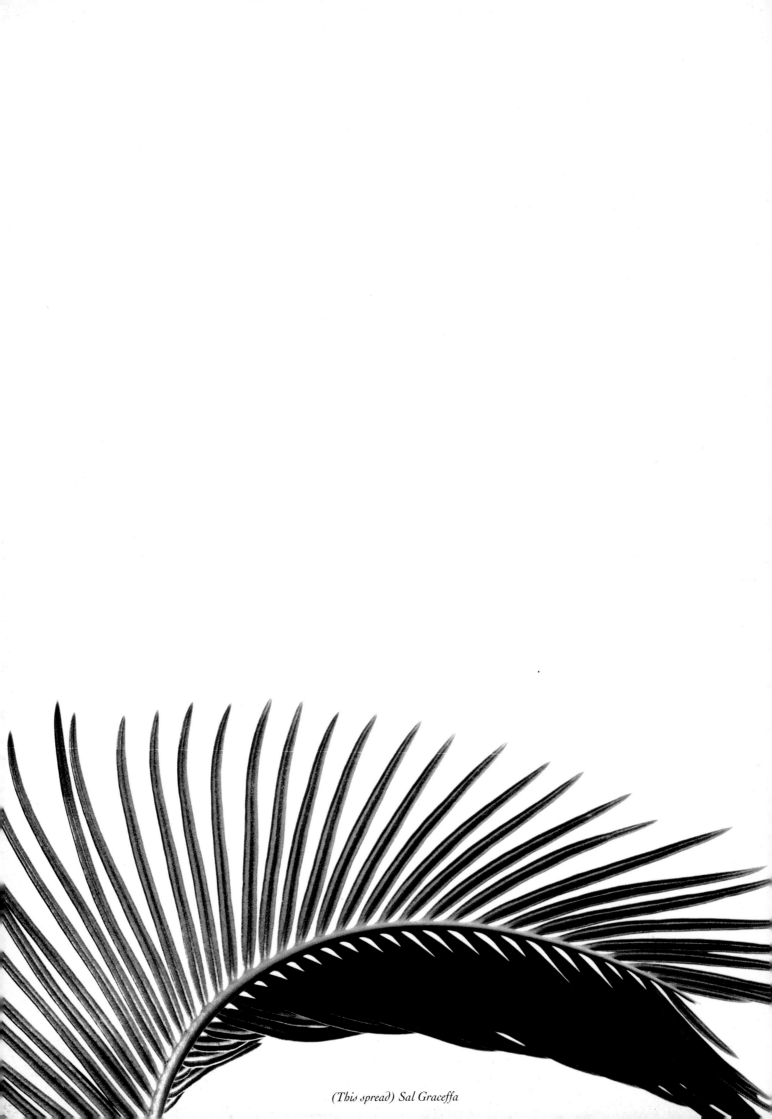

(This spread) Sal Graceffa

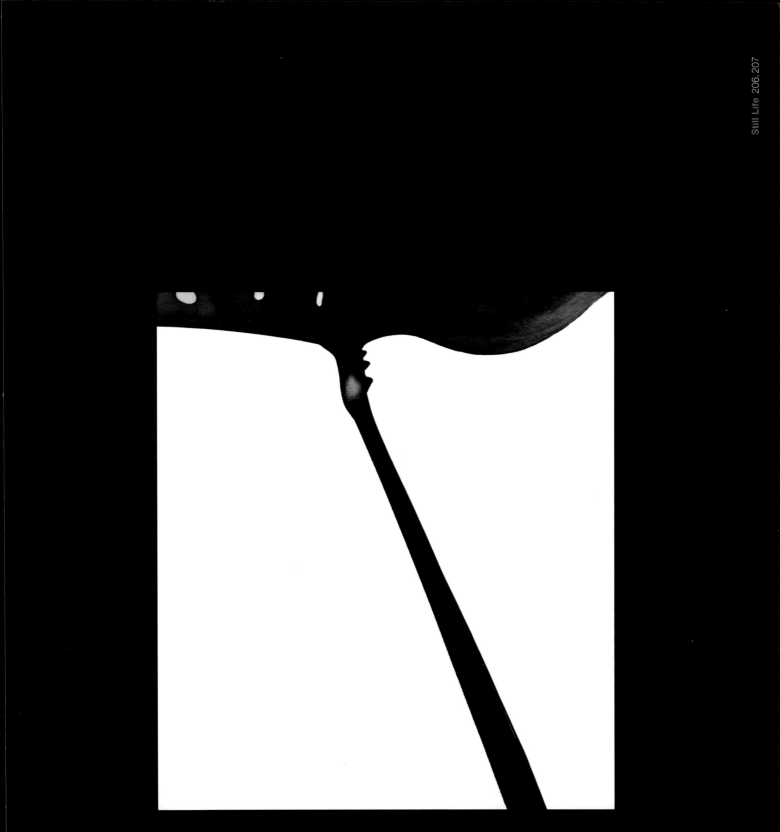

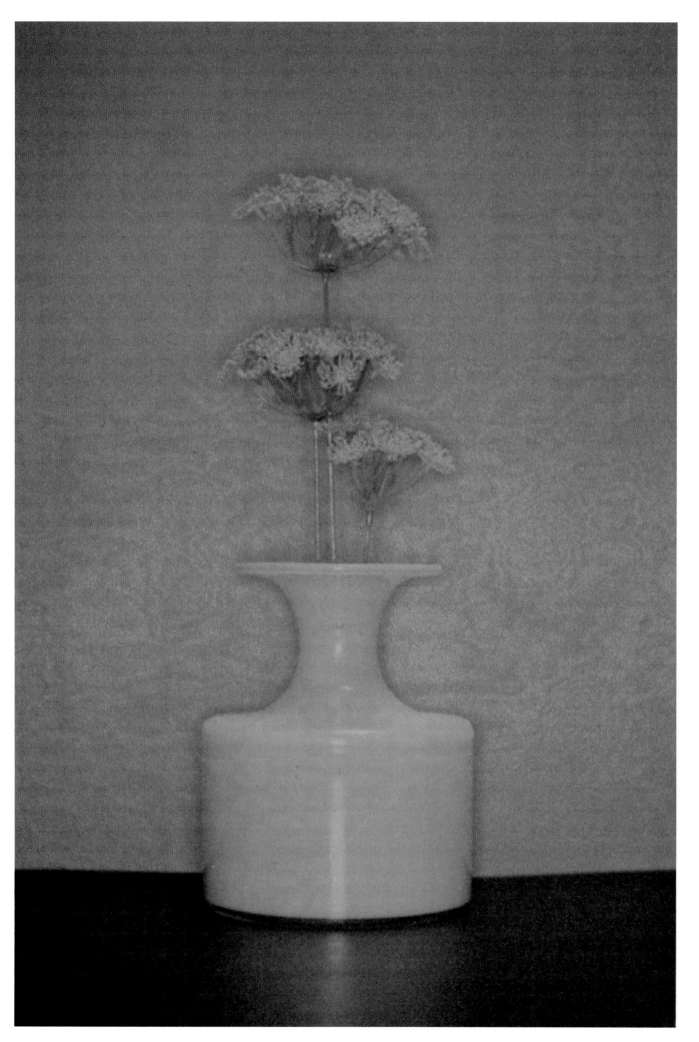

Melvin Lee

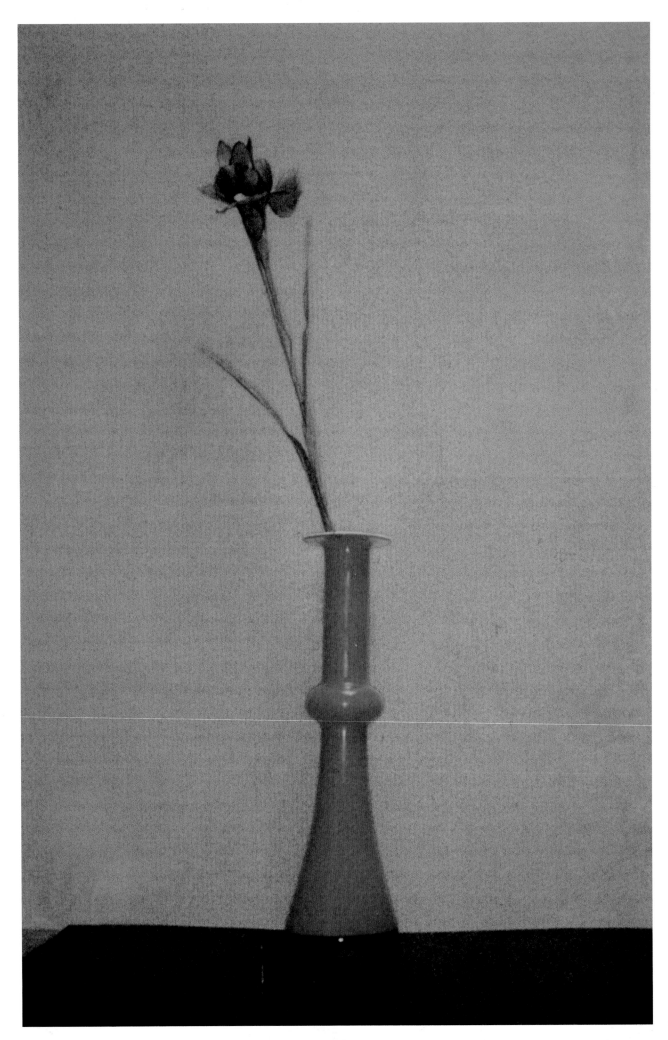

Melvin Lee

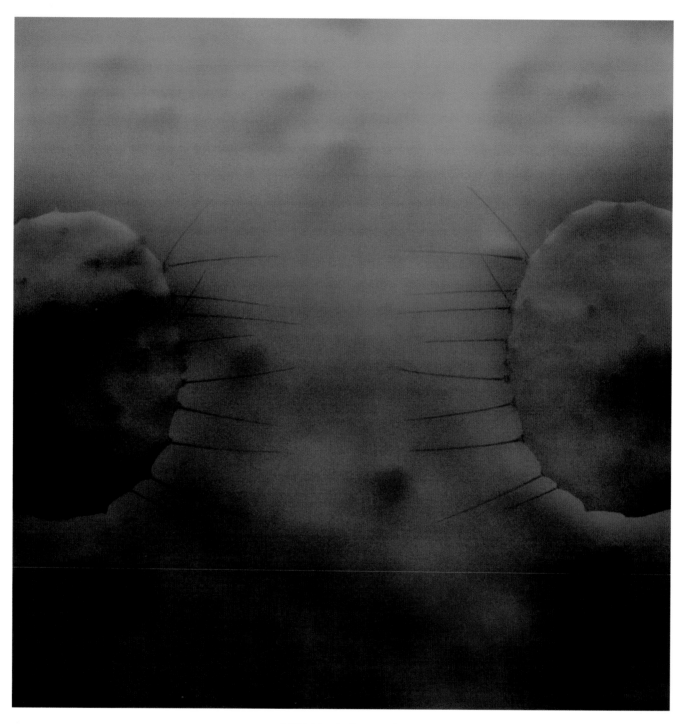

OSE Huit 10 Photography

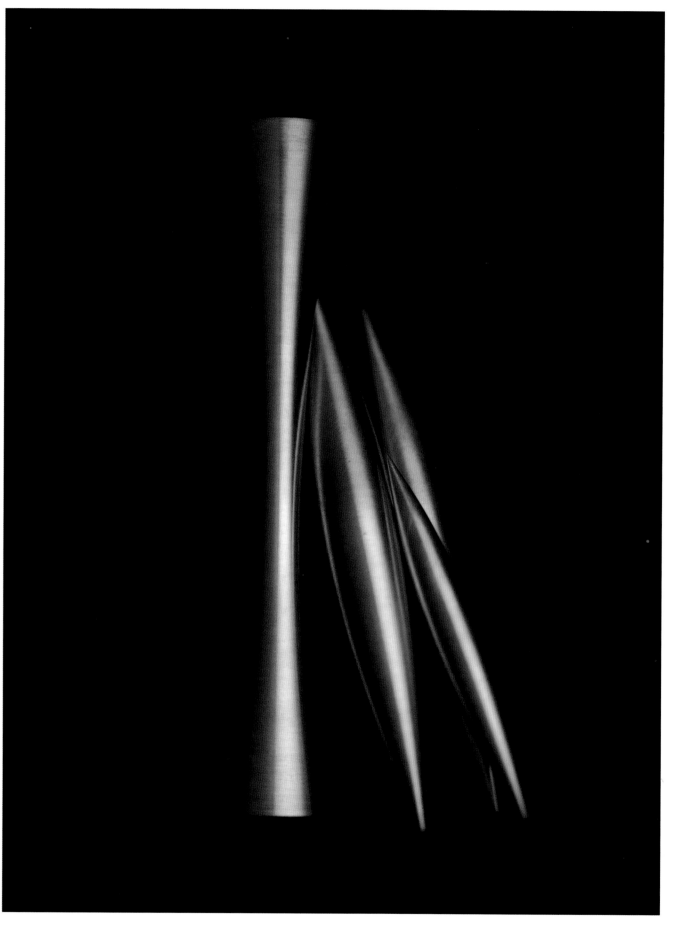

Mark Laita

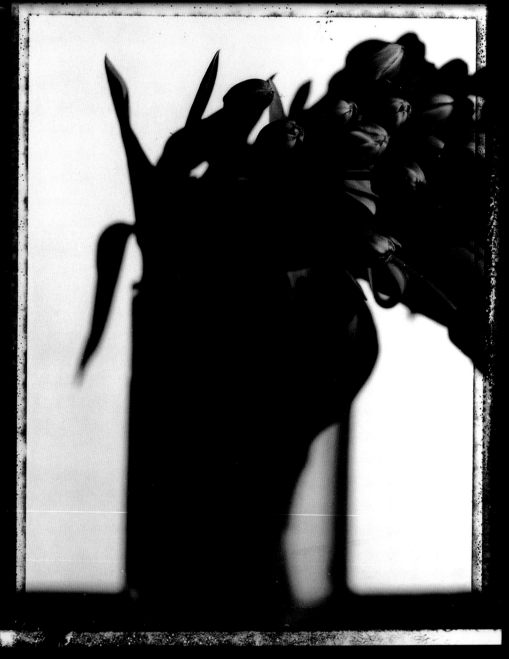

Jeffrey Apoian

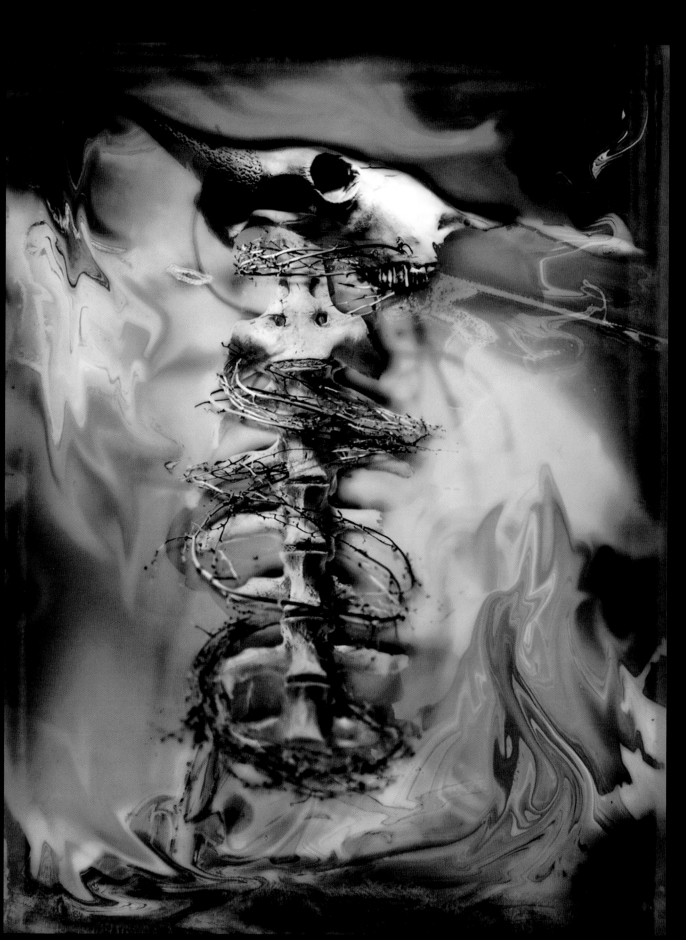

Scott D. Hamilton

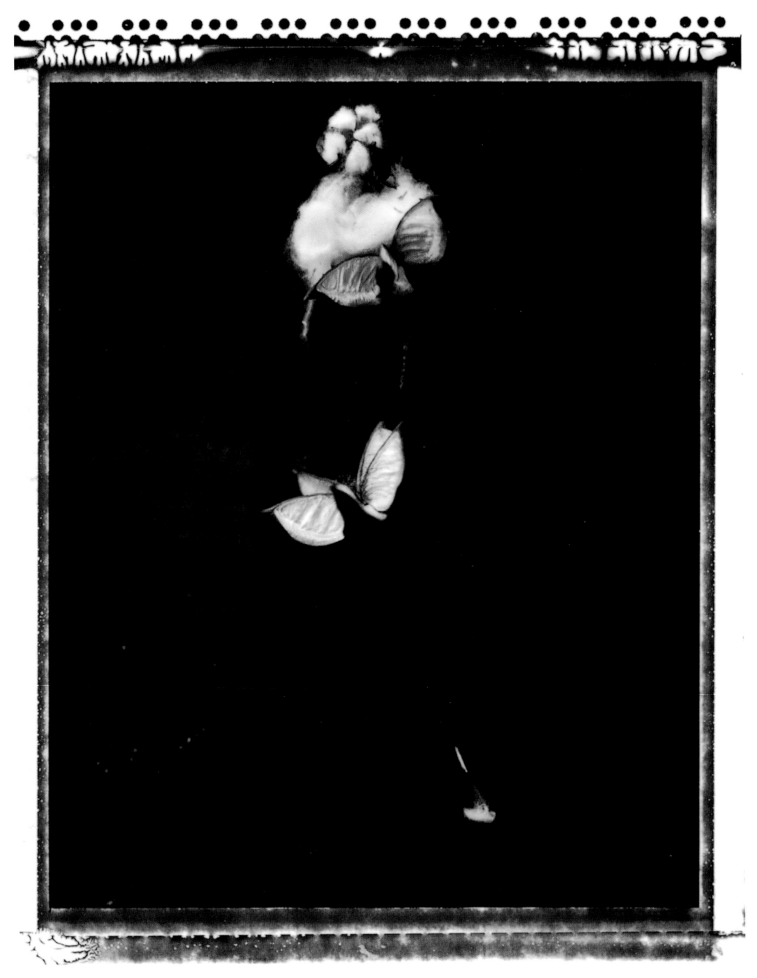

Fernando Ceja

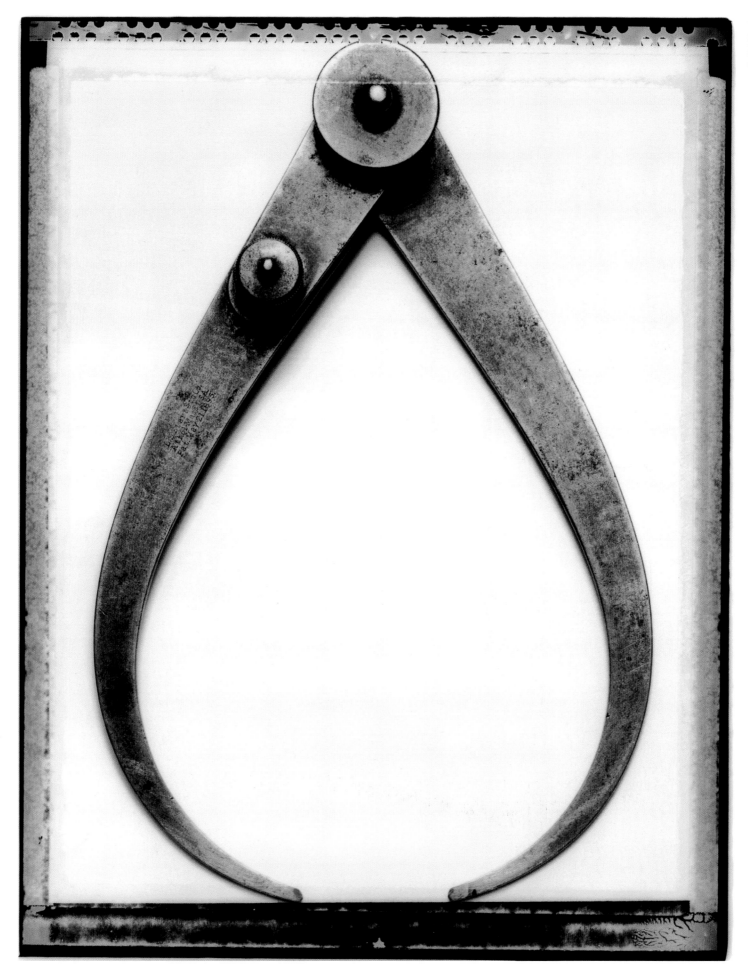

Alex Bee

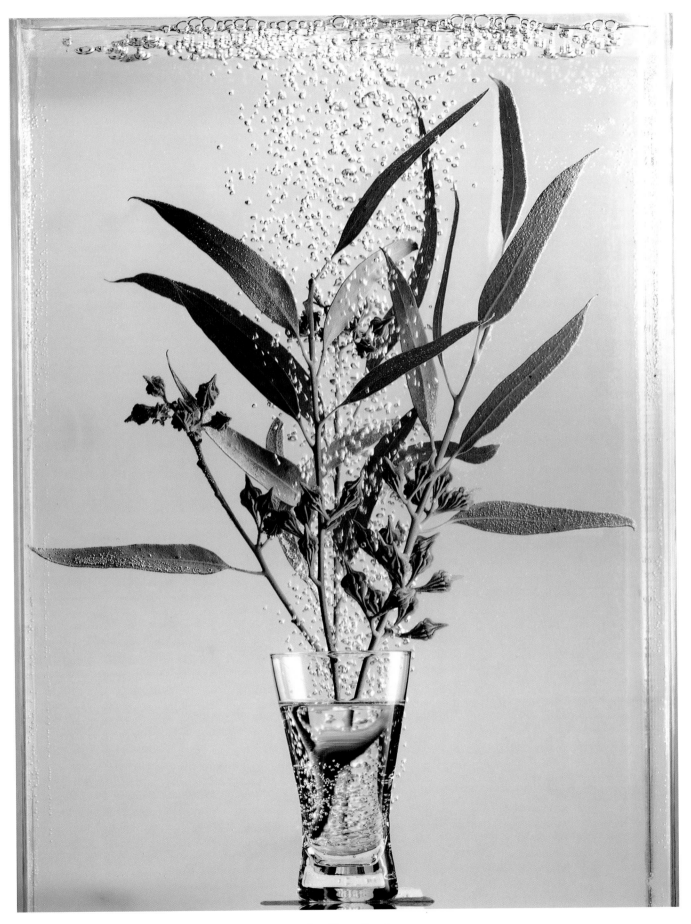

Staudinger Franke

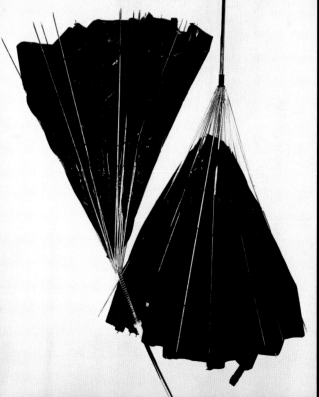

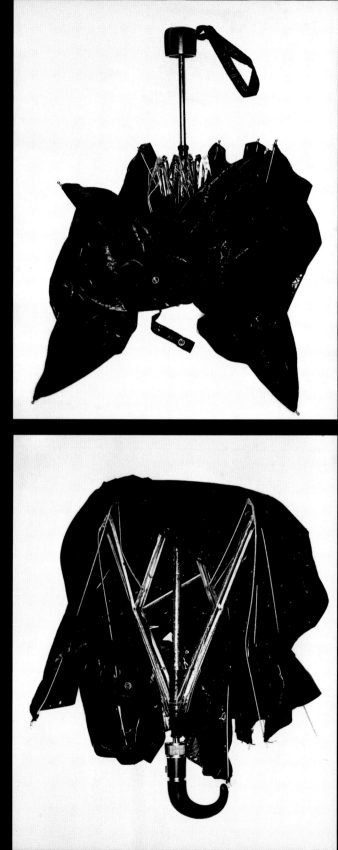

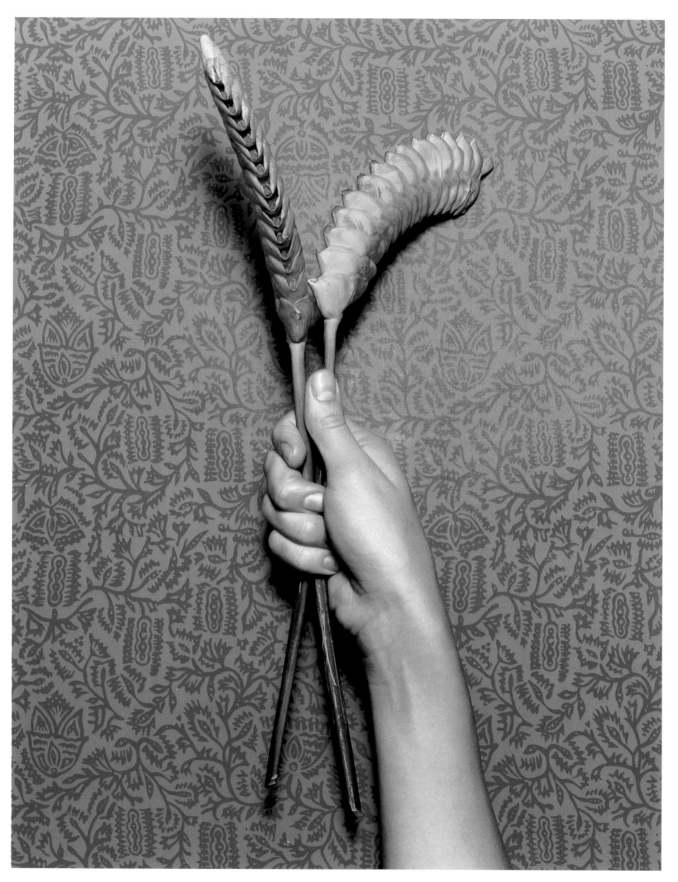

Craig Cutler

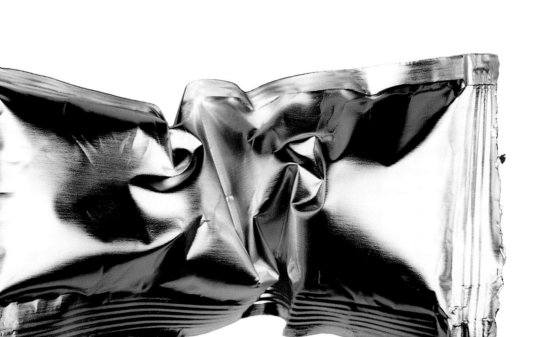

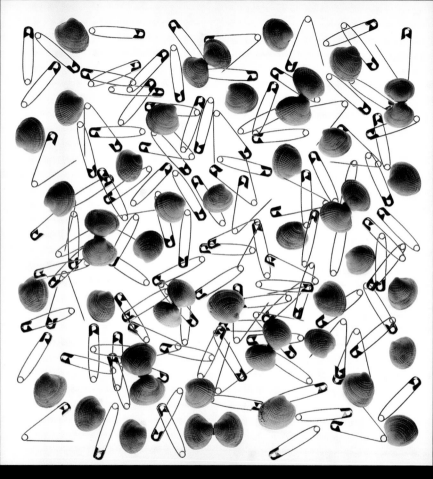

Craig Cutler

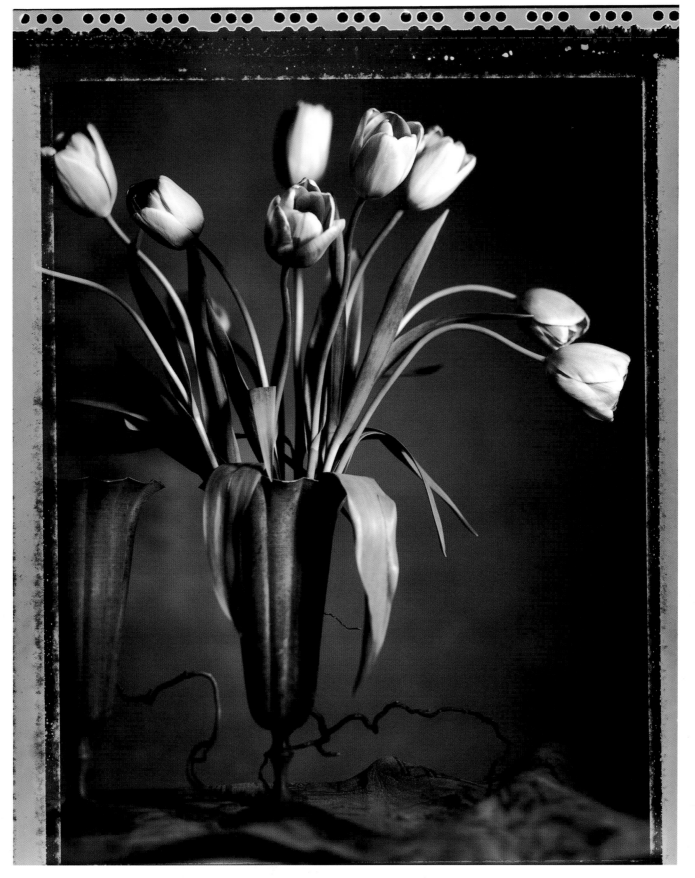

Rosanne Olson

Craig Cutler

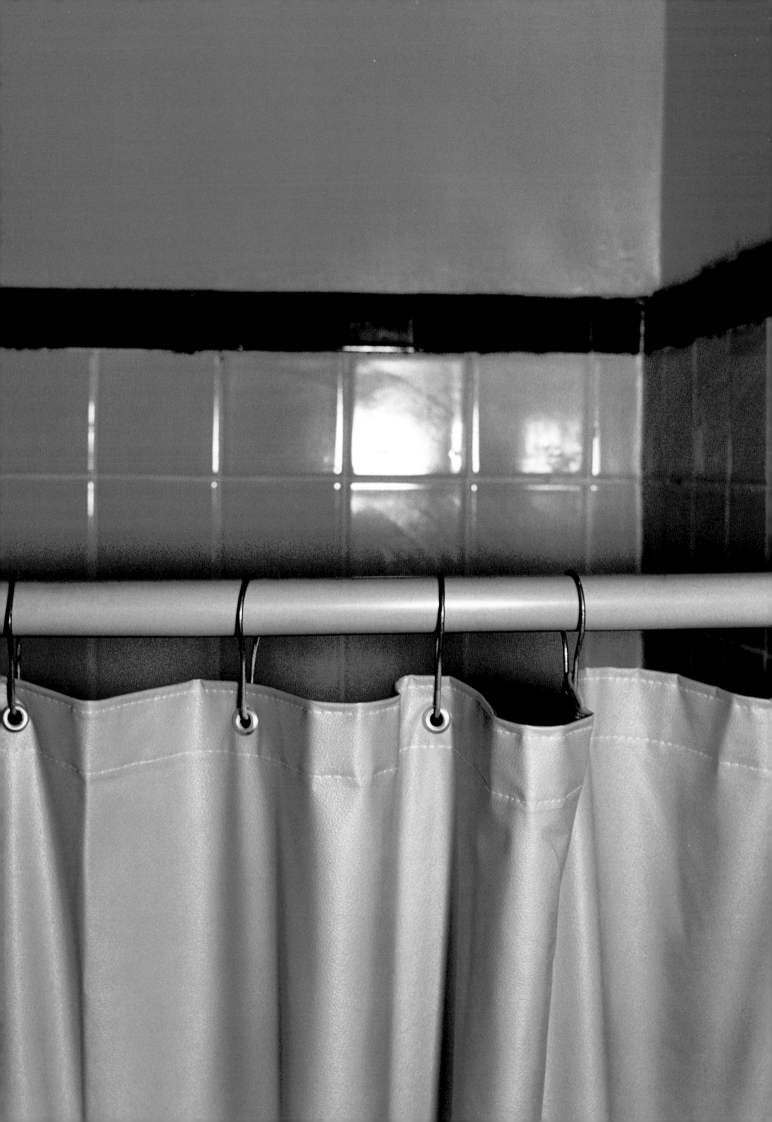

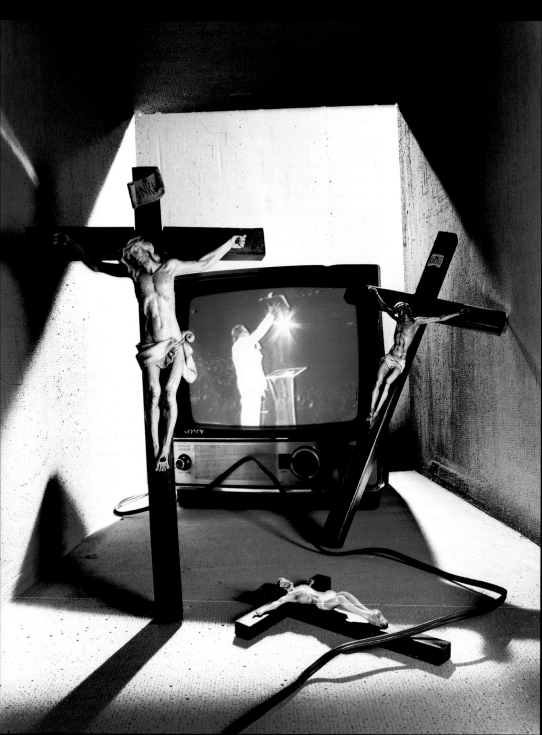

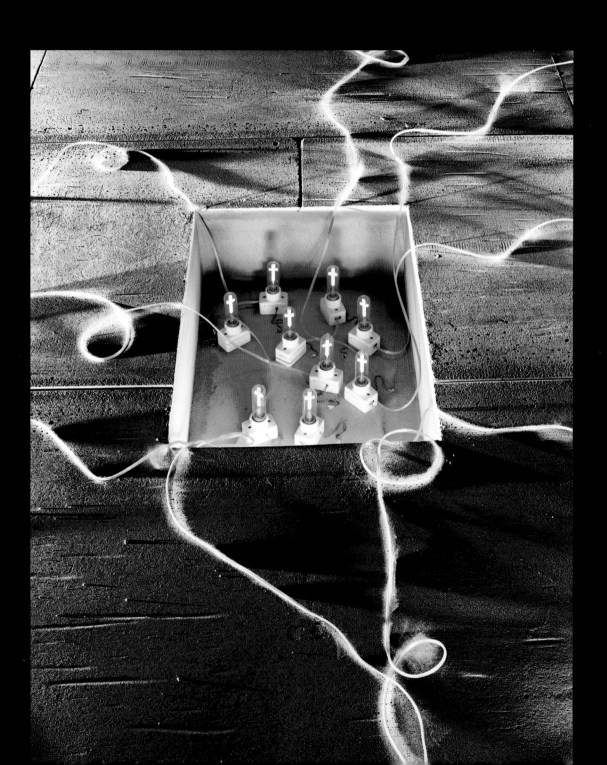

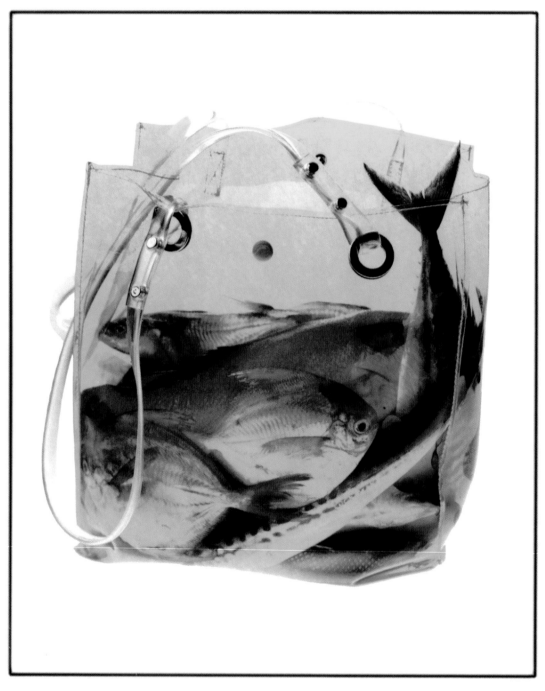

(This page) Joshua Dalsimer (Opposite page) James Worrell

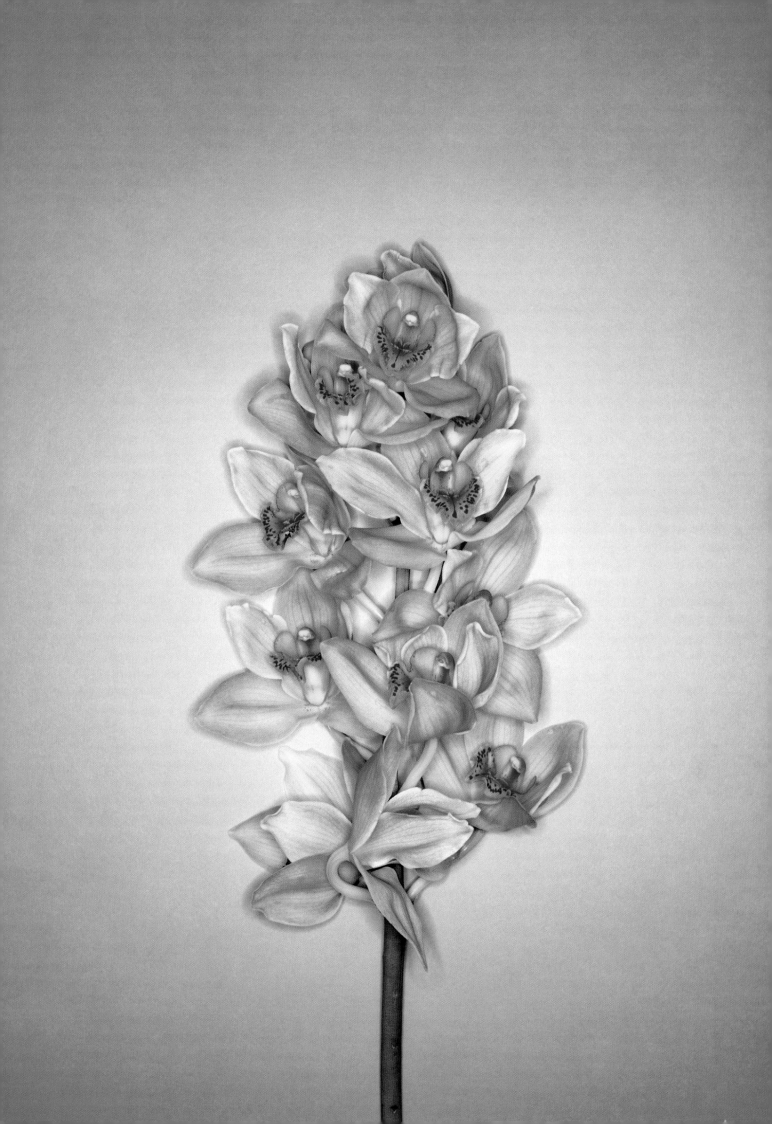

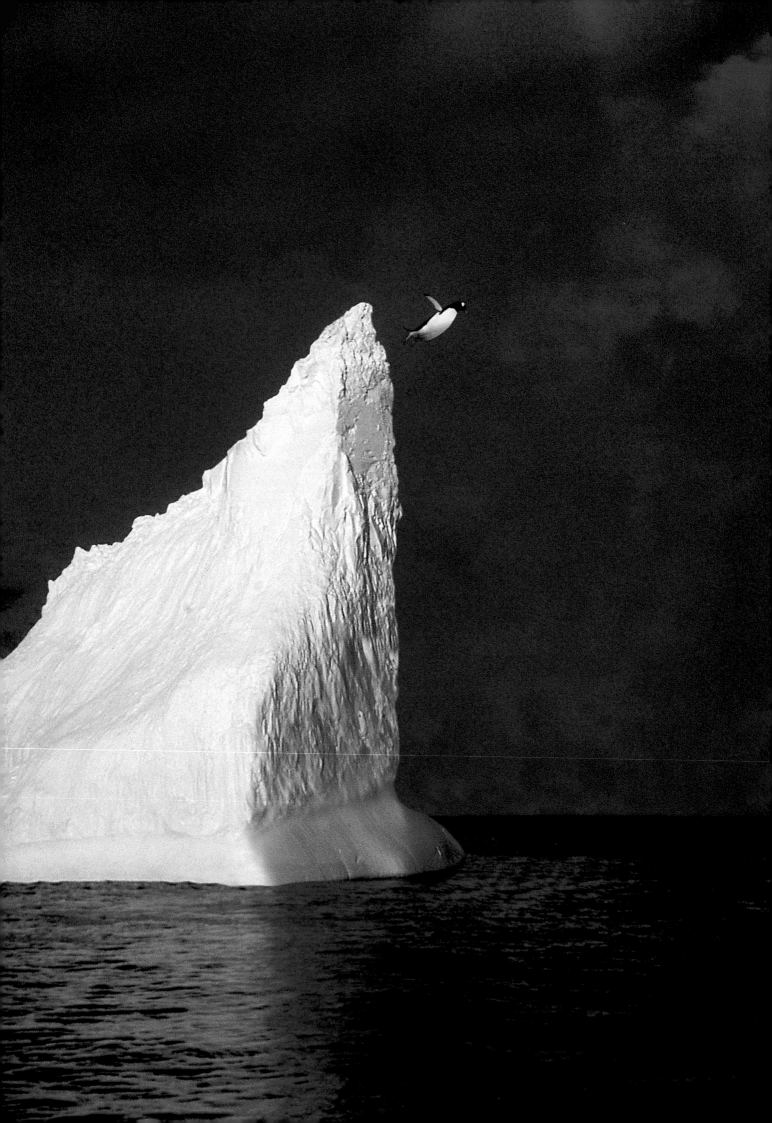

Wildlife

Randy Wells

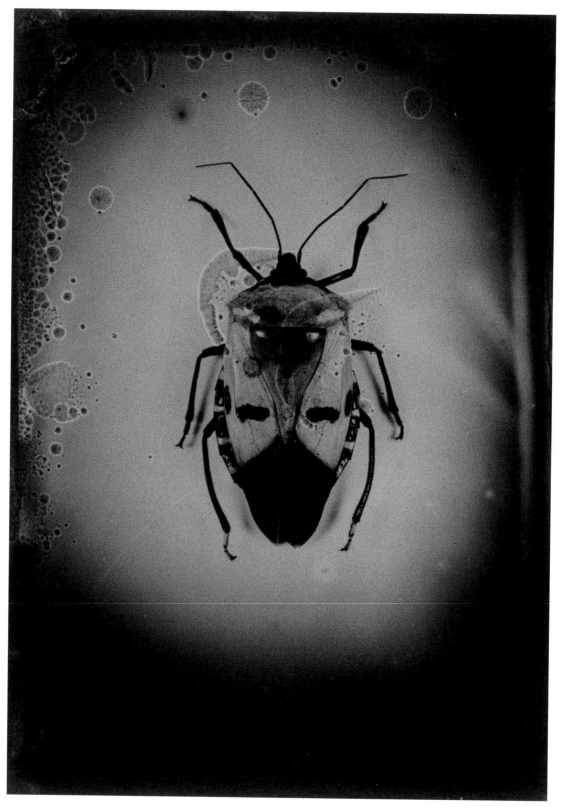

(This spread) Jayne Hinds Bidaut

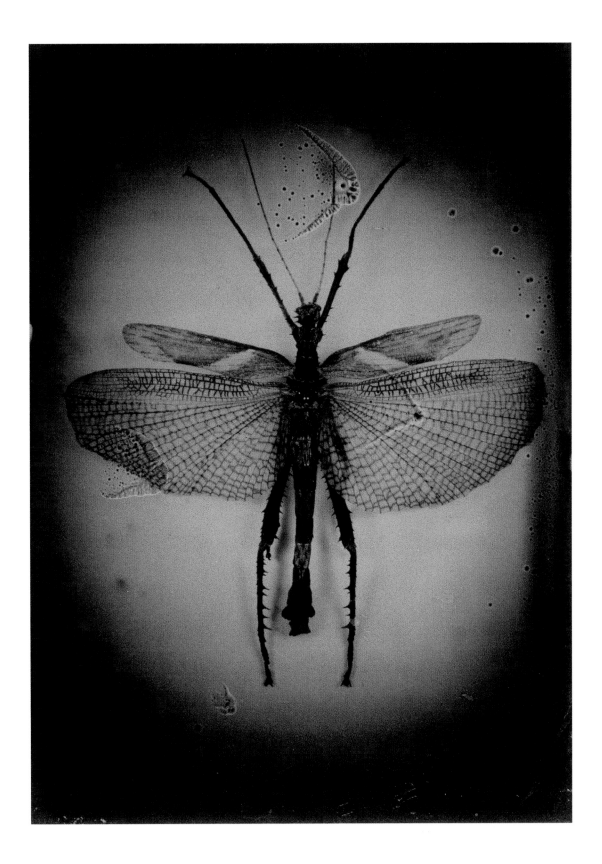

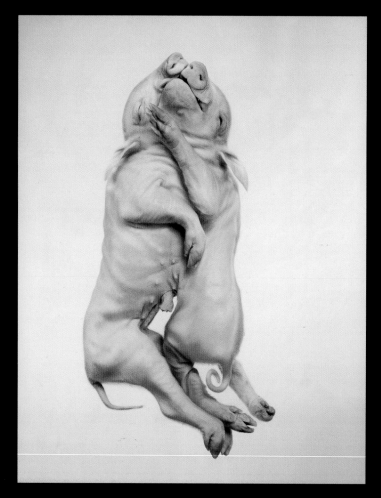

Peter Dazeley

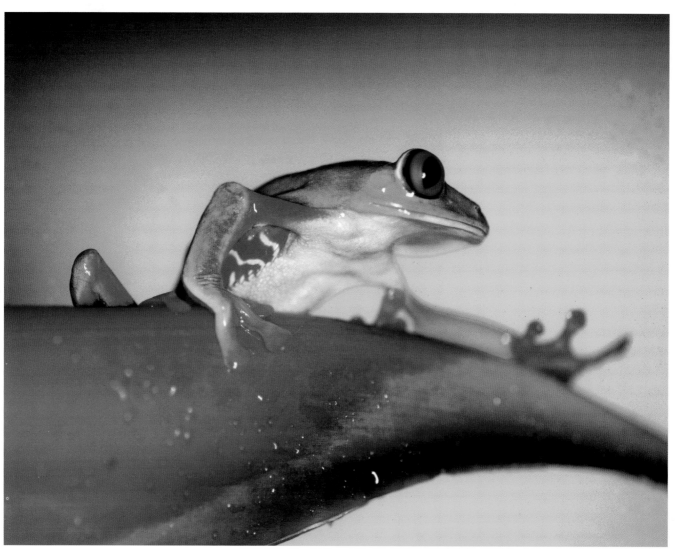

Tak Kojima

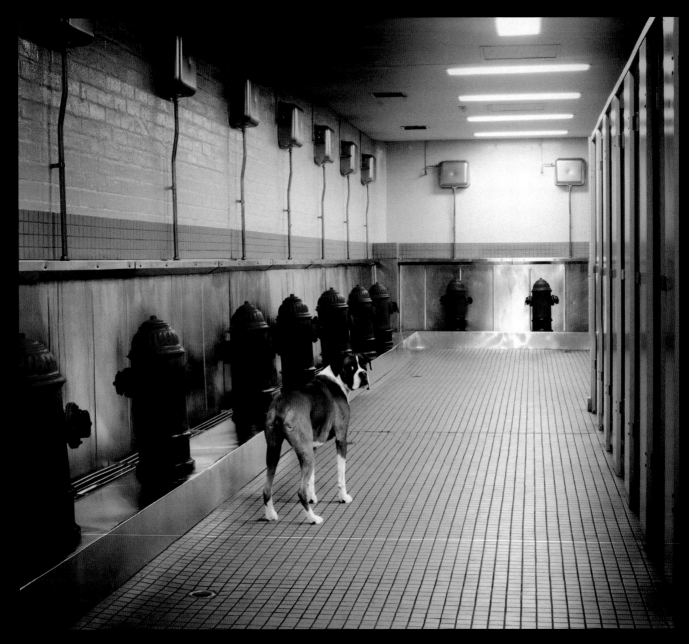

Michael Corridore

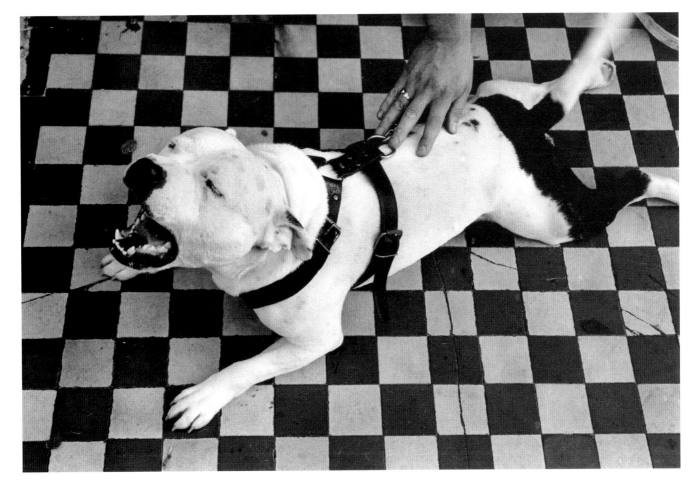

Mike Carsley

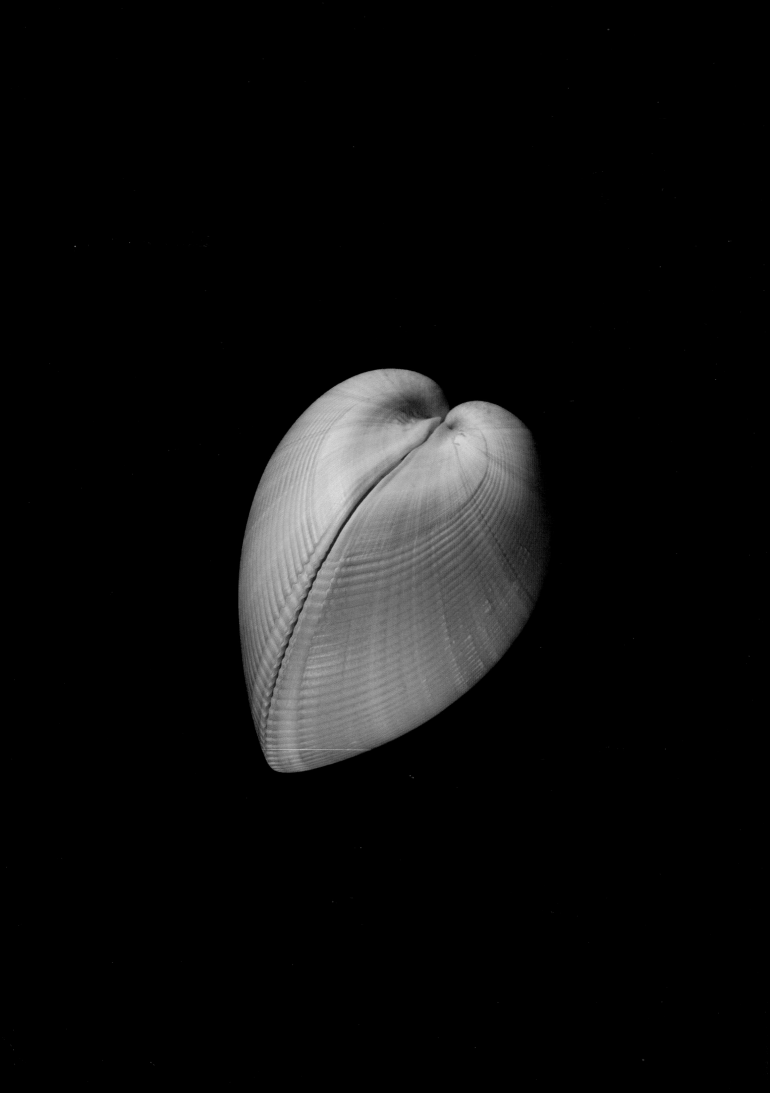

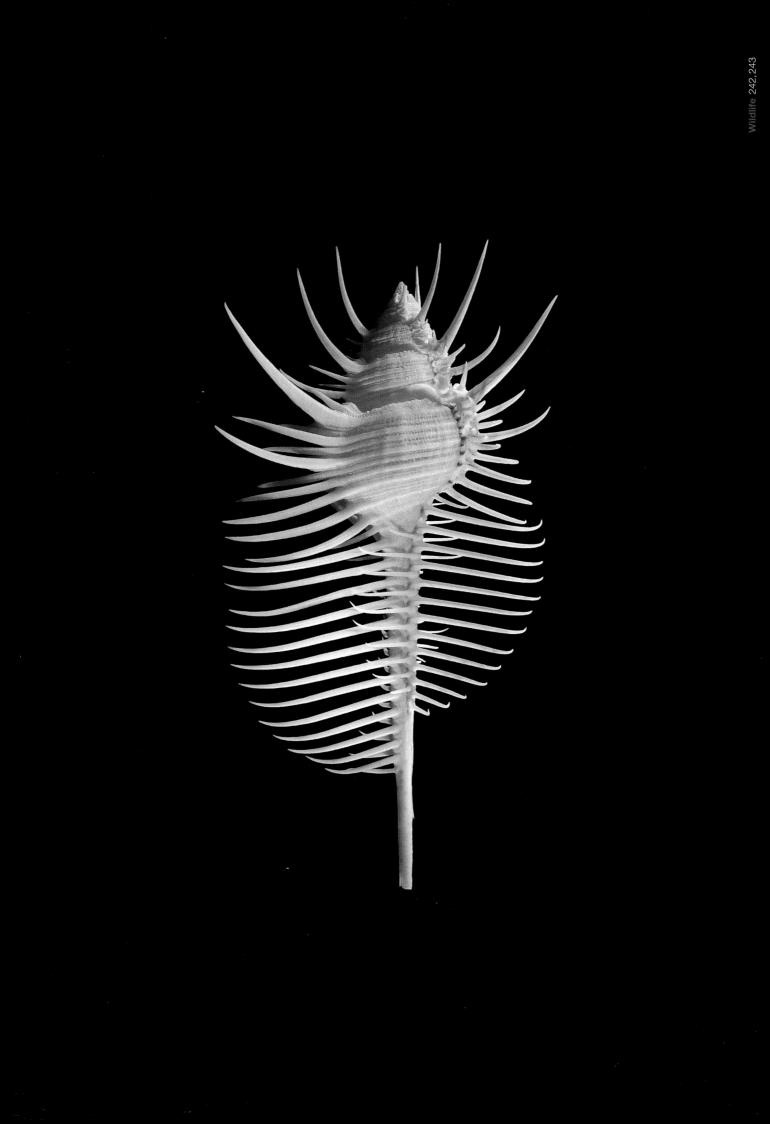

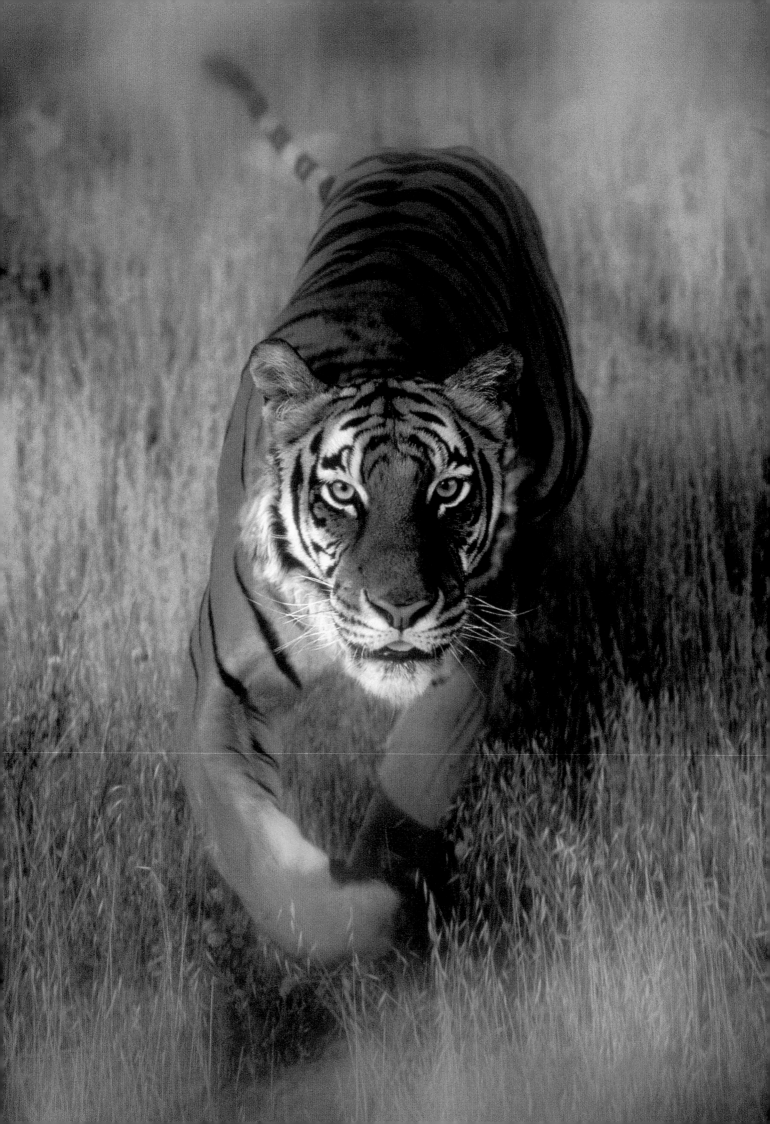

Randy Wells

Page 14
Photographer: Andrea Wells
Studio: Andrea Wells Photography
Camera: Leica R6 / Film: Fuji Velvia

Page 16
Photographer: Melvin Lee
Studio: Barney Studio BC Sdn Bhd

Page 17-18
Photographer: Craig Cutler
Studio: Craig Cutler Studio

Page 19
Photographer: Eugene Zakusilo
Studio: Eugene Zakusilo Photography
Camera: Horizon 202 / Film: Ilford HP-5 plus

Page 20-21
Photographer: Mike Seidl
Studio: Michael Seidl Photgraphy
Camera: Nikon F3 / Film: Fuji Velvia

Page 22-23
Photographer: Jon Shireman
Studio: Craig Cutler Studio

Page 24-25
Photographer: Craig Cutler
Studio: Craig Cutler Studio

Page 26
Photographer: James Worrell
Creative Directors:
Lori Ende, Michelle McDonald
Studio: James Worrell Photography
Camera: 4x5 Toyo G / Film: Fuji RDP II
Publisher: Funcuvm, Inc.

Page 28
Photographer: Joshua Dalsimer
Studio: Dalsimer Photography

Page 29
Photographer: Ron Baxter Smith
Studio: Ron Baxter Smith Photographer Ltd.
Camera: Hasselblad Elm / Film: Kodak Tri-X

Page 30-31
Photographer: Axel Hoedt
Camera: Sinar 4x5 / Film: Paper VC

Page 32-33
Photographer: Sanjay Kothari

Page 34
Photographer: Hans Neleman

Page 35
Photographer: Laetitia Negre
Studio: Tower View House
Camera: Sinar 4x5 / Film: Astia/Fuji

Page 37
Photographer: Hans Neleman

Page 38-39
Photographer: Timothy W. Hogan
Creative Director: James Hill
Photo Editor: Corey Chestnut
Camera: Horseman 450 / Film: Tri-X
Publisher: *Vertigo Magazine*

Page 40-41
Photographer: Mario De Lopez
Creative Director: Ricardo Chiu
Publisher: *Pub* magazine / Title: "Rojo/Negro"

Page 42
Photographer: Howard Schatz
Studio: Schatz/Ornstein

Page 43
Photographer: Howard Schatz
Studio: Schatz/Ornstein Studio
Publisher: Harper Collins
Comments: From the book *Nude Body Nude*
Kommentar: Aus dem Buch *Nude Body Nude*.
Commentaire: Tiré de l'ouvrage *Nude Body Nude*.

Page 44-45
Photographer: Parish Kohanim
Camera: Rollie Flex 6008 / Film: AFGA 100

Page 46
Photographer: Staudinger Franke
Camera: Sinar / Film: Kodak EPP

Page 47
Photographer: John Eder
Creative Director: Wanda Decca
Photo Editor: Raven Kaufmann
Publisher: *Glue* magazine

Page 48
Photographer: Dominique Thibodeau
Studio: at.47
Camera: Linhof / Film: Polaroid

Page 49
Photographer: David Stewart
Creative Director: Mark Reddy
Camera: Sinar 4x5 / Film: Kodak portra 400 NC
Client: Heal's

Page 50
Photographer: Michael Thompson
Publisher: *New York Times Magazine*

Page 51
Photographer: Sanjay Kothari
Creative Director: Robert Cristofaro
Publisher: Sportwear International

Page 52
Photographer: Leon Steele
Creative Director: Andy Kelleher
Camera: Sinar 4x5 / Client: Sainsbury's

Page 55
Photographer: Lisa DeCesare
Camera: Sinar 4x5 / Film: 4x5 E100s

Page 56-57, 58
Photographer: Craig Cutler
Studio: Craig Cutler Studio

Page 59
Photographer: Carin Krasner
Photo Editor: Julia Flagg
Camera: Fuji 680 / Film: Kodak E 100S
Publisher: Chronicle Books

Page 60, 62-63
Photographer: Les Stone
Studio: Corbis-Sygma
Camera: Canon EOS-1N
Film: Fuji RDP 100ES9
Comments: Legacy of Vietnam War Agent Orange victims, showing the long-lasting effects of dioxin 25 years after the war.
Kommentar: Opfer des Einsatzes von Agent Orange im Vietnamkrieg. Die Langzeitschäden des Dioxins machen sich auch 25 Jahre danach noch bemerkbar.
Commentaire: Victimes du gaz orange durant la guerre du Vietnam illustrant les effets à long terme de la dioxine, 25 ans après le conflit.

Page 64-65
Photographer: Terry Vine
Studio: Terry Vine Photography
Camera: Fuji GX 683 / Film: Kodak T-Max 400
Comments: Personal project documenting the life and traditions of the town of San Miguel de Allende, Mexico.
Kommentar: Dokumentation des Lebens und der Traditionen in der Stadt San Miguel de Allende, Mexiko.
Commentaire: Projet personnel, documentant la vie et les traditions de la ville de San Miguel de Allende au Mexique.
Title: "La Vida Tradicional"

Page 66
Photographer: Gary Harwood
Client: Kent State University
Comments: Marching band students wait for fog
to clear before picture day.
Kommentar: Wegen des anstehenden Phototer-
mins warten Studenten - Mitglieder der
Marschkapelle ihrer Universität - darauf, dass
der Nebel sich lichtet.
Commentaire: Clique d'étudiants attendant que
le brouillard se lève avant la prise de vue an-
nuelle.

Page 67
Photographer: Randy Wells
Studio: Randy Wells Photography
Camera: Canon EOS-1N / Film: Kodak E100
Comments: Masai Warriors, Kenya.
Kommentar: Masai-Krieger, Kenia.
Commentaire: Guerriers Masaï au Kenya.

Page 68
Photographer: Rachel Cobb
Photo Editor: Kathy Ryan
Camera: Leica M6 / Film: Tri-X
Publisher: *New York Times Magazine*
Comments: Kosovo liberation army soldier
asleep in his new home taken over from a Serb
who fled.
Kommentar: Soldat der Befreiungsarmee des
Kosovo schlafend in seinem neuen Haus, aus
dem der vorherige Besitzer, ein Serbe,
geflohen ist.
Commentaire: Soldat de l'armée de libération
du Kosovo, endormi dans la maison réquisition-
née d'un Serbe en fuite.

Page 69
Photographer: Victor C. Salvo
Camera: Mamiya C330 / Film: Kodak TX
Publisher: *The Cape Paper*
Comments: Right whale struck by a ship. Cape
Cod, Massachusetts.
Kommentar: Von einem Schiff gerammter
Bartenwal. Cape Cod, Massachusetts.
Commentaire: Baleine heurtée par un bateau,
Cape Cod, Massachusetts.

Page 70
Photographer: Ludovic Moulin
Designer: Lily McCullough
Comments: From the book *Photo Poems*.
Kommentar: Aus dem Buch *Photo Poems*.
Commentaire: Tiré de l'ouvrage *Photo Poems*.

Page 73, 74-75
Photographer: Craig Cutler
Studio: Craig Cutler Studio

Page 76
Photographer: J. Styranka
Camera: Hasselblad / Film: Kodak T-Max 100

Page 77
Photographer: Craig Cutler
Studio: Craig Cutler Studio

Page 78-79
Photographer: Lloyd Ziff

Page 80
Photographer: Jan W. Faul
Studio: Faces 'n Places
Camera: Noblez 150U / Film: AGFA Pan 100

Page 81
Photographer: Douglas Walker
Creative Director: Brian Collinson
Client: Adidas

Page 82
Photographer: Victor C. Salvo
Camera: Mamiya C330 / Film: Kodak TX

Page 83
Photographer: Frank Herboldt
Studio: Holborn Studios

Page 84-85
Photographer: Michael Corridore
Camera: Mamiya 7 / Film: Vericolor PRN
Comments: From a series for solo exhibition.
Kommentar: Aus einer Reihe von Aufnahmen
für eine Einzelausstellung.
Commentaire: Tiré d'une série pour une exposi-
tion monographique.

Page 86
Photographer: Sean W. Hennessy
Studio: Sean W. Hennessy Photography
Camera: Nikon F3 / Film: Tri-X

Page 87
Photographer: Steven Edson
Camera: Nikon

Page 88
Photographer: Bernhard Quade
Studio: Bernhard Quade Photography

Page 90-91
Photographer: Hubertus Hamm
Title: "Jelly Fashion"

Page 92, 95
Photographer: Jayne Hinds Bidaut
Publisher: Graphis

Comments: From the book *Tintypes*.
Kommentar: Aus dem Buch *Tintypes*.
Commentaire: Tiré de l'ouvrage *Tintypes*.

Page 96
Photographer: Gonzalo Rufatt
Camera: RB67 / Film: Tri-X
Title: "Nymph"

Page 97
Photographer: Jim Erickson
Studio: Erickson Productions
Camera: Linhoff Technika / Film: Kodak PRN
Comments: From the book *Mother*.
Kommentar: Aus dem Buch *Mother*.
Commentaire: Tiré d'un ouvrage intitulé *Mother*.

Page 98
Photographer: Howard Schatz
Studio: Schatz/Ornstein Studio
Publisher: Harper Collins
Comments: From the book *Nude Body Nude*.
Kommentar: Aus dem Buch *Nude Body Nude*.
Commentaire: Tiré de l'ouvrage *Nude Body
Nude*.

Page 99
Photographer: Frank Wartenberg
Studio: Wartenberg Photography
Camera: Mamiya RZ / Film: AGFA Pan & APX

Page 100-101
Photographer: Nancy Sleeth
Camera: 4x5 Graflex / Film: Kodak T-Max 400

Page 102
Photographer: Martin Schoeller
Creative Director: Michael Kochman
Studio: Saba Press Photos
Publisher: *Entertainment Weekly*

Page 105
Photographer: OSE Huit 10 Photography
Camera: Sinar P2 / Film: 160 NC Portra
Title: "Hope"

Page 106
Photographer: Bob Carey
Studio: Bob Carey Photography
Camera: Kodak Plus X
Film: Kodak Polymax Fine Art

Page 107
Photographer: Martin Schoeller
Creative Director: Elisabeth Biondi
Studio: Saba Press Photos
Publisher: *The New Yorker*

Page 157
Photographer: Rosanne Olson
Studio: Rosanne Olson Photography
Camera: 4x5 / Film: Polaroid 55
Comments: Photograph for *Jane Eyre*
playbill/poster.
Kommentar: *Jane Eyre*–Aufnahme für ein Theaterplakat.
Commentaire: Photographie pour l'affiche de la
pièce *Jane Eyre*.

Page 158
Photographer: Melody Cassen
Studio: Cassen Design
Camera: 4x5 Meridian / Film: Polaroid 55

Page 159
Photographer: Melody Cassen
Studio: Cassen Design
Camera: Cannon A-E1 / Film: Fujichrome

Page 160
Photographer: Gerald Bybee
Studio: Bybee Studios
Camera: Fuji 680 / Film: Fuji RAP
Publisher: *LA Times Magazine*

Page 161
Photographer: Gerald Bybee
Studio: Bybee Studios
Camera: Fuji 680 / Film: RVP

Page 163
Photographer: Dieter Blum
Studio: Dieter Blum Fotograf
Camera: Minolta 9 / Film: Ilford 400
Title: "Couples"

Page 164
Photographer: Stephen Wilkes
Studio: Stephen Wilkes Photography, Inc.
Client: Old Bahama Bay Resort Property

Page 165
Photographer: Charles Harris
Creative Director: Ann Harvey
Studio: Stone Soup Productions
Camera: Leica M6 / Film: Kodachrome 64
Client: Delta Airlines *Sky Magazine*.

Page 166
Photographer: James Salzano
Studio: Salzano Studio, Inc.

Page 167
Photographer: Hugh Kretschmer
Creative Director: Michael Vanderbyl
Designer: Michael Vanderbyl

Studio: Hugh Kretschmer Photography
Client: Teknion Corporation

Page 168
Photographer: Markku Lahdesmaki

Page 169
Photographer: Yuri Dojc
Studio: Yuri Dojc, Inc.
Camera: Nikon FM / Film: Scala
Title: "Swing"

Page 170
Photographer: Marcus Swanson
Creative Directors: Byron Jacobs, Kamol Prateepmanowong
Studio: Marcus Swanson Photography
Camera: Sinar / Film: EPP
Client: Nike

Page 172-175
Photographer: Dietmar Henneka
Studio: Fotograf
Camera: Sinar 8x10 / Film: Ektachrome 100VS
Client: Mercedes-Benz
Comments: From 2000 Calendar "artCars"
Kommentar: Aus dem Kalender «artCars» für das
Jahr 2000.
Commentaire: Tiré du calendrier 2000 intitulé
«artCars».

Page 176
Photographer: Alex Williams
Creative Director: Michael Jager
Studio: Jager Di Paola Kemp Design
Camera: Horsemam 4x5 / Film: Kodak E100S
Client: Champion paper

Page 177
Photographer: Satoshi Kobayashi
Creative Director: Jane Kobayashi
Studio: C S Company / Client: Brown Jordan
Comments: From Brown Jordan catalogue.
Kommentar: Aus einem Möbel-Katalog.
Commentaire: Extrait d'un catalogue de
meubles.

Page 179
Photographer: Craig Cutler
Creative Director: Carol Layton
Photo Editor: Mary Shea
Studio: Craig Cutler Studio
Publisher: *Bloomberg Magazine*

Page 180-181
Photographer: Mark Laita
Creative Director: Mark Bappe-Wallwork Curry
Camera: 8x10 FATIF / Film: Kodak E100VS

Client: Steinway Pianos

Page 182
Photographer: Steve Bronstein
Creative Director: Dan Brown
Studio: Bronstein Berman Wills
Client: TBWA/Chiat Day NY
Comments: Ad for Absolut Vodka
Kommentar: Für eine Absolut-Vodka-Anzeige.
Commentaire: Publicité pour Absolut Vodka.

Page 183
Photographer: Chris Collins
Studio: Chris Collins Studio

Page 184-185
Photographer: Mark Liata
Creative Directors: Susan Alinsangan, Michael
Rylander, Craig Tanimoto
Camera: 8x10 FATIF / Film: Kodak E100VS
Client: TBWA Chiat/Day

Page 186
Photographer: Eric Axene
Camera: Hasselblad / Film: Tri-X

Page 187
Photographer: Bryce Bennett
Studio: Bryce Bennett Communications
Client: San Pellegrino

Page 189
Photographer: Paul Sinkler
Studio: Sinkler Photography

Page 190
Photographer: David Emmite
Creative Director: Byron Jacobs
Designer: Jeff Dey
Studio: David Emmite Photography
Client: Nike

Page 193
Photographer: Marshall Harrington
Creative Director: Lois Harrington
Studio: Harrington Studios
Comments: From a series of Track & Field participants in a Senior Olympics.
Kommentar: Leichtathleten an der Senioren-
Olympiade – Thema einer Photoreihe.
Commentaire: Extrait d'une série de portraits
d'athlètes participant aux Jeux olympiques pour
seniors.

Page 194
Photographer: Mark Seliger
Creative Director: Fred Woodward
Publisher: *Rolling Stone*

Page 195
Photographer: Jean-Baptiste Mondino
Creative Director: Fred Woodward
Publisher: *Rolling Stone*

Page 196
Photographer: James Salzano
Creative Director: Eric Revels
Studio: Salzano Studio, Inc.
Client: Dell Webb Retirement Communities

Page 197
Photographer: Chris Gordaneer
Studio: Westside / Camera: Nikon
Title: "Cuba"

Page 198
Photographer: Markku Lahdesmaki
Camera: Hasselblad / Film: Kodak EPP

Page 199
Photographer: Michael O'Brien
Creative Director: Randall Montgomery
Client: Nortel

Page 200
Photographer: Greg Pease
Camera: Nikon / Film: Fuji Velvia

Page 201
Photographer: Craig Cutler
Studio: Craig Cutler Studio

Page 202
Photographer: Hugh Kretschmer
Studio: Hugh Kretschmer Photography
Publisher: *Bloomberg Personal Magazine*

Page 204-205
Photographer: Daniel Naylor
Creative Director: Bill Healey
Camera: Toyo 4x5 / Film: Kodak E100S
Client: Zanders USA

Page 206-207
Photographer: Sal Graceffa
Studio: Graceffa Photography
Camera: Toyo View / Film: Kodak T-Max

Page 209-210
Photographer: Melvin Lee
Studio: Barney Studio BC Sdn Bhd
Camera: Hasselblad

Page 212
Photographer: OSE Huit 10 Photography
Creative Directors: Ronald Gelinas, Dominique Lafleur

Camera: Sinar P2 / Film: EPP Kodak 4x5
Title: "Perseverance"

Page 213
Photographer: Mark Laita
Camera: 8x10 FATIF / Film: Kodak T-Max 100

Page 214
Photographer: Jeffrey Apoian
Camera: Nikon / Film: Kodak

Page 215
Photographer: Scott D. Hamilton
Camera: Sinar / Film: Kodak 64T Lumijet

Page 216
Photographer: Fernando Ceja
Studio: Fernando Ceja Photography
Camera: Sinar P2 / Film: Polaroid Type 55

Page 217
Photographer: Alex Bee
Studio: Alex Bee Photography
Camera: Sinar P2 / Film: Polaroid Type 55

Page 219
Photographer: Staudinger Franke
Camera: Sinar / Film: Kodak EPP

Page 220
Photographer: Jon Shireman
Studio: Craig Cutler Studio

Page 221-224
Photographer: Craig Cutler
Studio: Craig Cutler Studio

Page 225
Photographer: Rosanne Olson
Studio: Rosanne Olson Photography
Camera: 4x5 / Film: Polaroid Type 55

Page 227-231
Photographer: Craig Cutler
Studio: Craig Cutler Studio

Page 232
Photographer: Joshua Dalsimer
Studio: Dalsimer Photography

Page 233
Photographer: James Worrell
Creative Director: David O'Connor
Studio: James Worrell Photography
Camera: Mamiya RZ 67 / Film: Fuji RDP II
Publisher: *Yahoo E-Shopper*

Page 234
Photographer: Randy Wells
Studio: Randy Wells Photography
Camera: Canon EOS-1N / Film: Kodak E100

Page 236-237
Photographer: Jayne Hinds Bidaut
Publisher: Graphis
Comments: From the book *Tintypes*.
Kommentar: Aus dem Buch *Tintypes*.
Commentaire: Tiré de l'ouvrage *Tintypes*.

Page 238
Photographer: Peter Dazeley
Camera: Sinar P 5x4 / Film: Fuji Velvia
Title: "Siamese Twins"

Page 239
Photographer: Tak Kojima
Camera: Canon EOS-1N / Film: Fuji Velvia
Client: N.Y. Gold

Page 240
Photographer: Michael Corridore
Creative Directors: Edmund Choe, Jagdish Ramakrishan
Camera: Hasselblad / Film: Fuji RDP II
Client: Animal Planet

Page 241
Photographer: Mike Carsley
Camera: Leica M6 / Film: Neopan

Page 242-243
Photographer: Steven E. Knyszek
Creative Director: Steven E. Knyszek
Camera: Minolta X-570 / Film: Fujichrome 64

Page 244
Photographer: Randy Wells
Studio: Randy Wells Photography
Camera: Canon EOS-1N / Film: Kodak E100

IndexVerzeichnisseIndex

IndexVerzeichnisseIndex

PhotographersRepresentatives

Art Directors Designers Photo Editors

Client Publisher

Cameras and Film**Kameras und Filme**Appareil Photo et Films

This Year's Most Popular Cameras and Film Les appareils photo et films les plus populaires de cette année Die beliebtesten Kameras und Filme diesen Jahres		Last Year's Most Popular Cameras and Film Les appareils photo et films les plus populaires de l'année dernière Die beliebtesten Kameras und Filme des letzten Jahres	
Cameras		**Cameras**	
Sinar	9%	Hasselblad	13%
Hasselblad	5%	Sinar/Toyo (tie)	10%
Nikon	4%	Canon	9%
Film		**Film**	
Kodak (4% Tri-X)	22%	Kodak (7% E 100SW)	31%
Fuji (2% Velvia)	7%	Fuji (10% Fuji Velvia)	7%
Polaroid (4% Type 55)	4%	Polaroid (15% Type 55)	15%

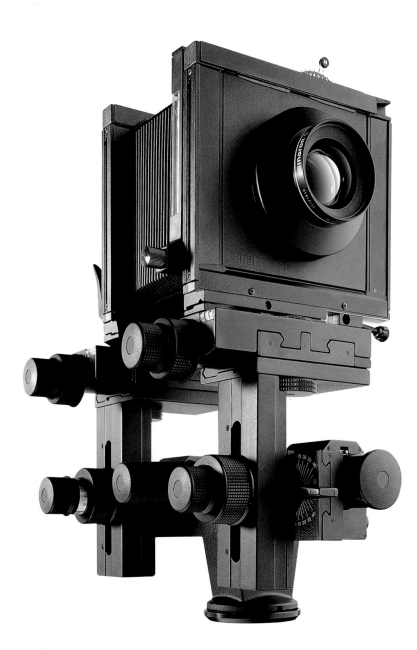